# Enrich your Calligraphy

is for Mabinogion · Maccabaeus · macédoine · machair · maestoso · mahlstick · maleutic · makar · mammock · mampoer · margaric · main · maximus · megrim · menura · meseems · metathesis · mezereum · millefiori · min · minikin · minuend · mirepoix · mise · misoneism · mixte · moiety · moly · mondaine · monophthong · monostich · montane · monteith · montero · monticule · mooi · mooned · moquette · moreen · mouldy · fig · mousseline · mouton · mridang · mudra · Muenster · muir · muley · muliebrity · muller · million · munnion · murphy · murrey · myrrhine · mutchkin · mzee & Margaret·

'B is for Birthday' · 5 · XII · 93 ·                              d · Hardy · Wilson · 1993

# Enrich your Calligraphy
## Diana Hardy Wilson

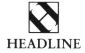

HEADLINE

First published in Australasia in 1996 by
Simon & Schuster Australia
20 Barcoo Street
East Roseville NSW 2069

Viacom International
Sydney New York London Toronto Tokyo Singapore

First published in Great Britain 1997
by HEADLINE BOOK PUBLISHING

10 9 8 7 6 5 4 3 2 1

British Library Cataloguing in Publication Data

Wilson, Diana Hardy
Enrich your calligraphy
1. Calligraphy
I. Title
745.6'1

ISBN 0 7472 1955 9

Printed and bound in Hong Kong

HEADLINE BOOK PUBLISHING
A division of Hodder Headline PLC
338 Euston Road
London NW1 3BH

for JWW • WWW • WHW
and the colours of Tasmania

# Contents

# Acknowledgments

The primary sources of my inspiration are the works of the scribes, illuminators, illustrators, rubricators, binders and workers of the scriptoria. Every generation must attempt to leave something of beauty for succeeding generations and, by all artistic standards, these people have certainly achieved that aim. As my grandfather William Hardy Wilson wrote in one of his books, 'People are judged by the works of beauty they leave.'

The pursuit of any artistic endeavour is exhilarating, at times frustrating, a solitary undertaking, spurred on by personal belief and vision - often accompanied by a stern inner critic. In writing this book I have had the encouragement of many people. Although this alone may not have quelled my own self criticism or made the journey less lonely, the generosity of their support has been most sustaining.

My personal and especial thanks to Tom Slowey who read the first and subsequent drafts, sorted out the commas, brainstormed with me and provided unstinting constructive criticism. Adele Cox for showing me how to avoid legal pitfalls, and Lynne Spender of the Australian Society of Authors for her legal guidance. Bronwen Holly for bringing her excellent editorial skills to the final drafts. Jan Blake, James and Andrew Cumming, Eric Farge, William Lai, Phil May, Moira Shippard and Steve Twohill who read sections for content and made technical contributions. To the many friends and colleagues who I am unable to mention individually - you know who you are - thank you for your patience, advice and putting up with me during the writing of this book and the years since this manuscript was completed in 1993, again thank you for the tolerance shown.

Finally, to Dr Michael Ryan, Director, Charles Horton, Western Curator and Reference Librarian and all the staff at the Chester Beatty Library and Gallery of Oriental Art, Dublin, Ireland - one of the world's great sources of culture and great wealth of courtesy. Thank you.

x

# Picture Acknowledgments

Grateful thanks and acknowledgement to Barrie Walsh for putting original artwork on film; David Huxtable, Helene Sinclair Smith, Raffles Hotel, Singapore and Guinness Mahon, Dublin, Ireland, for graciously granting permission for their material to be used. To the Trustees of The Chester Beatty Library, Dublin, Ireland, for the permission to use material from the Western Manuscript Collection.

To the Calligraphers who generously permitted their work to be published in this book and, who know that patience is a virtue, the author extends her professional thanks.

The publisher and the author have made every effort to ensure there are no errors in these acknowledgements. We apologize unreservedly if any omissions have occured.

Timothy R. Botts
Stuart Barrie
Gemma Black
Robert Boyajian
Frances Breen
Pat Chaloner
James Clough
Lynda Cowan
Sue Cox
Gwyneth Daley
Ludo Devaux
Daphne Dobbyn &
Catriona Montgomery
Rosalin Duncan
June Francis
Melanie Gomm

Michael Harvey
Deirdre Hassed
Anne Irwin
Pat Johns
Jane Kent
Celia Kilner
Jean Larcher
Margaret Layson
Colleen Little
Elizabeth MacDominic
Megan MacDonald
Annie Moring
Reitlín Murphy
Karl Wilhelm Meyer
Timothy Noad
Mary Noble

Caroline Paget Leake
David Pilkington
Anna Pinto
Ella Pos
Eva-Lynn Ratoff
Gail Rust
Rodney Saulwick
Paul Shaw
John Smith
Kennedy Smith
Angela Swan
Helen Warren
Gretchen Weber
Diana Hardy Wilson
Elaine Witton
Dave Wood

# Preface

This book aims to offer help to the many people who take up the study of calligraphy and are brave enough to return to their classes and persevere: practice, practice and more practice. It is written for all those people who every week attend day or evening classes in calligraphy, and the unknown number who painstakingly attempt to teach themselves and equally for those who love and appreciate the beauty of the line and the curve of a letter.

Practising this artform can bring immense enjoyment to the creator and to the observer. Large amounts of patience and inspiration are required because the learning of this exacting art is full of frustrations, for example, the pen nib which just will not make the marks so clearly envisaged in the mind's eye or the line that will not scan calligraphically.

Inspiration to write this book came from many directions and sources. Included among these is the student who arrived at one evening class and excitedly invited us to come and see something. The focus of attention was a shop fascia of long-abandoned premises. For nine years this student had passed this building on her way to work each day, but she had never noticed the beautiful lettering until she was introduced to the discipline of observation.

I am acutely aware that, from one week to the next, many students are unable to put pen to paper, such are the demands on their time. This in no way questions their eagerness and dedication. It is simply a fact of life. Yet it is possible to add to one's repertoire by simply walking around actively seeing, not just looking. On any occasion, visits to markets and book fairs, your eye will catch small ephemera which can considerably add to your collection of calligraphic shapes and layouts.

In passing, I want to make some comments not just on the calligraphy work you do, but on how you can use everything that is around - visual material - as a stimulus, encouraging you to use your personal experiences to influence, inspire and nurture your work, thus making it truly your own, sealed with your own personal mark, drawn from individual experience.

Through an introduction to the design and creative processes, adapted for the calligraphic perspective, I hope you can find succour for your work, and courage, so the imagined boundaries may be removed and your calligraphic ambitions fully realized.

Calligraphy is an individual pursuit and it can be a lonely one. It needs nurturing and a degree of inner discipline. Doubts may arise as to whether your efforts are any good. The answer lies in your own judgement. Be reassured by the validity of your own concepts and opinions. Calligraphers are resourceful people with an eye for beauty in the arrangements of letters, patterns, shapes and colours. This will come to you with practice.

The opportunity of meeting so many of you at classes and calligraphy demonstrations has further convinced me of the need for this book. Take it and use it as a springboard to embrace design and creativity, and extend the boundaries of your experience with calligraphy. Take your work to new heights and flights of discovery.

Find time to visit the museums and libraries which house collections of the master scribes and their apprentices. Revel in the majesty of their great legacy and keep the art alive in their memory.

# Introduction

In contemporary society, calligraphy flourishes - taught in adult education institutes, colleges of art, and through the interest of individual teachers in some schools. Many people are literate in the language of calligraphy, able to manipulate its tools and create calligraphic forms. However, skilfully combining these characteristics to produce meritorious works requires something more.

Calligraphy was once the domain of master scribes and their apprentices working in the scriptoria of monasteries, and of freelance writers and illuminators employed by wealthy benefactors. In mid-fifteenth century Europe, the advent of printing by mechanical means diminished the scribe's role while ensuring the written word gained a larger audience. Pure art gave way to information. As wooden printing blocks gave way to mechanical hot-metal printing, that, in turn, was joined by the new technologies of the nineteenth and twentieth centuries and these drew further and further away from the art of the scribes towards a machine-dominated craft. While the widespread accessibility of the preparation and production of printed material is to be applauded, it exposes accompanying problems. There may be a noticeable lack of an aesthetic or sense for design, without which the resulting product can fail to achieve its purpose.

Knowledge of the design process, attendant considerations and methodology can help you to be a more effective communicator. Without this, frustration ensues and presentation will suffer.

Design is a process, not a product, and calligraphy demands good design be invested in its creation. The disciplines in the design process can be broadly divided into two: creative and production. A blank sheet of paper exemplifies the creative discipline, and a sheet of paper with marks on it, the discipline of production.

The methods of organisation of a contemporary design practice and a scriptorium are similar, with individuals working solely in their area of particular expertise. However, the twentieth century scribe is likely to be in a situation that demands of him or her to be both creator and producer (maker). Calligraphy is both an art and a craft, and the creations of any calligrapher are best served by constant practice, exploration and experiment. This also applies to the design process, the skills of which require constant revision and attention. A free-flow of experience into the work is the vital factor which makes each piece of work unique. Work thus becomes a cumulation and expression of one's own quintessential experiences.

The production of calligraphy is not dissimilar to some aspects of the design process. In calligraphy, the letters are constructed stroke by stroke in manageable stages. The manageability is dictated by the tools of the craft. So it is with a visual design problem, which can be broken down into manageable parts, an approach which can help nurture growing confidence and give a better understanding of any process. The progression through the design process is complicated because we may travel back and forth through some of the stages before moving on.

An understanding of the creative process will help you to appreciate what happens when you pursue your artistic and calligraphic ambitions. During the creative process there are times of exhilaration and excitement, but there are also times of depression and staleness, and failure to recognise the discouraging stages can lead to the abandonment of excellent projects. Positive action can be taken which will further enhance personal creativity and enrich your work.

Nurturing your visual awareness and powers of observation requires commitment and constant practice, so that they become second nature, a part of everyday life. Research is one element which plays a significant role in any specific situation, but it should also be regarded as a continual process. The searching for, locating and collecting of material to furnish a personal reference makes an indispensable contribution to any practice. Such a compilation can include the sublime, ridiculous, curious and even plain tacky. An important part of this acquisition is finding where the sources are and learning how to gather, identify and collate information. Studying other works will help you to develop an individual working language to discuss how and why some solutions work, and others do not.

Inspiration is everywhere. It can come from surprising and conventional sources, and, fused with an individual's own experience, can produce

sensational results. Your own experience is a vital ingredient in the design process, so it is crucial that you learn how to include it.

The great legacy of the scribes, illuminators and binders, and the early printed texts of Europe demonstrates clearly the foundations of much contemporary typographical and graphic design. Curiously enough, the centuries old language of typography continues to be employed in the software packages of contemporary technologies.

A calligrapher works with tools and language which have ancient origins, but this should not prohibit the employment of contemporary technologies as aids to both the design and production processes. There is absolutely no reason to shun equipment which may assist the realisation of a work. The humble photocopier (compared with the latest scanners for computers) can be most useful in a number of ways. However, preparatory work is necessary in order to obtain the greatest benefit from any piece of equipment. Time spent acquiring some understanding of the capabilities of the machinery and how best to prepare the work prior to using the equipment is time well spent.

This book is not intended to and, indeed, could not accomplish the task of making anybody into a 'designer', but many of the methods used in the process of design are absolutely relevant to the production of calligraphic forms; it is some of these methods which will be addressed. The techniques and procedures are intended to assist in the continuation of the learning process, and to illuminate and add to the pleasure derived from practising calligraphy.

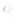

# Design Considerations
## *The Application of a Discipline*

The practice of calligraphy involves much more than writing beautiful letters. Understanding the art and incorporating principles of design is a fundamental necessity. Fine hand lettering and calligraphy demand the examination and application of a plethora of design considerations without which, even works of letters made with decisive, well constructed strokes will fail in their intention, marred by the absence of knowledge and understanding of these concepts.

The discipline of calligraphy is intrinsically linked with typography and the wider area of graphic design. They all deal with visual communication. Sometimes this is effected solely with words, on other occasions with words and images. Good visual communication design conveys information in a legible, balanced manner suited to a specified target audience. This is a good maxim for calligraphers. For their work to be recognised and recommended as good or successful, attention must be given to the whole work, not just the construction of letters.

The calligrapher physically manipulates specific tools to create the letters which make up the words for this particular form of visual communication. How the space surrounding the words is used and visually manipulated is very important; it is the difference between getting the message across to the observer or reader, and not. Good design attracts the eye of the prospective reader and draws attention to the message through an easy visual flow. It can be forcefully argued that this matter of initial visual attraction and subsequent ease of reading comes from the proper understanding and use of design principles.

The overall layout of the work - the arrangement of the words with additional borders, applied ornament and/or images - is only achieved after an often lengthy and multifarious process. The overriding demand is to 'solve the problem', that is, to find the best way of imparting the information in the intended piece of work. This is facilitated by working through the design process, a series of recognisable stages of problem solving. This, in turn, is supported by the application of a suitable method of working which is pertinent to both the specific issue and the abilities of the solver.

Never underestimate the significance of a well-informed and coherent definition of 'the problem', that is, how to convey the required information in a form appropriate to the overall purpose and content. Insufficient consideration of this can be the root cause of the failure of a work. To avoid such occurrences, apply discipline to your working

SIXTEENTH CENTURY
Within the pages of antiphonaries lurk visual delights like this over-indulged letter 'I'. These huge choir books were not all gloriously decorated on each and every page. Some volumes may be devoid of any effusive ornamentation; they were after all primarily practical books, often rendered by one or more of the intended users, who had no special skills apart from being able to read and write. However, it is the elaborately decorated volumes which usually dominate exhibitions.

Examination of this letter reveals that its additional decorative elements are constructed of a series of single fine lines and groups of circles or individual circles. These might be an allusion to pearls, a much valued gem extensively included in the decoration of manuscripts. The lines and circles finally result in a few stems of delicately drawn foliage. The use of abbreviations is evident in the red lettering. Note the square dots of the notes on the four line stave of the plainsong.
CBL.WMS 195.106

RODNEY SAULWICK
This work is the result of an invitation to submit a design for a page in a publication entitled *The First Hundred Years*, a celebration of the first century of an Australian paper range. The variety of calligraphic styles was used to reflect the breadth of the company's range of papers. This is also captured in the tools and materials used to produce the full colour artwork, which is best summed up in the words of the calligrapher: 'Everything I could lay my hands on, and more'.
450 x 355mm (original format)
17.75 x 14in

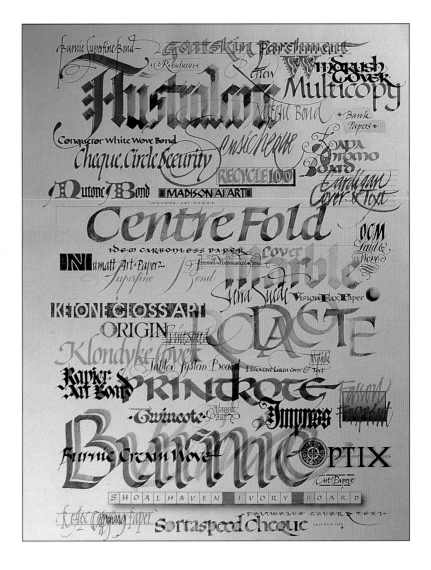

practice. This can be particularly aided by a methodology, that is, the organisation of the subject matter in a logical and practical manner.

By the time a conclusion has been reached concerning the actual visual solution, the calligrapher's work has hardly begun. The selection of methods for implementation, their attendant tools, equipment and suitable materials have yet to be determined. The choices have great interdependence; for example, the use of paint will necessitate the selection of a paper suitable to receive the extra moisture involved when working with that medium. The final placement of the work, perhaps in a frame, could require extra board or paper to be left beyond the actual margin area of the work.

Sight must never be lost of what we are trying to do: conveying some kind of information in a manner suitable for both the overall purpose and the content. In the final work, the aim must be for clarity which will result in visual balance, legibility and a fulfilment of the intention laid out in the

definition and by the original specifications. The achievement of these ends must match our own individual capabilities.

Learning more about, and applying design - the process and considerations - will support this practice and greatly improve our individual work. Delights, discoveries and challenges may be new, or encountered regularly on every problem. The realisation is quickly made that the purpose of a work has to be considered. Is it to be folded into an envelope, or displayed? Is it personal, or formal? These considerations can be more easily assessed by identifying the target audience and analysing its point of view. Incorporating this nature of focus, and the concept of challenge, into working practice, can have a profound and positive effect.

Similarly, your work can be improved by discovering the importance of what is not there, from counter spaces to interlinear spaces. In effect, this is learning not by looking at what is done, but at what is left undone.

# The Design Process
## *Problem Solving*

Design is a process not a product. It is about problem solving and, in particular, creative problem solving. It involves a number of conscious actions, including the recognition of intentions, and the manipulation, organisation, and selection of material and ideas to produce a final work. The recognizable stages of the design process for calligraphers include: identification of the problem, analysis, definition, research, producing visual roughs, selection of a solution, preparation for production, implementation and, when the work is completed, evaluation.

Thus the process is multifaceted and a number of its components are interdependent. There are phases within each stage, some of which we must explore thoroughly and through some of which we may travel back and forth before moving on. It is a process without end.

Making the decision that the best solution has been found is not easy. At some stage, a conscious decision to forego any further attempts to solve the problem or improve on the chosen solutions has to be made. On occasion, we may feel we have completed a job, or we will have to decide that any further time spent on the work will not necessarily improve it, although we may not even feel particularly satisfied with the solution.

The process is flexible and requires a complementary agility in attitude and approach, and in using and applying its components, methods and procedures. The more we understand and know about the stages, the more we can push against them and any limitations in our own working practices. This is very important, because acquiring a greater understanding and familiarity can give us more freedom in our working methods, thus making our work more enjoyable.

Neither commissions nor self-generated work will necessarily follow a predetermined or prescribed route. Every work must be addressed on its own merits, even though there will inevitably be some inherent common factors. Barring experimental works, and not all of these are necessarily exempt, all work has an intended result or purpose.

The greater knowledge we have about ways of doing things, and the more discoveries of methods to apply, the better our chances are of achieving the best solution. Widening our choices and acquiring more skills allows the freedom to select the best methods to tackle a particular problem. The design process also requires us to draw on our own experience. It is our individual experience which brings the unique quality to our work, not just our ability to solve problems and apply methods.

## Gather the data about the intended work

From the outset we need to define our objectives clearly. In order to do this, gather all the known data

JAMES CLOUGH
Commissioned by a company promoting tourism in Venice, this lettering designer delved into his knowledge and experience of that great city. His intent was to evoke the voluptuous and exotic tradition that surrounds the Venetian carnivals. The lettering was inspired by the use of a pointed pen, a tool renowned for its ability to aid the production of elaborate flourishing. The letter 'z' in Venezia is suggestive of the stripes on the gondola mooring poles along the edges of the canals.

and criteria about the intended work. If it is a commission, make sure you get as much information as possible about the proposed work from the client. It is surprising how easily pertinent data can be overlooked. If the visual problem to be solved is one identified by the calligrapher, collecting the known data is still important. All the details are necessary to make a draft of initial intentions and to analyse the problem.

Collate all the data and make a firm decision that you intend to proceed with finding solutions and doing the work. With this acceptance, which should include recognition of the challenge involved, begin your assessment.

## Analyse the problem and define the objective

To help with this part of the process, ask lots of questions, make comparisons and get to know as much as possible about the work.

First, consider the overview: what is it you are setting out to do? What is the intention? What are the specifications? What is it all about? What is the purpose? Who is this for? How will it be presented?

Define this in simple terms, using your own language, and write a statement of intent with an accompanying list of criteria. Omit nothing, even if you think it to be of lesser importance, as it may

## Design process

| Stimulation | Identify problem | Analyse | | Research |
|---|---|---|---|---|
| ● brief<br>● job<br>● idea<br>● commission | ● identify obstacles | ● define end result to satisfy commission/client and self;<br>● intention/purpose of whole - this definition open to further analysis | ● *at this stage marshal all your thoughts, own artistic capabilities, technical facilities and time available to you within given parameters* | ● own experience<br>● other sources - books, references, collections, museums, galleries, institutions, libraries, clubs, societies, colleagues |
| ● recognition of a solution to improve<br>● asked to do something for a specific purpose | ● get to know everything about problem | | | |
| ● creating limits/parameters<br>● agreeing guidelines/subject | ● discussions<br>● acquisition of information<br>● collate information<br>● ask questions | ● establish time schedule<br>● financial considerations | | ● collate and process information<br>● refer back to original definition and check for any conflict / contradictions |
| NOTE: make visuals at any time, as signposts, and ideas to expand, (thumbnail sketches) | | | | |

turn out to be fundamental. The method of producing an original one-off work in calligraphy, in contrast to the preparation of camera-ready artwork, means there are a limited number of ways of rescuing a work. Camera-ready copy can be composed of various elements prepared on paper and pasted up on board into a format which can be stripped off, replaced and/or rearranged. In producing a one-off original piece of artwork, all elements are rendered by hand on a single sheet of paper. Corrections are not so easy and alteration sometimes means redoing the whole work. So, all considerations must be deemed to be of equal importance.

A detailed analysis of the problem provides the information for a solid definition, and this aids the later stage of selection. Never be held back by a lack of information. Find out as much as possible about all aspects. Question and compare. Interrogate the problem, pull it apart, find interconnections, compare it with other situations, identify common factors, look at it from all angles and get to know everything about it. One fruitful analytical method involves asking why, what, who, where, when and how? Add the data supplied by the answers and dispense with any superfluous information. Repeating this process, maybe several times, clarifies the objectives.

| Roughs | Select | Preparation for production | Implement | Evaluate |
|---|---|---|---|---|
| ● develop possible solution | ● adjust<br>● amend<br>● refine | ● presentation of the piece | ● action | ● does the final work satisfy your original concept |
| ● review | | | | ● the most valuable and constructive action now is to look at the whole project just completed and learn from what you have done |
| ● try alternative: different material, equipment, paper, colour etc<br>● try brainstorming method | ● final decision<br>● confirm the commission<br>● do finished rough -as appropriate: full size, full colour, dummy, mock-up, model<br>● bring up to presentation status for final confirmation<br>● make presentation | ● confirm: all materials, equipment, techniques and methods, layout, do mechanical (copyfit),<br>● check-list of all materials and equipment for acquisition;<br>● final check for any technical problems introduced by printers, photography, paper, binders, etc | | ● identify areas you feel you could and need to improve on and consider ways to do this<br>● recognising shortcomings will benefit your whole approach and method of working and add to your intellectual and artistic development;<br>● from the sourcing of the piece - to this stage - a piece to present, to be framed, printed:<br>● **this is it** |

This type of thorough analysis will enable the components of the specifications to be clearly identified, thus assisting the initial definition. As you continue to pursue this analysis of the problem, some initial perceptions are likely to change several times and redefinition will be necessary. This can occur more than once.

Always note any ideas or thoughts which come to mind (at any stage), either in words or images. The latter can be thumbnail sketches, made with enough marks to enable you to understand the nub of the idea when you look at it later. It is important to get these ideas down and worry about their possibility and feasibility later.

Some posters, invitations, stationery, postcards and leaflets will present readily identifiable possible solutions, particularly concerning format and size. These conventional guidelines can be called upon to aid definition of the work's intention. They can then be followed up, or disregarded and an attempt made at a new solution. There are no laws against this form of experimenting.

Taking note of what you have written and know concerning the data and intention, identify what is unknown and needs to be found out. This list may include the target audience, physical properties and location or site (where is the work going to end up?). Is it going to be displayed, framed or hand held?

A fusion of these elements (target audience, format and physical properties) will provide some more ideas. A thorough review of all the information now known on the subject may prompt an opinion as to whether this work requires, for example, an informal or formal, neoteric, or traditional solution. The work accomplished thus far should provide ample scope for a final defining of the work's purpose.

The detailed analysis which leads to this final definition of the objectives is a form of research conducted on a very broad basis. Working through the problem, its implications, possibilities and potentials, adding and pruning information, defining and redefining, will provide a hypothesis or specific focus for investigation. This is the true definition of the work and one which will provide the basis for the next stage of research.

## Research

The research cannot proceed until it is known what needs to be discovered. Begin by spending as much time as required drawing on the breadth of your own experience and knowledge of the subject or subjects of investigation. The importance of this first step cannot be overestimated. The problem has been identified, accepted, analysed and defined, the intention formulated - all of these actions have

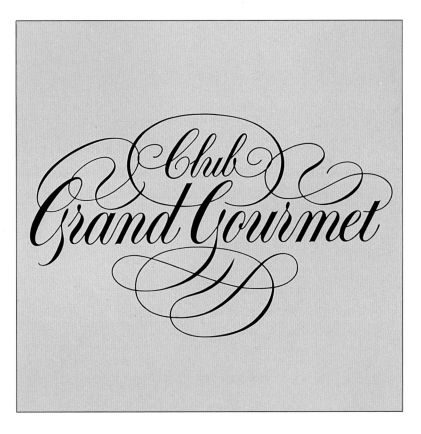

JAMES CLOUGH
These elegant letter forms, with carefully considered flourishing, were created for the masthead of a publication, for a company selling gourmet food by mail order. For this kind of work, consideration has to be given to the fact that the brochure and the products themselves are possibly the only contact the customer will have with the company. Therefore the target audience must be clearly identified so that the design can be accurately aimed and can help to capture custom. The design must also reflect the image the company wishes to project.

already drawn on personal experience and knowledge. It is important to acknowledge this, particularly if faced with a problem whose criteria are initially viewed as being outside one's personal experience.

In the search for further and more specific details, the logical beginning is therefore to continue this exploration and perhaps discover unexpectedly what you actually do know about the proposed project. Record everything, however unimportant the information may appear, or however tenuous the connection. It can be confirmed or rejected at the next stage. Apply similar questioning techniques to those used for analysing the problem to evoke what is known of the subject. It can be surprising what is already perceived if a methodical approach is taken (see also research project, pages 59-61).

Work in a calm and relaxed manner. This quells any panic which may arise from a feeling of not knowing or comprehending. Be reassured that there is always someone to ask, or a place where inquiries can be answered. The relaxed approach will enable you to think clearly and draw more easily on your own experience to identify gaps in understanding. If you find you are not thinking clearly - you are panicking.

Make notes and lists of what needs to be found out, and try to identify the best available sources of information. Support this by referring to immediate and accessible resources: your own books, picture and reference collections, local libraries, organisations and institutions, friends and colleagues.

Initially, contacting previously unknown sources for the information you require may be slightly daunting. To acquire the precise information, you must set aside all pride. Rediscover the inquiring mind that we all possessed as children. Determine what it is you want to know - and ask! This can be done either by telephone or letter, but work out in advance exactly what you want to know and ask the most likely people, organisations or institutions.

Some information may be more elusive, outside the remit of local libraries, museums and organisations. If this is the case, ask if they can direct you to another possible source. When you contact any organisation or society, particularly outside your local area, keep a record for future reference. Help can be found in some strange and very interesting places.

Work through all the questions which need to be answered. If it makes it easier, put them into lists with notes on their priority, subject matter or source. Collate, organise and reorganise the research material, always checking back to your statement of intention and definition of objectives. The additional material should clarify the problem.

Develop the habit of dating all work. Also, date, log and, where appropriate, keep copies of, all contacts made during the research stage. A notebook is a good format for compiling a logbook. The entries can be chronologically arranged and dated, with contact name, address and telephone number and details of the request.

A measure of patience is required during the different stages of the design process, particularly during research. Waiting for requested information can delay progress but, if time permits, it is invariably well rewarded.

## Make roughs to identify possible solutions

The nature of most calligraphic solutions means that the entire work may have to be executed as a finished rough before the final piece is begun. Since many of the works in production will be one-offs, this is not such a bad thing in terms of getting it right. In calligraphy, some formats are dictated by the intended result, but this does not furnish the total visual solution. Using the supplied information, additional research material and any ideas and thumbnail sketches already produced, start on your rough workings.

Work in pencil (at least B or 2B) on blank paper, A3 (297 x 420mm) or A2 (420 x 594mm). The importance of doing roughs can never be over-emphasized. Learn your own visual language. In time, you will know after only a few marks when something is not working, and should be abandoned for a new approach. Do not get stranded working and reworking an idea that really has no future; move on. Comparing this way of working with earlier attempts at layouts will possibly show work which was laboured and far more detailed than actually necessary.

Roughs are sketch designs, which need to be produced with agility and alacrity. Try to develop a free and fluid approach. There can never be too many roughs. Often dozens need to be attempted before you discover that an early idea indicated the solution. Effecting many roughs allows comparisons to be made, all possibilities to be explored, and eventually, may confirm the potential of an earlier concept.

Sometimes one small part elicits a feeling of potential, but the adjacent marks are wrong. In this case, start again, repeating the part that seems right, and manipulate the surrounding marks differently. This idea can be pursued many times and may either

RODNEY SAULWICK
This certificate of generous proportions was commissioned by the City of Moorabbin, Victoria, to commemorate the historical bond between Australia and Turkey, and specifically its own link with the Turkish city of Canakkale. Using all available instruments, methods and materials, this full-colour rough gives a totally clear picture of how the final work would appear. There were specific areas of information - text and image - all of which had to be presented clearly and legibly. The final wording of the body copy was not known, but an indication of the size and style of lettering and amount of space it would occupy had to be incorporated to address other features and the whole layout.

An important reason for such roughs is that it cannot be presumed that the commissioner has the same standard of visual literacy as an accomplished calligraphic designer. The latter may be able to indicate how something will appear with just a few marks, but the former, with an untrained eye, will need to see more detail.
562 x 382mm
22.12 x 15in

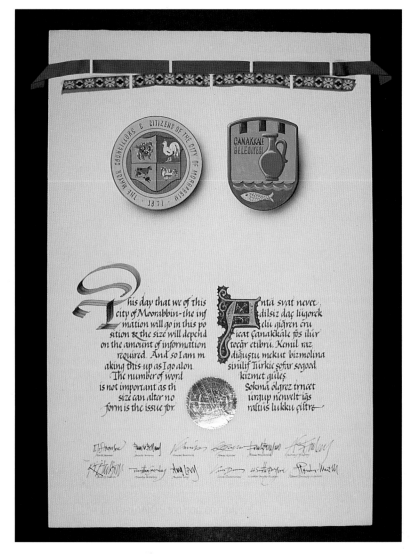

develop into a possible solution, or be rejected. It is not unusual to work through many pages of roughs, manipulating the marks, trying and testing different positions, styles, ideas, and layouts. If you find working solely in pencil constricts the flow or development of visual ideas, use any instrument and medium with which you can work freely.

As you become more adept and relaxed using this process, doing the roughs can be an exciting and satisfying adventure: the search for the elusive solution. There will be times fraught with frustration, when possible solutions fail to develop as hoped. Stop, rest and try something else, or apply the brainstorming method outlined in Methodology (page 11).

What is fundamentally important in the production of rough visuals is making marks on paper, sometimes any marks. It is not enough to think about visual ideas. Thinking makes a big contribution, especially at times when we are

moving around and cannot use pencil and paper, but we need to be prepared to record ideas as they develop. The eye-brain-hand cycle assists in this development. Although thinking, even day-dreaming, does elicit ideas, actually making marks on paper with a pencil or pen can actively encourage them. When looking for a visual solution to a problem, the most expedient practice is to try to find it visually. These rough works are also called visuals, visualisations or presentation visuals, rough or quick sketches to show how the finished work will look.

Since design is about feeling as well as knowing, in time and with practice, your intuitive feelings about solutions will be honed. Sometimes this can be a feeling of balance between what is within the self and what is on the page. A phrase often used to describe a completed work, 'the work sings' (off the page, of course), can equally and aptly apply to the discovery of the visual solution through your

roughs. Keep all your roughs, at least until the work is completed; then perhaps edit out some of the really bad non-solutions.

Doing calligraphy roughs will mean using square-cut nibs when working through your concepts. However, initially, for effecting a general layout of the words on the page, using a pencil and simply indicating the text with lines or areas of tone can suffice. As the work progresses, letters can be roughly indicated in pencil. Only as you move towards the solution do you need to work with the pens and start to see if the copy will fit the page.

As the solution evolves, more detail can be included in the roughs to confirm and consolidate the emerging visual arrangement. If colour is a feature of the finished work, start to include it in your rough. You could use colour pencils or paint, both of which will put life into the work. Even a small area of colour will begin to give succour and substance.

Refer to your original intentions and definition, and evaluate the progress. Make certain that the objectives have been adhered to and that no details have been omitted. You will find this particularly helpful if more than one possible solution is emerging, because careful scrutiny of the original aims may mean some of the ideas must be eliminated. In making the final selection from the well developed roughs, again refer to the list of criteria and the definition of the problem.

The nature of calligraphic solutions requires a well-prepared and accurate approximation to the finished work. This can be accomplished with the production of a finished rough, which will allow all design considerations to be confirmed as correct and ensure that the work fits the proposed space. There are few exceptions. Even when the final work is to be produced in full colour, a good simulation must be produced. Costly mistakes can usually be avoided by referring to a good finished rough.

### Prepare for production

Use the finished rough to identify and select the best method and techniques to execute the work. In producing the finished rough, coloured pencils can indicate the colour of any paint to be used. Then you are ready to select the correct equipment and materials. This requires care and attention to detail, so assemble all the requisites before beginning work. Compose lists of the necessary equipment and materials and a running order for production (see page 87).

Finally, do it!

# Methodology
## *The Journey Towards a Solution*

The production of calligraphic work involves more than the practical consideration of the various design elements. The solving of a visual design problem, finding a viable solution, can be a daunting and exasperating experience. It can also be immensely exciting, a journey of discovery or adventure, with the final, totally satisfying, reward of finding a solution.

The way you work in order to arrive at a solution may demand a considered methodology, an application of a system, a more organised approach. Developing and adapting your own methods of working is essential. Sometimes, working through the design considerations is simply a process of elimination, which certainly makes the task easier. However, other problems are less straightforward and, at first glance, may appear more difficult.

The choice of method and solution must suit both the problem and the problem solver. As more methods are identified and put into practice, the processes involved become more familiar and relatively automatic. Parallel to this, the augmentation in skills increases your individual potential as a creative problem-solver.

The first exposure to a new problem can conjure up a mixture of feelings and emotions. It can be overwhelming, frightening and intimidating. It can also arouse excitement, great anticipation, curiosity and be seen as a tantalizing challenge.

At this early stage, it is not unusual to find yourself feeling negative or doubtful about proceeding. Looking at the problem as a whole, its very proportions suggest a seemingly impossible task. The solution in this first instance is: just do it for yourself, enjoy it and have fun.

### Break it down into manageable parts

So, where to begin? The first step is to break it down into manageable parts. Approach the problem in a systematic and organised manner. Identify its various components, and separate them out into their own space. This can be done on a large sheet of paper where each section can be broken down further. Some aspects may be actions which have to be performed in a sequential manner; identify these and list them accordingly. Another area may be things which need to be found out; note beside each item possible sources of the required information. Continue working in this manner, successively breaking down each smaller problem into

RODNEY SAULWICK
Designing a football-poster title which expresses an appropriate festival atmosphere is not an easy task. However, by using an item probably found in hundreds in the after-match refuse, the title comes to life. The humble 'iced-lolly' or 'icy-pole' stick, used with ink on A4 Bond paper, manages to produce a title which would not alienate any supporter, an important factor given the partisan nature of some football crowds.

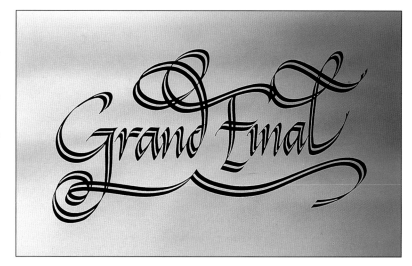

manageable parts. Working this way will enable you to plan a strategy, co-ordinate your actions and organise your time.

The astonishing thing is that as soon as you begin to break the problem down into manageable parts it becomes just that: manageable. Earlier fears and uncertainties will begin to disappear. Their weakening may be due in part to the concentration you put into the breaking down task, but the most likely reason is that what was perceived as a frighteningly large, unsolvable problem has been reduced to a series of manageable, smaller tasks. (This method can also be applied to many other situations, beyond the solving of visual design problems.)

## Create an ideal world

A wonderfully free method for solving visual design problems is to conjure up the virtually impossible. This is moving into what can be called 'ideal-world space' and imagining the most outrageous, idyllic and crazy concepts. To manage this feat, we must project our thinking over an imagined barrier, which represents the limits of personal experience and skills. This method allows a suspension of all the usual financial, physical and practical restrictions, giving space for the truly outrageous, extravagant, over the top and even plain silly ideas to be explored.

Having accomplished the risky and dangerous journey to an area inhabited by all these wild ideas, we can back-track to the possible, and probably more acceptable solutions. We might not yet have the necessary experience or skills to produce these solutions, but the possibilities they display have captured the imagination; so we set about finding

out how to produce them. The result of working with this method could be a wonderful solution and an enlarged repertoire of skills and knowledge.

This method demands the ability to ask for help, seek out and inquire, to find appropriate sources of information. If you find this difficult because early training has instilled the idea that it is bad, or even forbidden, to display a lack of knowledge, keep reminding yourself that it is, of course, quite acceptable to seek assistance. In design work it is regarded as much more sensible than trying to use the same safe, tried and tested solutions. Live dangerously and have fun!

## Seek out and use sources of inspiration

Referring to visual material provides another excellent method to use during the journey towards solving a visual design problem. Some early educational methods discouraged referring to sources because this was believed to lead to copying. In effect, seeing how others solved the same or similar problems was banned. The reasons for this atrocious practice have, let us hope, passed into antiquity with the concept, but there are still plenty of people who were taught this way. Copying was regarded as bad, though it is a fundamental element of learning behaviour. Unfortunately, this early training can get in the way of making progress.

Other people's work can be inspirational and enlightening. New discoveries, are encountered; such as the work of an artist you did not know, a particular juxtaposition of two letters, or an interesting layout, format or use of colour.

It is terribly important for improving our own skills and abilities to be able to seek out and see for ourselves wonderful examples of calligraphy.

Although the original, ancient manuscripts are often housed in inaccessible locations, every effort should be made to see them whenever possible. Remember, too, that access to these works is available internationally through excellent print reproduction. The growth in this market provides the opportunity for anyone to enjoy full colour, good quality reproductions of both ancient manuscripts and contemporary works. This provides a rich vein of inspiration, exhilaration, encouragement and consolidation (see also Nurturing Visual Awareness page 63-85).

Use this method as a 'kick-start'. If a deadline looms, or you are unable to focus on a possible solution, 'walk' through the pages of a selection of illustrated books while thinking of the problem. Sometimes ideas evolve during this meander. Jot them down. On other occasions, after the book is shut and the pencil and pens are to hand, the solution begins to appear. It is unlikely that the result will bear any relation to what was seen on any page. Seek out some good books which can become your personal sources of inspiration (see page 79-83).

## Make a plan of action

In the production of calligraphy, both as one-off and camera-ready artwork, there are so many different considerations to be addressed you simply cannot afford (in all senses) to do the work in the wrong order. When mistakes occur, or something is missed in the 'running' order, usually the only option is to begin the entire work again. However, some errors are not always the total disaster they appear at first sight and remedial action may be taken. (We are, after all, only fallible human beings - witness some of the ancient manuscripts with frequent reminders of the fallibility of the revered master scribes and their apprentices.)

To prevent unnecessary mistakes, it is helpful to plot out a plan of action. Write out the sequential arrangement of the production and its attendant methods with a check list of materials and equipment. Part of the key is that many calligraphic productions are sequential.

Another reason for preparing these lists is that they free us to concentrate on the work without struggling to remember what comes next. Without them mistakes can easily occur, particularly during a lapse in concentration or after an interruption. It is at such times that we also recognise the need for a rough developed to a highly finished standard. Ultimately, having a finished rough, an organised plan and lists allows the creation of the work to go ahead in an atmosphere of pleasure and enjoyment.

Develop your own working practice, use it and refine it; keeping it flexible allows it to be highly adaptable. You will need to be able to alter and adjust your methods to suit the demands of the work in hand. This will not work if the method is too constricting, static and inflexible.

## Talk it through

Talking through the problem, your ideas and proposed plan of action can clarify your intentions. This does not have to be done with someone who knows about calligraphy, design or the subject under observation. In fact, this technique can be more effective if the person has no knowledge of these areas, because the responses will be intuitive, without any technical bias.

Use spoken words, complemented with pencil and paper as required. Explain simply but comprehensively what you have set out to do - the purpose of the work - and then present your final solution and how it will be produced. (It is not necessary to retrace the often tortuous paths of exploration and discovery.)

This method can also be used at an earlier stage, to overcome a sticking point in the development of a work. Talk through what you have set out to do and illustrate your work so far. This in itself can produce very positive results, and suddenly you can find yourself able to resume work, having travelled beyond the point where you were previously stuck.

## Try brainstorming

The design process illustrates the importance of utilizing one's own experience in creative problem-solving. As we all have some difficulty remembering instantly everything we might know about any topic, access to the information can be facilitated by brainstorming. This is an extremely powerful and very useful method. Initially, it appears similar to conjuring up the impossible (see Create an ideal world, page 10) but, where that method will probably address a specific problem, this is about making connections and finding relationships where there appear to be none.

To practise this method, the sessions should be intense, energetic and sharp so that crisp responses and ideas can flow freely. Ideally there should be no interruptions or intrusions, such as the telephone or door bell. If you can find people whom you trust to share the session, so much the better. If not, consider talking aloud as you venture forth on a road of discovery. Conduct the exercise in a manner which

allows your thoughts to roam freely so that any ideas, however bizarre or unconnected, can be noted. Arrange the ideas in groups on a large sheet of paper, draw lines to connect them and include arrows to indicate where one group leads to or from another.

Another version of brainstorming can be applied when a solution is elusive, and exasperation is setting in. To free yourself of this, consider the following list of possibilities and add your own:

- change the size: larger/smaller
- change the shape/format/colour/try black and white
- change emphasis: more formal/less formal/ bolder
- add: rules/a border/decorative device/ illustration/an enlarged initial letter/ texture/ pattern/detail and information/letter and line space/an element that bleeds
- reverse out one element/the whole
- change the style: condense/expand/ bolder/lighter
- change the instrument: another pen/pencil/ brush
- change the substrate: another paper/paper size/paper colour/layout
- remove or simplify elements
- hold it up in front of a mirror
- sleep on it, look at it later
- try something completely different/ converse and totally unsuitable
- add humour or make it very serious.

Effective brainstorming incorporates sound lateral thinking. Brainstorming allows the problem to be viewed from all angles and lateral thinking contributes with its side views, glancing in obliquely to illuminate the obscure. Lateral thinking is a relevant method to employ on its own because it provides refreshing insights to problem solving. Attempting to find solutions by following a logical path of thought can be considered as 'vertical thinking'. Applying lateral thinking involves a greater flexibility and willingness to take risks. The curious result of lateral thinking is that the ideas that evolve appear so obvious or 'logical' in hindsight. Using the logical process, progress is made from one step to the next, whereas lateral thinking has an exciting tendency to make connections with seemingly unrelated facets which can be built on.

You could consider the roughs and sketches produced during the search for a solution as a form of brainstorming with oneself, an exploratory dialogue.

# Paper and Paper Sizes

Paper and board are dispatched from the paper mills to the paper merchants in rolls or large sheets. When the paper and board arrives at the shop, it will probably have been cut to a manageable size whose measurements are a recognised International Paper Size. This system was selected by the International Standards Organisation (ISO) from a practice established in the 1920s by the German publishers Benth-Verlag. The company had created a system of issuing paper standards with the nomenclature 'DIN', Deutsche Industrie Normen (German Industry Norm).

The size is based on a sheet with an area of one square metre and referred to as A0. The system allows for the paper to be folded in half many times with the resulting divisions always having their sides in the same ratio: 1: √2. The printer will buy paper and board in a size prefixed by RA or SRA. RA0 (1220 x 860mm) is an untrimmed sheet size for work which does not bleed off the page (unbled work). SRA0 (1280 x 900mm) is a larger, untrimmed sheet size for bled work.

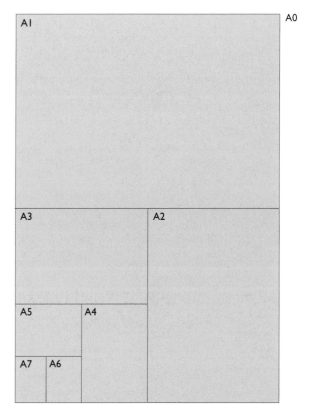

The 'A' series paper sizes are based on a sheet size of one square metre (A0). All sizes are proportionate reductions, that is, however many times the sheet is folded in half, the sides of the resultant divisions are in the same ratio 1: √2 (1:1.4142).

The international paper size system is arranged in three groups:

- ◆ 'A' series, the most commonly recommended and used sizes
- ◆ 'B' series, an intermediate size, commonly used for posters and envelopes
- ◆ 'C' series, primarily for envelopes
- ◆ Specials (envelopes): DL takes A4 folded twice to one-third A4, and C6 takes A5 folded once to A6.

The Standard English Paper Sizes, known as Imperial sizes, were used in the United Kingdom before the adoption of the ISO metric 'A', 'B', and 'C' Series. The Imperial sizes are still widely used, both by printers and retail stockists of paper and board. Some people will argue that they are more comfortable to work with and are aesthetically more pleasing for design work than the metric sizes whose existence owes much to convenience, need and economics.

Some of the paper sizes have names dating back to the fourteenth century, when European papermakers wanted an identifying mark. Each papermaker made one size of paper at his mill and needed a characteristic mark for his product. Watermarks provided the solution. These are faint wiremark designs, impressed on the paper during manufacture and visible when the paper sheet has light behind it. In time, the watermark became synonymous with the size of paper it adorned. Foolscap is an example of this practice. In 1588, a European watermark of a jester with cap and bells, was employed by John Spielman at his mill in Kent, England. This, and other watermarks are still in use today, many identifying different paper mills. Watermarks can now be designed and supplied to the specifications of private companies and individuals.

Traditionally, the weight of paper was calculated in pounds per ream (500 sheets), however this had obvious inherent problems because larger sheets weigh more. The international method for calculation is now accepted as grams per square metre (A0 sheet). The resulting figure is given in grams per square metre, either gsm or $g/m^2$. This method allows the weights of different sizes of sheet to be compared. The weight of the paper can sometimes help to determine its thickness, for example a $90g/m^2$ is 0.09mm thick. The thickness of board is measured in millimetres or microns (micrometres) and the weight in grams per square metre.

The selection of paper for calligraphy is a crucial consideration and depends on several factors, including weight, thickness, sizing or water absorption, surface strength and finish. Hand-made, mould-made and machine-made papers are manufactured in a form which can take ink and paint, but not all papers have the necessary surface finish.

Paper is a porous substance composed of air and fibres bonded together by fillers. Paper made with cotton has durability and a good surface. It is made with acid-free ingredients which ensure it will not yellow or go brittle with age. Chemical wood pulp, a cheaper form of cellulose, is used in the manufacture of wood-free paper, giving it similar (though not as good) properties as the paper made with cotton. Paper of archival standard which is resistant to deterioration is made with pure water and acid-free fillers. Calcium carbonate is used as a buffer to stop the paper absorbing, and being affected by, pollutants in the environment.

Paper can be uncoated or coated. Uncoated paper has an uneven surface. Coated paper has a smoother surface which is whiter, takes ink and has good opacity. An old method of testing to see if a paper is coated or uncoated is to rub the surface with a silver coin - a coated surface blackens. For

### International paper sizes
### (*all measurements in millimetres*)

| A0 | 1189 × 841 | B0 | 1414 × 1000 | C0 | 1297 × 917 |
|---|---|---|---|---|---|
| A1 | 841 × 594 | B1 | 1000 × 707 | C1 | 917 × 648 |
| A2 | 594 × 420 | B2 | 707 × 500 | C2 | 648 × 458 |
| A3 | 420 × 297 | B3 | 500 × 353 | C3 | 458 × 324 |
| A4 | 297 × 210 | B4 | 353 × 250 | C4 | 324 × 229 |
| A5 | 210 × 148 | B5 | 250 × 176 | C5 | 229 × 162 |
| A6 | 148 × 105 | B6 | 176 × 125 | C6 | 162 × 114 |
| A7 | 105 × 74 | B7 | 125 × 88 | C7 | 114 × 81 |
| A8 | 74 × 52 | B8 | 88 × 62 | | |
| A9 | 52 × 37 | B9 | 62 × 44 | Specials | |
| A10 | 37 × 26 | B10 | 44 × 31 | DL | 220 × 110 |
| | | | | C7/6 | 162 × 81 |

### American paper sizes
### (*all measurements in inches*)

| | | |
|---|---|---|
| 16 × 21 | 24 × 36 | 34 × 44 |
| 17 × 22 | 24 × 38 | 35 × 45 |
| 17 × 28 | 25 × 38 | 35 × 46 |
| 19 × 24 | 26 × 34 | 36 × 48 |
| 20 × 26 | 26 × 40 | 38 × 50 |
| 21 × 32 | 26 × 48 | 38 × 52 |
| 22 × 24 | 28 × 34 | 41 × 54 |
| 22 × 34 | 28 × 42 | 44 × 64 |
| 22.5 × 35 | 28 × 44 | |
| 23 × 35 | 32 × 44 | |

## Imperial paper sizes (*measurements in inches & millimetres*)

| | Foolscap | | Crown | | Demy | | Medium | | Royal | |
|---|---|---|---|---|---|---|---|---|---|---|
| | inches | mm | inches | mm | inches | mm | inches | mm | inches | mm |
| **Broadside** | 17 x 13.5 | 432 x 343 | 20 x 15 | 508 x 381 | 22.5 x 17.5 | 572 x 445 | 23 x 18 | 584 x 457 | 25 x 20 | 635 x 508 |
| **Folio** | 13.5 x 8.5 | 343 x 216 | 15 x 10 | 381 x 254 | 17.5 x 11.25 | 445 x 286 | 18 x 11.5 | 457 x 292 | 20 x 12.5 | 508 x 318 |
| **Quarto (4to)** | 8.5 x 6.75 | 216 x 171 | 10 x 7.5 | 254 x 190 | 11.25 x 8.75 | 286 x 222 | 11.5 x 9 | 292 x 229 | 12.5 x 10 | 318 x 254 |
| **Octavo (8vo)** | 6.75 x 4.25 | 171 x 108 | 7.5 x 5 | 190 x 127 | 8.75 x 5.63 | 222 x 143 | 9 x 5.75 | 229 x 146 | 10 x 6.25 | 254 x 159 |
| **Double** | 27 x 17 | 686 x 432 | 30 x 20 | 762 x 508 | 35 x 22.5 | 890 x 572 | 36 x 23 | 910 x 584 | 40 x 25 | 1016 x 635 |
| **Quad** | 34 x 27 | 864 x 686 | 40 x 30 | 1016 x 762 | 45 x 36 | 1143 x 890 | 46 x 36 | 1168 x 910 | 40 x 50 | 1016 x 1270 |

Basic sheet size is a Broadside. Double: short side of sheet doubled. Quad: both dimensions doubled

Broadside / Folio / Quarto (4to) / Octavo (8vo) / 16mo / 32mo / 64mo

Broadside or broadsheet is the basic size of any sheet, uncut and not folded. It also refers to a sheet printed on one side only and the format of the large newspapers. A broadside folded once becomes a folio (4 pages); folded twice, a quarto (8 pages); folded three times, octavo (16 pages); folded four times, 16mo (32 pages); folded five times, 32mo (64 pages); folded six times, 64mo (128 pages).

writing with nib and ink, a paper with a size-coating is desirable. Writing in ink on a paper with no coating is like trying to write on blotting paper; it is not impossible, but it does not give a sharp, true line.

The traditional method of sizing was to immerse the paper in a tub of hot gelatine which was allowed to soak into the paper, and then air dried. The usual watermark read TSAD, tub sized and air dried. Another method used to make a good surface finish involved laying alternate sheets of paper and zinc or brass plates and passing the lot through rollers moving at different speeds. This created friction, which gave the paper the required glaze. The contemporary method of glazing sized, machine-made papers involves passing the paper through highly polished steel rollers, then through a silver calender (horizontal rollers), which act as polishing irons.

Size can be applied internally during the making process, or externally. Surface-sized paper is resistant to abrasion and will not absorb liquid; it takes ink and the surface should not be damaged by masking material. This method of sizing binds the surface, giving rigidity and strength. Internally sized paper has similar properties, plus the added advantage of retaining these properties if the surface of the paper is damaged or broken.

Paper can be coated with minerals - china clay and calcium carbonate mixed with synthetic resins - suspended in water. Starch (made mainly from potatoes), resin and alum, are the ingredients for most sizes. The paper is compressed as it goes through the drying cylinders to the calenders which produce a machine finish (MF) paper.

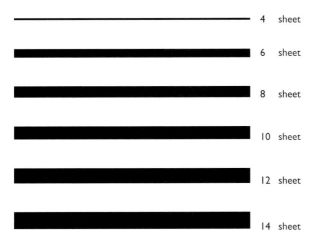

The word 'sheet' prefixed by a number is used to describe board thickness. This reflects the traditional method of manufacture, by laminating sheets of paper together. Now many boards have a 'sandwich filling' of recycled waste and outer layers of woodfree board. The two surfaces of any one board can have the same or different finishes.

Hand-made papers are costly and slow to make and may not have a suitable writing surface. However, if a good surface can be found, these can be exciting papers to use. The fibres of mould-made papers arrange themselves at random and mean the paper does not cockle (buckle) when moisture is applied. It is particularly good for applying washes. Machine-made papers are produced much faster, and therefore more economically than mould-made papers, but the fibres tend to align, giving the paper a tendency to cockle when wet.

Papers have different finishes. Paper marked HP ('Hot Pressed') has been sized and is ideal for most calligraphic works. The surface is smooth and suitable for work involving pen and ink, fine brush work and paint.

Papers marked 'Not' (not glazed) or 'CP' (Cold Pressed) have a matt finish with a semi-rough surface. These papers can be used for washes and watercolour. The most textured paper surface is indicated simply as 'Rough'.

The importance of the surface of any paper used for calligraphy cannot be overstressed. Substrates (paper and board) must be comfortable to write on, and must take ink and the extra moisture involved when working with paint. Comfort in writing is paramount when producing calligraphy. Writing on some papers can mean a constant fight with the surface, a strong indication that this is not the correct paper to use. Similarly, if paint (watercolour or gouache) is used on ordinary cartridge paper, it will cockle as it attempts to deal with the added dampness. Cartridge and other thin paper can be stretched to take this extra moisture (see page 91).

Commercially manufactured watercolour papers are especially created to take the added moisture involved when working with paints.

Whenever possible, always work on a sheet of paper or board which is larger (untrimmed) than the final trimmed size, whatever the intended form of presentation. A larger size allows the masking tape to be fixed outside the working area, so if it does damage the surface on removal, the work is not affected. Leaving a 'waste' area around your work will keep it clean when it is being handled, and can be trimmed off after the work is finished and cleaned.

If the work is a one-off original it may not seem to matter what size of paper is used. The measurements can be calculated and incorporated at the time of planning the layout and simply reflect the best size for the design and job. However, if the work is to be framed, it is worth considering before starting work if the final piece will be mounted before framing. If so, leave some extra space beyond the margins of the work to allow for an overlap behind a window mount. You might also consider whether the frame will be purchased ready-made, as they and many of the frameless frames (glass, clips and backing board), now retail in 'A' sizes or slightly larger.

There are two main considerations to be made concerning size when preparing work for reproduction by a printing process. One is the size of paper or board on which the camera-ready artwork will be presented, and the other is the purpose of the finished product. Stationery, (letterheads, with-compliments slips, invoices, estimates, and other printed ephemera) may need to be folded to fit into envelopes. The choice of paper and envelope size should be an integral part of your design work, although many situations will dictate that the accepted sizes are used. The most commonly used sizes for stationery are: an A4 letterhead, one-third A4 with-compliments slip, and the DL envelope. The DL allows the letterhead to be folded twice, and the with-compliments slip to be inserted unfolded.

For the preparation of the artwork, use a sheet or board which allows enough room outside your trimmed, finished work size to indicate trim marks for the printer. For example, an A4 letterhead will need artwork presented on a sheet larger than A4. Not all printers will insist on or even expect this, especially if the work will be printed on cut-size paper (that is, paper the same size as the final specification), but it is good working practice. Furthermore, when your camera-ready artwork is handled, there is no reason for anyone to place a possibly greasy finger on the clean artwork area.

Basic formats: portrait, landscape, square, circular and an irregular shape. The proportions of the page need to be determined in conjunction with the character of the text and image, as well as the purpose of the work. Square, or nearly square dimensions are of less appeal than proportions which have one dimension at least one-and-a-half times the other.

landscape

circular

portrait

square

irregular

# Formats

In its broadest sense, the format of a work encompasses its whole appearance, including size, paper, writing or type, layout, style, treatments used and the binding (if bound). Some work may follow a traditional format, where the solution is drawn from existing conformations. In the case of certificates, citations and heraldic work, some of these formats have been established over many centuries.

Format also refers to the finished dimensions of a work, whether it is a single page or a bound book. The final size and shape of a work is often predetermined by the nature of the specific task, the person commissioning the work or the intended purpose of the work. The most commonly used and recognisable shapes in the format genre are: portrait, landscape, square, circular and irregular (asymmetrical). A landscape format has its longer sides running horizontally. A portrait format has its longer sides running vertically.

The overall format of any work must be carefully considered. The main issues involved are the nature of the visual material and the intended outcome of the work. The format must be considered as an integral part of the whole design.

# Margins

The areas surrounding the text and/or image on a page are called the margins. The width of the margins is of vital importance in achieving a visual balance between the text and/or image and the surrounding 'white' space on the page. Too much white space makes the words appear to float and reduces impact; too little white space makes the words seem cramped and may veer towards illegibility.

On a single page margins in a simple ratio of 2:2:2:3 provide pleasing proportions. The units are two (2) at the head, two (2) units for each of the side margins and three (3) units for the foot.

An alternative is 1.5:2:2:4, making the head margin proportionally less deep than the two side margins, and the foot margin twice the depth of the sides. These examples are reasonably conventional, but, none the less, provide a genuinely pleasing visual balance, which is rarely the case when all margins are of equal dimensions.

There are many fine examples of contemporary work where these traditional proportions have been eschewed in favour of exploiting the whole of the available space. The result is no equal margins, and in some cases a border or extension of a heading or

2:2:2:3 Remember to consider the purpose of a work before deciding the depth of the margins. An invitation or personal message may need a generous margin so that none of the work is obscured when it is being hand-held.

2:4:2.5:2 An irregular configuration can be used to add extra interest and catch the viewer's eye. Try placing an element, a single letter or the first word, in the margin.

1.5:2:2:4

Golden Rectangle

The classic page proportions used in medieval manuscripts and early printed books provide an elegant format. The proportions are derived from the 'golden section'. The Greeks called this the 'golden mean' or golden rectangle. (This could form the basis of further investigation.) The proportions are based on the pentagon (five-sided polygon) which with its five-pointed star (pentagram) contains many golden sections.

　　The golden rectangle has proportions of 1:1.618. One method of construction is to make a square based on the short side of a rectangle; from its half-point draw a diagonal, and making this a radius, draw an arc to create the long side of the rectangle. A rectangle drawn thus on an A4 sheet using the diagonal line method will give a narrower page.

A grid provides an invisible framework to organise the layout of textual and illustrative matter. A grid of two or three equal columns is frequently used in magazine and integrated books (text and pictures) because of its great flexibility and possible variations. Text (including headings) and images can be positioned in the individual columns, or run across two or all three columns. Some designs allow for further division of the columns, creating a highly flexible grid of four, six or more columns.

Give your work room to breathe.

decorative device bleeds off the page. In other cases, more traditional ratios have been used, but an image, decoration or letter extension will break out of the text area into a margin. These two examples can be quite quirky in appearance, and highly successful.

The late-medieval manuscripts had elegantly proportioned margins which, with little variation, have been used for book design over the succeeding centuries. The classical proportions are usually ascribed as: 2 units (inner margin or gutter) : 3 units (head) : 4 units (outer margin or foredge) : 5 units (foot). [Note: 6 units is sometimes given to the foot margin.]

Margins are easier to understand if you consider them as a frame to the work. Study the daily newspaper and every book you pick up. Look at mounted and framed pictures in a gallery and identify the margin proportions. You will notice that some books and the newspaper pages are further divided into columns. This layout is called a grid. All books, periodicals and publications have a grid system over which the text and image matter is placed. The grids are designed to provide great flexibility and variation in page layout. The columns provide a constant width for the setting of the type and a guide for accompanying images.

Grids can be used very successfully in conjunction with some calligraphic design, the obvious examples being a leaflet, brochure or manuscript book. They can introduce symmetry and harmony to work that is placed on a single page, for a poster or information broadsheet.

Investigate further by working out what grid is used for your reading matter. Pay particular attention to material which has text and pictures. See if there is any alignment across the page; is there any

consideration for a hand-held book (paperback) or a large format book which needs to rest on a table?

Two facing pages are referred to as a double-page spread, frequently shortened to 'spread'. If you use this layout, consider the entire format as a single visual unit, not as two independent pages, but bear in mind, neither is it a poster to be fixed to a wall and seen from a distance. The layout requires a more intimate solution.

## Styles of Writing

There are several points to consider when choosing a calligraphic hand for a specific piece of work. Given the constraints of our own individual repertoire, there is wide flexibility within the calligraphic range.

Identification of the purpose of the work will eliminate some hands as viable possibilities.

Attention can then be directed to other requirements: flexibility, texture, tonal value, mood, authority, formality and informality. A work with a lot of text, barring exceptional circumstances, should not be transcribed solely in bold capital letters. A personal message conveying tender and delicate sentiments is unlikely to project quite the right image if it is rendered in a bold, dense Gothic black letter.

Legibility is a priority. The reader must not be unduly challenged, or presented with a series of marks whose configurations are meant to say something but are beyond recognition. This should not, however, inhibit the calligrapher from attempting work which consciously challenges the reader and his or her preconceptions of how things should look.

Calligraphy has enormous versatility. The weight and size of letters can be changed by using different nib sizes, while still working within the established guidelines governing pen angle, number

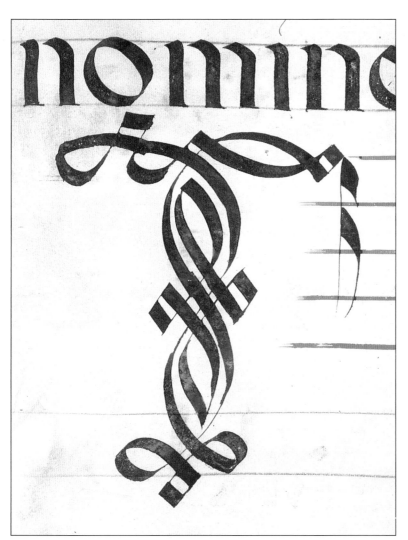

SIXTEENTH CENTURY
The letter 'I' is positioned towards the spine, at the bottom of a recto in an antiphonary. This is a good illustration of an oft neglected fundamental point of calligraphy: the letters are constructed of a series of similar strokes, used in a variety of combinations to produce entire alphabets. After learning the letter shapes, progress and confidence will continue to soar if this fact is not overlooked.

So, this elegant letter, looking frighteningly complicated is merely constructed of the most basic calligraphic strokes, controlled, as always, by the pen angle. Note the repeated strokes used to construct the letters immediately above. To the right of the 'I', the marks on the staff indicate the key for the sung response.
CBL.WMS 217

of nib widths for height and corresponding proportions. Further alterations can be effected by slightly varying the accepted guidelines. An example of this would be using a depth of six nib widths for the height of the lower-case italic letters instead of the traditionally accepted five nib widths. The resultant letters are still well proportioned, slightly elongated and elegant; very suitable for a formal presentation. Similarly, using four nib widths instead of four and a half for a lower-case, roundhand letter will produce a squatter, bolder letter which is still perfectly legible. This latter technique can be used for some headings, or for emphasizing a particular section in a text. Further emphasis can be made by introducing colour to different areas.

Initially, the early manuscripts were written solely in black. The introduction of the rubrica to highlight certain letters brought a new life to the pages. For the contemporary calligrapher, discovering for the first time or even rediscovering, the juxtaposition of red and black in the same work can be exciting. Try rendering a heading in red capital letters and the text copy in black.

Selection of a suitable hand also depends on the purpose of the work and its relationship with certain styles. Formal solutions can be well presented with a formal italic hand, a roundhand (Foundational), or one of the Uncial hands. These are conventional solutions and other less obvious hands would do equally as well. A bookhand, such as Carolingian, in a very traditional rendering would be elegant, provided there is enough room in the overall format to allow for the increased interlinear space needed for the exaggerated ascenders and descenders. The Humanistic italic hand (with an echo of the Carolingian in its slightly extended ascenders and descenders) would also be an excellent choice for a formal work. The letters have sharp arching strokes which assist the visual contrast between thin and thick strokes, creating an elegant style with texture and rhythm on the page.

When choosing and writing in a style, reflect on the following points. What is the purpose of this work and its presentation? What do the words mean? How can the message of the words be complemented? What feelings are evoked by the words? Are there any colours, sounds, shapes the words evoke? If the result seems mundane, why do it? The scribes in the Scriptoria were often nothing more than copyists; there is no need to be that. Seek a sense of fun and adventure in your solutions. Find ways to create texture, employ methods to introduce tone and rhythm, contrast weight, colour and styles, use complementary components and techniques. If using more than one style, use a complementary hand for your second and/or third choice. There is a basic rule in typography, also valid in calligraphy: do not use too many different lettering styles in one work. Calligraphic hands provide plenty of scope for changing weight and size without introducing too many styles. However, as always, there are occasional exceptions to this rule, and the use of many different styles can sometimes produce a perfect solution to a specific problem.

Finally, if you ever hear yourself say, 'Can this solution be produced mechanically?', STOP, and start again on a different route.

## Capital and initial letters

The early manuscripts provide the contemporary calligrapher with the most extensive collection of solutions to the problem of how to treat a capital or initial letter.

The tradition of conferring special treatment to an initial letter stems from a time when most written work was read aloud. Even an individual reading alone might read *sotto voce*. The latter may have been necessary for the readers in ancient Greece and

Simply decorated letters can be used to indicate change in a text (a new verse or chapter) or create a point of interest. Experiment with different methods, including filling in the counter space or plotting a single row of dots around the letter; try these two solutions together. The addition of colour will increase the impact.

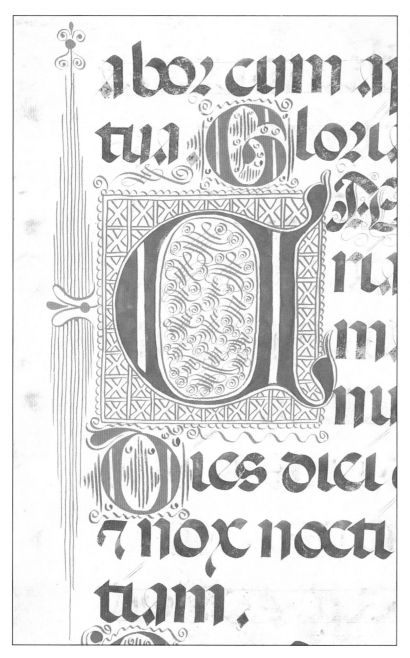

SIXTEENTH CENTURY
Some of the large books used by the choirs are effusively endowed with enlarged decorated, historiated or illuminated letters. Large letters allowed scribes the opportunity to show their prowess in creative decoration. The counter of this blue 'a' is wholly filled with combinations of fine flourish strokes. These free flowing lines contrast sharply with the rigid lines creating the squares around the letter; the whole reminiscent of a tile, or set of tiles.

Note the construction of the lines made necessary by the serif extension to the vertical stroke of the letter. The whole square is embraced on its perimeter by small scallop lines; simple, repeated strokes. In the margin, the red linear element provides another example of effective decoration whose simplicity is deceptive. The decoration of the smaller initials echoes the marks already described.
CBL.WMS 211

Rome as there was then little or no punctuation, and words were rarely separated, except occasionally when a dot or an inverted comma was inserted to acknowledge a separation or draw attention to a specific point.

One of the earliest ways of alerting the reader to a change in the text which required a change in the rhythm of presentation, such as a new verse or chapter, was the writing of the initial letter in red. Rubricators were apprenticed to perform the sole task of writing headings, title pages and chapter openings in red ink made with rubric (red ochre; Latin: *rubrica*). The text would be transcribed in black ink.

The high cost of materials, as well as the lack of punctuation, helped to create a variety of ways of notifying the reader of a change. A simple indicator, used profusely later in highly decorated manuscripts, was a single row of red dots following the outline of the capital letter. This could occur mid-text, following perhaps three black dots used to indicate the conclusion of the preceding passage. As other colours were introduced (green, blue, and yellow), counter spaces (see page 30), both enclosed and semi-enclosed, were filled in, and an outline of dots was also added. Ironically, most of the decorations used in early manuscripts are the same models most children experiment with before they

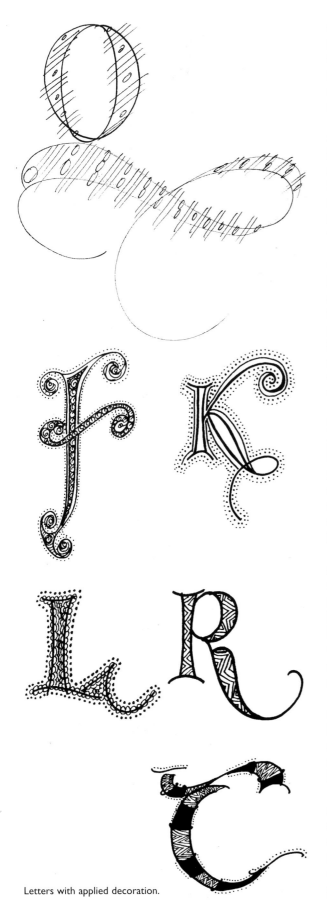

Letters with applied decoration.

can write, when they have learnt to manipulate a pencil and 'colour in'. The range of simple and effective solutions on which to draw is vast, but almost always consists of employing very simple marks of dot and line constructed in an infinite number of ways.

Another solution, which led to much embellishment of the capital letter, was to pull it out into the margin. Sometimes it was decorated quite simply, in much the same manner as those letters formerly done mid-text, or it would be enlarged and then decorated. (Gold and silver on white or purple-stained vellum, and later azure and pure cinnabar were the most commonly used materials.)

Versals, which are drawn or built-up letters, were used extensively in early manuscripts as the first or initial letter of a verse or chapter. Their attraction was in providing an excellent foundation for rich decoration, often in gold or silver, and with added ornamentation and a measure of distortion, for example by enlargement, they were frequently unrecognizable. The most basic decoration of versals is simply to fill in the hollow letter shapes with a contrasting colour.

Interest can be drawn to a work where the initial letter is entirely constructed of ornament, repeat patterning or decorative marks. Creating decorated letters in this manner requires a good pencil rendering of the basic letter shape. You must also decide whether the decoration is to be applied or used for the construction of the letter. A confusion of these two approaches can obstruct progress and blur your focus during production.

There is an infinite range of options, from very simple to complex. Some could be based on treating the surrounding area with colour or decoration in a simple or complex manner. Interesting contrast can be achieved with richly embellished individual letters and beautifully crafted text copy, presented without too much additional flourishing or decoration; in other words not too busy, so it will not detract from the main ornamentation.

Do not be afraid to experiment. There is no right or wrong way; providing you never lose sight of legibility. For practice, play with the simpler solutions, even reverting to filling-in and decorating the news headlines with dots, line, patterns, cross-hatching and colour.

The introduction of colour to the letters or surrounding area, with or without the addition of ornamentation, can create great interest. The most obvious way, other than using coloured inks, is to use paper which is not white. There are methods which can be employed to create a more stimulating ground on which to work.

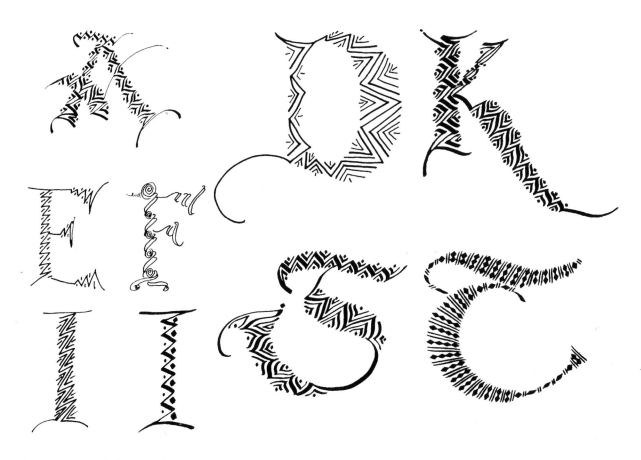

Letters constructed of repeat and random pattern.

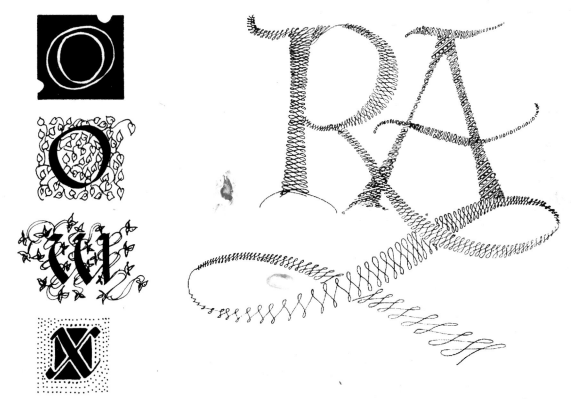

Consider the background.

Make a rendering in pencil of the basic letter shape before creating the letter of pattern.

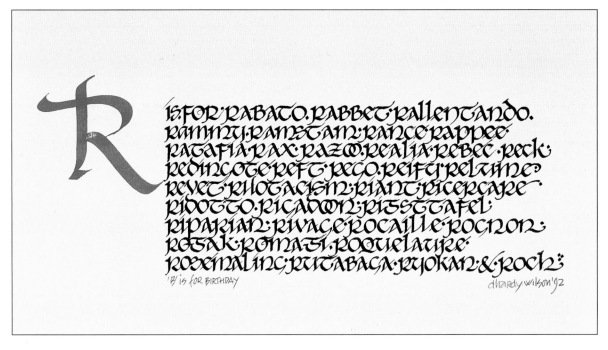

DIANA HARDY WILSON

*B is for Birthday* was the title given to a range of personalised celebratory works. The initial letter of the first name of the recipient was enlarged and placed in the margin, with the text aligned left and a ragged right edge. The texts were composed of unusual words whose definitions, where possible, pertained to each receiver. The enlarged initial capital was produced with metal nib and gouache, and the freely inspired text letters rendered in fountain pen and ink.
80 x190mm/3.12 x 7.5in

A wash can be applied to the substrate, either totally or just in selected areas. Alternatively, apply the wash with a gently gradated tone across or down the page.

An extremely interesting ground to work on is produced by applying watercolour or gouache paints with a natural sponge. This can give results ranging from exceedingly delicate to quite bold, depending on whether the texture of the sponge is fine or coarse (the latter has bigger holes). The sponging method also provides a great level of flexibility. The amount of drying time left between successive applications of colour can affect the finish. Varying the amount of moisture and colour used can also give dramatic effects, as can changing the order in which the colour is applied. Experimentation will help you to discover the delights of this method.

One note of caution: always experiment first with all the materials you intend to use. Test the paper for moisture absorption and be aware that if you are going to rule guidelines you may remove some of the wash or sponged ground when you try to erase them. The application of masking fluid or, in some cases, low-tack masking tape, can effectively block out an area while a wash or sponging is applied. Apply the chosen masking medium to the substrate then work freely over and around it. If working in paint, leave plenty of drying time before attempting to remove the mask.

## Text Layout

The arrangement of the words (text) on the page with any accompanying illustrative material, headings and credits is called layout. Any preliminary plans or work which shows this are called rough layouts (roughs). A most obvious and important consideration for any layout is legibility, but this is not enough on its own. Achieving a balance of textual matter and white space requires attention to be given to many interdependent relationships which occur on the page. These include the space within and between letters in each word, the space between words, the space between lines (interlinear space), and the relationship between textual matter and remaining white space, including margins. There are no set formulae for achieving legibility and visual balance on a page, but there are recognised arrangements of text, and there are some useful guidelines and ideas.

There are five basic and accepted arrangements

for text layout. They are referred to as: ranged left/ragged right; ranged right/ragged left; justified (aligned both sides); centred and asymmetrical.

To range text left or right means the lines are aligned vertically on one side (indicated left or right), sometimes this is referred to as justified on one side. The other side is then referred to as ragged.

Justified describes text which fills lines of equal measure, resulting in the lines being aligned vertically on both the left and the right sides.

Centred text has the mid-point of each line of words aligned vertically. The vertical is usually placed at the centre point of the measure of the whole page or column of text. Some layouts may require the text to be centred below a heading, and the whole placed as a block towards one side or the other to accommodate an image on the same page.

Some text demands less constrictions in its presentation and the ideal solution is simply to place the lines of words in an asymmetrical (irregular) arrangement.

It is worth noting the layout of some poems which may have a number of lines indented, and aligned, and other lines ranged left. In most cases the verses will be ragged on the right.

While working on the layout, you will become aware of the interdependence of many of the considerations. The choice of writing style and its layout needs to reflect the content of the words, suit the purpose of the piece and fit the page in a balanced, legible manner. Retaining this latter point as a keynote, a degree of prudence is sometimes required to offset an overabundance of flourishes. Similarly, extensions to descenders and ascenders of successive lines will become entangled and hinder legibility unless the interlinear space has been calculated to accommodate such revelry.

Beyond this is the need to create interest in the

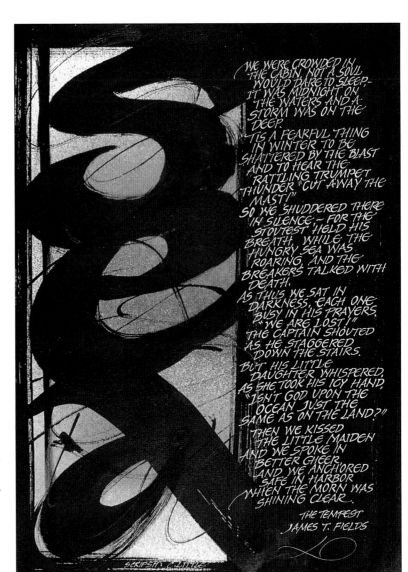

**COLLEEN LITTLE**

James T. Fields' poem *The Tempest* is rendered on Arches paper. The background colour for the word 'sea' was prepared using an atomizer, and then the large letters were written in Chinese black ink using a household paint brush, with the intention of emphasising the negative shapes. The free Roman letters of the text were rendered by metal nib with gouache. Further emphasis is afforded to the bold letters by the way their dense black quality bleeds, to merge with the margin.

500 x 300mm
19.75 x 11.87in

piece, to avoid ending up with a bland result after much hard work. There is plenty of scope for taking the initiative. Explore different weights and sizes of letters, spacing, and the addition of colour and decorative devices. Such exploration should introduce visual tension through contrast to the whole work.

Sometimes, when making decisions on text layout, and without losing sight of the aim of the work, a process of elimination is helpful, such as when planning a simple letterhead. The amount of information is limited and usually falls into predetermined groups. Arranging the information on the page can be relatively straightforward, the end result being arrived at by a simple method of aligning the various groups of details. Although this method is frequently used successfully, it should not deter you from approaching the problem from a more adventurous angle.

Do not alienate the reader by making choices of text layout and style which make the information inaccessible. Length of line is a feature which should not be overlooked and must be dealt with during the planning process. Most work can achieve a visual balance, whether the lines are short or long, simply by judicious working with the spaces around the lines, and any other decorative or illustrative elements.

a   The arrangement of the text matter includes ranged left, ragged right.

b   Ranged right, ragged left.

c   Justified: words ranged (aligned) vertically both sides.

d   Centred: the centre point is determined from the measure of the full width of the page, the text, or any area where the words to be centred are to appear.

e   Asymmetric arrangement requires planning to avoid bad line breaks. This works well with calligraphy, developing a rhythm and creating visual texture.

f   The text sometimes needs to be centred as a block to one side of an image, heading or a subsidiary part of the information.

g   A poem may have some lines indented and ranged left, and other lines ranged left.

# Juxtaposition of Capitals and Initial Letters with Text

Irrespective of the placement and treatment of an initial letter, it must retain its relationship with the remaining letters of the word it begins. Bad letter spacing leads to illegibility - an inability to read the first word is more than a little off-putting. Attention to letter spacing is crucial and may make the difference between the success or failure of a work. There are several ways of presenting the juxtaposition of an initial letter and the text.

There are many alternative positions for an enlarged letter, that is, one larger than the body copy (see diagrams). The letter can be pulled out into the margin, and the text ranged left, to the right of the letter. The enlarged letter can share the base line of the first line of words, but extend above the x-height. It may visually align with the ascender height or project beyond it.

Using the same idea, the enlarged letter can: share the ascender or x-height of the first line, and the base line of the third or fourth line of text; be dropped into the text, sharing either the ascender or x-height of the first line, and the base line of the third or fourth line, with the text ranged left and aligning with the outside edge of the initial letter.

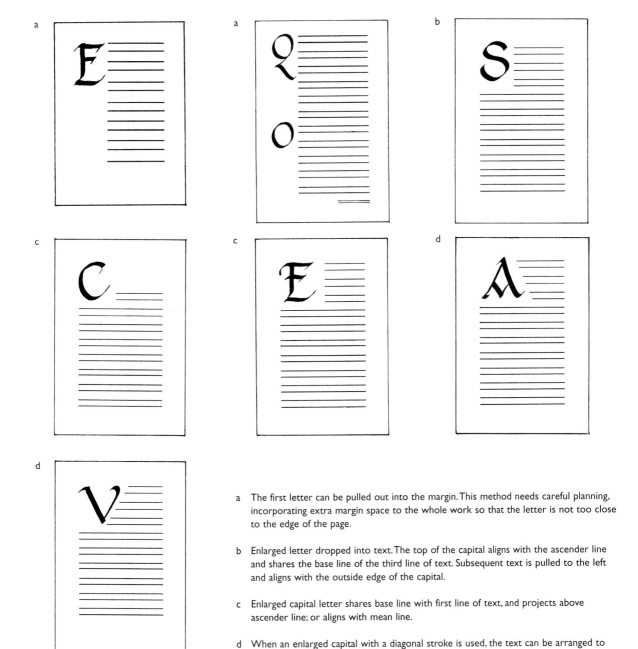

a The first letter can be pulled out into the margin. This method needs careful planning, incorporating extra margin space to the whole work so that the letter is not too close to the edge of the page.

b Enlarged letter dropped into text. The top of the capital aligns with the ascender line and shares the base line of the third line of text. Subsequent text is pulled to the left and aligns with the outside edge of the capital.

c Enlarged capital letter shares base line with first line of text, and projects above ascender line; or aligns with mean line.

d When an enlarged capital with a diagonal stroke is used, the text can be arranged to parallel the diagonal stroke.

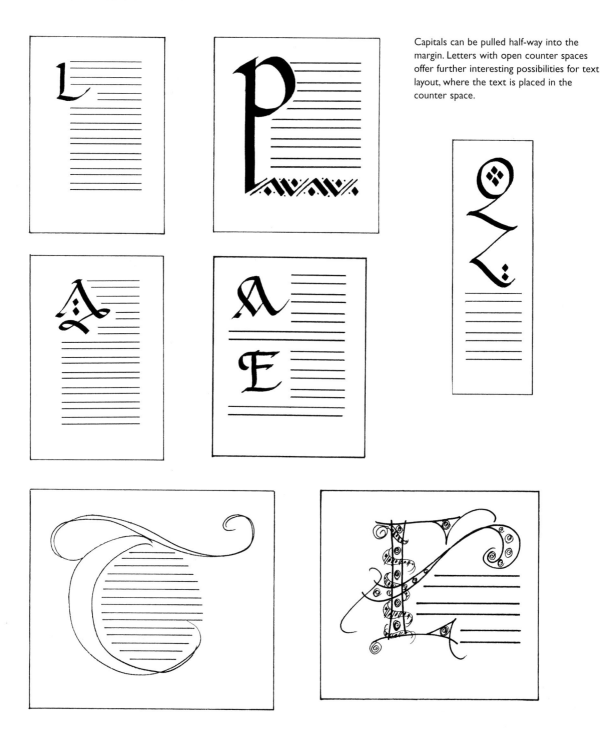

Capitals can be pulled half-way into the margin. Letters with open counter spaces offer further interesting possibilities for text layout, where the text is placed in the counter space.

Letters with oblique strokes, open counter spaces or a combination of strokes can be used to semi-embrace the text to good effect.

Some lists and poems can be beautifully presented by pulling the initial letter of each stanza or verse into the margin. The letters do not need to be overly enlarged and care is needed with the spacing between the capital and the second letter of the word. Test all the letter combinations before proceeding with any idea. Just one bad spacing judgement can flaw an entire work.

There are plenty of sources where examples of this spacing is displayed. Most printed work, including daily newspapers, books and journals, use some form of enlarged initial letter at the beginning of each article or chapter. Notice, however, that doing this work by hand affords a greater flexibility compared with the rigidity enforced by working with metal type. The metal body of the type, although able to be cut away, never allows for overlapping or getting letters close together, unless there is a second printing. This involves running the

entire work through the printing press for a second time. Phototypesetting can afford some measure of flexibility but nothing like that obtained by hand production.

There are many variations which are used in conjunction with the enlarged initial letter. The remaining letters of the first word can be rendered in smaller capitals before reverting to upper and lower case for the body copy. The first line, or paragraph may be transcribed in a larger size than the remaining text.

# Headings and Credits

The head, heading, headlines - that word or those words which are the title of a work - will invariably be the first place the eye rests. The treatment of this important word or phrase needs to be simple, yet pertinent. The most obvious and commonly employed technique is to write the head in larger, bolder letters than the text. Decoration, ornamental devices, colour, banners and borders are some of the other elements used.

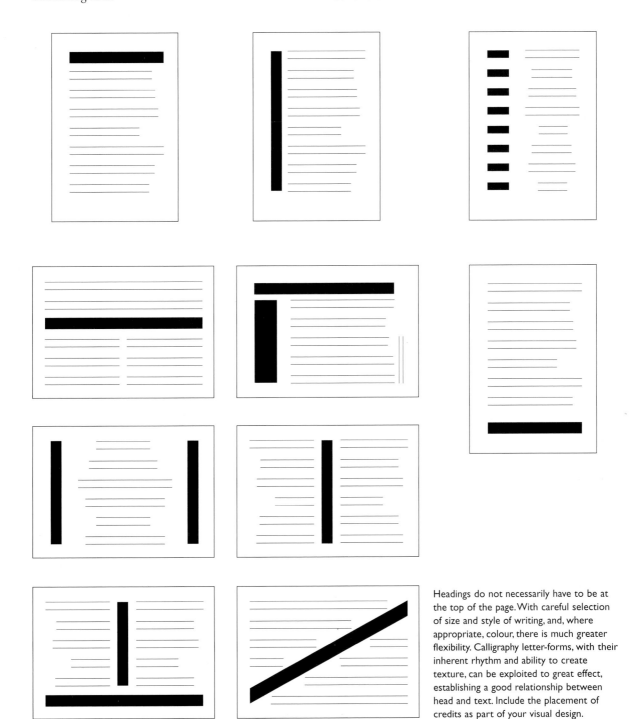

Headings do not necessarily have to be at the top of the page. With careful selection of size and style of writing, and, where appropriate, colour, there is much greater flexibility. Calligraphy letter-forms, with their inherent rhythm and ability to create texture, can be exploited to great effect, establishing a good relationship between head and text. Include the placement of credits as part of your visual design.

The status and different treatment of the heading affords a measure of flexibility in its placement on the page. It can be positioned almost anywhere, as long as a keen eye is kept on the surrounding space and consideration is given to the visual balance with the text on the whole page. Possible positions may include: vertical, on either side of the page; across, slightly above or below the centre; at the bottom, or on the diagonal. Consider the head as an integral part of the overall layout of the page, not as an appendage. Intriguing solutions can be found with a little ingenuity, and a will to experiment (see diagrams, page 29).

The same approach is necessary when placing the credit of a poem or prose piece. Identifying the source of the words is very important. You have considered the words worthy of being written out beautifully, so do not neglect their author. Similarly, do not neglect to acknowledge the calligrapher, yourself, and to date the work.

## Spacing

### Letters

The white area enclosed or semi-enclosed in a letter is called a counter space. This is an integral part of the letter design, and provides the key to the arrangement of letters in a word. The space between the letters cannot be measured on a linear scale. The

LES DERNIERES PAROLES DE
MONSIEUR D'HERVART
c.1670
This opening page from a small format 85 x
125 mm (3.25 x 5in) book sets the style for
the entire volume. Each page of text is
framed by a gilt, rectangular border. The title
lines are rendered in alternate colours of
Roman pen letters beneath a floral
cartouche embracing a winged skull.
Elsewhere in the volume there are more
skulls and cross bones.
   Note the opening capital 'M' is
succeeded by a capital 'O', as the second
letter of the same word. Throughout the
volume enlarged letters are repeated in the
colour sequence of gold, blue, and red. The
binding is modern with gilt clasps.
CBL.WMS 203

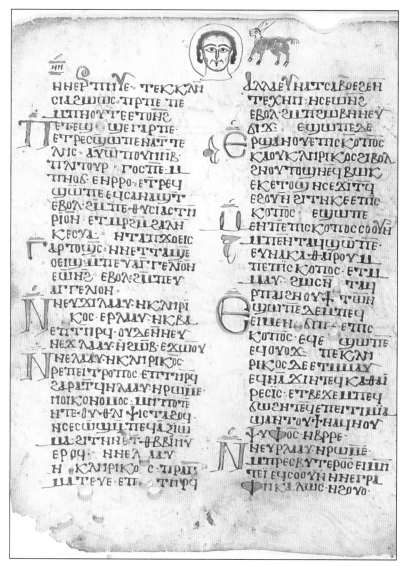

CANONS OF ST. BASIL
c.900
This fragment of Coptic text set in two columns is written on vellum. An endearing, line-drawn portrait possibly of St. Basil ('the Great', c.330-379) with accompanying animal welcomes the reader. The (monastic) Rule suggested by St. Basil is the basis still for the usual rule followed by some religious of the Eastern Church. Translations into Coptic and Arabic were made from the original Greek.

Enlarged initial letters have been placed in the margins and adorned with colour, thus drawing attention to a change in the textual matter, in this case, a new rule. Close study reveals a single dot placed mid-height between words, as punctuation. A short horizontal line above some letters indicates a shortening of a word, an abbreviation; this was common practice, used extensively in the transcribing of manuscripts. Inevitably, the Coptic church exerted strong influence on the West particularly in matters concerning the production of books.
CBL.WMS 819

aim, therefore, is to achieve a visual balance between the counter spaces of the letters and the spaces between the letters. Although this sounds simple, it will not seem so in the beginning, but with practice the eye will become well trained and the letters beautifully spaced.

Sometimes, when learning calligraphy, we seem to forget that we know how to write letters in words, and have been writing by hand for years. Do not forget that, everytime you write, you are automatically spacing letters into legible words. The extra care needed when working with calligraphy should not block or reject what you can already do, your experience is valid; so use it.

The spacing will improve with practice, but complement this by getting acquainted with both good and bad letter spacing. Splendid examples of appalling letter spacing abound, much of it emanating from the users of the new technologies.

Examples are provided by the appointments pages of newspapers, some journals and periodicals. Sadly, book design is not exempt, and some cover typography provides further examples, easily observed in a bookshop. Note that capital (upper-case) letters with large open counters may need a little less space between them compared to those with vertical strokes, which may need slightly more space.

## Words

The demands of legibility should dictate the spacing of words. A general guide for obtaining consistent word spacing is to allow the width of the 'o' (in the same size and style as the work is being written) in-between the words. This will produce a word space of the correct proportions for the writing size.

*sic laureatus, et insignitus felici coronetur in*

*patria, per eum, qui Trinus, et Vnus regnat*

*Deus per infinita saeculorum saecula gloriosus.*

*M A N D A N S Q dictus illustris, et excelletiss*

*D. Annibal Marescottus mihi Annibali Rus=*

*ticello ciui Bononiensi notario infrascripto, et*

*praefatus Dñus Innocentius Doctor Excellen=*

*tiss*

**1594**

This is a page from a Diploma of the University of Bologna, conferring the Degree of Doctor of Canon and Civil Law on Innocentius Guelphus Romanus. The extravagantly bound Diploma has a contemporary Italian red morocco binding, richly tooled with gold. The Latin script is presented on vellum in an elegant Italian italic hand, clearly showing an exaggeration of the height and weight proportion of the letters.

There are pleasing features including the loop ligature on some of the ascenders, the rounded ends to some strokes and the interruption to the descender of one 'g'. Throughout the entire manuscript there are many line breaks, such as where the letters of the final word on this page run over and are inserted into the border.

CBL.WMS 200  8 folios 171 x 229mm/6.75 x 9in

Some calligraphy hands, such as many of the Gothic black letter styles, benefit from fine adjustments made to their letter, word and interlinear spacing. Condensing the space between lines of Rotunda, with its short ascenders and descenders, does not diminish legibility, but enhances the texture of the whole work.

Inserting extra space between the letters of a bold heading or display words can, on occasion, bring authority and balance to a work. For titles, headings and display words, each word needs to be regarded as an individual shape within its own context. The profusion of letter combinations which a calligrapher has to render, necessitates the application of slightly different solutions to deal with their complexity.

If you are exploring the rhythm and texture created by different weights and sizes of letters, you may play with spacing to great effect, but there are some pitfalls. Occasionally, the word spaces on consecutive lines can occur immediately above and below each other, in effect they align. The result is an unattractive white gap on the page, in the midst of the text. This can be avoided by subtle changes in letter and word spacing on the affected lines, and maybe previous and succeeding lines. If the alignment persists for a number of lines, an unsightly white streak or 'river' runs down the passage.

Individual, and therefore unique, designs can exploit spacing in a most creative and interesting manner. Do not be afraid to experiment.

## Line breaks

Some work, like the transcription of poems, will have defined line breaks which you may not wish to alter. This leaves the calligrapher with the difficult task of fitting the lines on the page. Deciding where to make a line break in a prose piece is also far from straightforward. The visual design considerations

RODNEY SAULWICK
*Calligraphy is...* was produced as a page design for a calligraphy book. Given the opportunity to record personal thoughts and reflections on calligraphy in order to introduce and inform, free italic lettering was chosen as an accessible and complementary style to the free reign of these observations. The artwork was prepared on A4 Bond paper with metal nibs and ink.

(such as format and layout) need to be addressed before the mechanics of fitting the piece to the page or any final work commences. There are various methods of working, so finding and practising ones which suit you best should be a priority, but remember that no single method will cater for all problems. (See Copyfitting, page 101-105.)

If a work has only a single line, or one separated from the main body copy, consider it as an individual unit (like a heading), with its own shape and form and therefore its own relationship with the surrounding space. The line may not be devoid of connection with the other words on the page, but it is essential that you also view it as an individual unit.

Lines should not be too long, unless you are creating a special work, such as a banner or display panel. Over-long lines are difficult to read. Relate the length of the line or lines visually to the surrounding space.

There are, of course, so many different situations that there cannot be one set of guidelines to suit

every eventuality; what is a brilliant solution to one design problem is a total catastrophe for another. Individual expression and judgement is always important, and not necessarily without humour. A reasonable and literate adjudication is required to group words into coherent units so there can be no misinterpretations nor misunderstandings. This is particularly important in work of only a few lines in length.

The use of hyphens should be avoided in works of short line length and short overall length, especially those used for display purposes. Where hyphenation is unavoidable in longer prose pieces, try to follow traditional rules of grammar and break the word after a syllable. If you are trying to justify the text copy, this is more than likely to occur. Careful planning and trying out different arrangements at the rough layout stage may eliminate some unnecessary hyphenation. A little less, or more, space between words or some letters may save or gain space on a line and not be too

**DIANA HARDY WILSON**
In a series entitled *B is for Birthday*, a knitted initial letter was window mounted using Saunders Waterford Series watercolour paper with Hot Press surface. This allowed words pertaining to the recipient to be written on the adjacent area.
310 x 92mm/12.25 x 3.63in

detectable. An alternative is to use a decorative line filler, or a letter extension, but too many of these may disturb the balance of the whole work.

The fitting of copy to a line measure is an excellent illustration of the importance of doing rough layouts and, particularly in calligraphy, their need to be precise.

## Interlinear Space

The space between lines, interlinear space, known in typography as 'leading', demands careful calculation. Manipulation of this space is a key factor in any work involving the transcription of words. It is much more than just space inserted to aid legibility and provide room for ascenders and descenders. Unless an integral part of your design involves a reduced space, you should avoid entanglement of the descenders and ascenders of successive lines.

Interlinear spacing is also about the creation of texture and rhythm, tone (light and dark, positive and negative), and what occurs between what exists on the page and what does not. All these elements work in conjunction with one another, and with basic considerations such as the length of line, the content, the written style and the purpose of the work.

Lines of larger letters require a proportionately greater space between them than smaller letters. If large letters do not have enough interlinear space they will appear cramped and difficult to read. The insertion of extra space immediately improves the situation and gives the letters room to 'breathe'. Not

all solutions depend, however, on letter size.

The calculation of the interlinear space can be difficult if factors beyond the aesthetic have to be addressed. Faced with the demands of a tight budget or limited space in the proposed layout and format, choices are restricted. The smallest increase or decrease in the amount of space between lines of words has a very pronounced visual effect, so it is wise to experiment and discover just how crucial the determining of the optimum space can be.

In your own research, examine heads and introductory paragraphs in printed ephemera. The larger, bolder lettering will usually display a greater interlinear space to increase emphasis.

## Verse breaks and new paragraphs

When writing a poem or work which has words in lines arranged in units, such as verses, the object must be to achieve a visual balance on the page. The dangers are the two extremes: too much space, or too little, between the lines and verses. The series of units should be placed on the page so they relate to each other and the total surrounding space in a well-balanced arrangement. It is quite usual for new verses to be separated from the preceding stanza by a greater space than the interlinear measure used within each verse. Paragraphs can be treated in a similar manner, although other methods are usually employed.

A new paragraph is often introduced by indenting the first line. This simply means leaving a blank space at the beginning of the first line. The measure of the indentation depends on the nature of

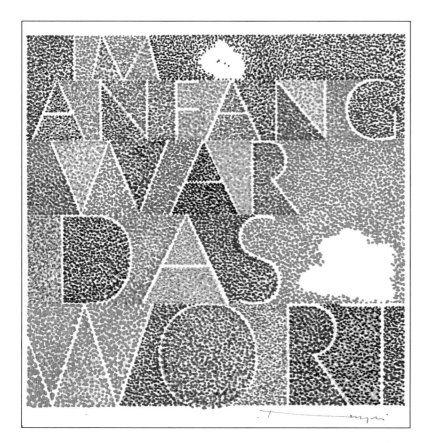

KARL WILHELM MEYER
Using colour felt pen in a pointillist manner creates a strong surrounding ground for these opening words of the Bible. The exclusion of colour from some areas has left the foundational forms of Roman capital letters exposed.

each individual work, but it is commonly only a few letters deep. The indentations should align vertically throughout the whole work. If indenting contradicts your layout design, a special treatment of the first letter of the first word may be a better solution. If each paragraph starts on a new line, try to avoid having less than five or six letters on the last, that is, preceding line, except when using a narrow measure.

There are other methods to indicate the beginning of a new paragraph or verse. The first letter or word can either be put completely in the margin or half in the margin and half in the text. There are also several interesting methods in the early manuscripts, which do not have punctuation as we might recognise it, and do not begin a new verse or paragraph on a new line. The Greek scribes developed a system of punctuation based on series of points, which was subsequently used by the scribes of Latin manuscripts.

In many of the ancient manuscripts there is either no space, or just a small space to indicate the end of a passage or paragraph, even if this occurs mid-line. The new passage is heralded by a letter which could be in a different colour, or have simple decoration, such as a filled-in counter space, or a line of dots following its outline. Use is also made of a specific identifying mark (see page 39). In more recent times, this same method was used by William Morris in his work for the Kelmscott Press.

# Decorative Devices

Devices can be functional as well as purely decorative, and can serve a range of purposes. While they may enhance and consolidate the layout of a work, they may also provide a point of interest, a brief resting place for the eye or a mark of individuality. They may perform a distinct role as an integral part of the whole work. On occasion, a device can solve an unforeseen problem, which may arise when doing the final work. However, beware of including a device as an afterthought - it will most likely be seen as just that.

## Flourishing

Flourishing is the ornamental embellishment of letters with strokes to give a sense of refinement or elaboration (though it should be used with a modicum of discernment). Examples exist in works from the sixteenth, seventeenth and eighteenth centuries, where pure exhilaration and excitement

poft hoc opus temptabo conlcribere. Conuer
tar autē ad rerum narrationem. reminilcens
primitus eozum que de mundi fabrica moy
ses dixit. Hec autem in lacris libri comperi
tta conlcripta.;

EXPLICIT PROLOGVS:

INCIPIT LIBER PRIMVS

ANTIQTATIS IVDI

CE FLAVII IOSEPHI

HISTORIOGRAPHI.

IVDEORVM

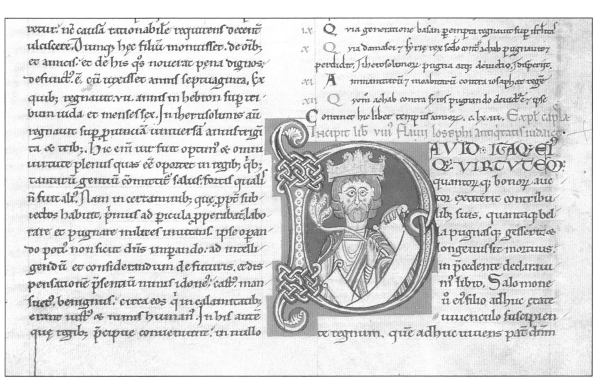

IOSEPHUS FLAVIUS, author
ANTIQUITATES IUDAICAE, (HISTORY OF JEWS), TWELFTH CENTURY
The fragment opposite is from a volume measuring 524 x 356mm (20.63 x 14in). These Versal letters, arranged in alternate lines of red and blue, create their own rhythm and texture by the sharing of strokes and spaces. The addition of a small mark (basically a diamond dot made with an acute pen angle) at intervals on some strokes adds to the pleasing configuration of the layout and juxtaposition of the letters within the words. The marks are only included at the thinnest part of any one stroke, almost as a linking device, a clasp. The Latin text is rendered in German minuscule.

    The existing books of the History open with an historiated letter or large initial. Ornament is used to bind the letter and anchor it to the page where it is set on solid ground: red for the outer space and blue for the counter. The rope letter is knotted and ends in interlacing at the top and bottom of the vertical stem.

    The letter 'D' of (King) David above is set at the bottom of a column at the foot of the page. Twentieth-century sensibilities on layout might preclude such positioning of a grand decoration to begin a chapter; it would be taken over to the next page. Such considerations were set aside at a time when space and material costs were at a premium. Regardless of modern sensibilities, it works.
CBL.WMS 167 3 folios set in 2 columns of 56 lines

combine to produce splendid results. Other works from the same period illustrate the need for a more refined approach to flourishing, because its over energetic application resulted in reduced legibility. Understatement often produces the best results.

    Study examples of flourishing, observing how the strokes are individually constructed and then combined to create a series of fluid marks. Note the shape of the space occupied by the flourish and the relationship between its thin and thick strokes and the surrounding area.

    Flourishing need not be confined to very formal works, provided its inclusion is planned. It is essential to allow enough space for the flourish. In a heading, there must be adequate surrounding space, and body copy may need greater interlinear space so the descenders and ascenders do not create a series of disastrous messes. A word of caution: flourishing will not disguise ill-formed letters.

## Swash letters

If flourishing is too ornate for a particular work, especially headings, where legibility is crucial, a more simplified version known as swash letters may suffice. These are recognised in printing as letters (traditionally italic capitals), with a clearly defined flourish. Calligraphically, this technique can be considered as a form of letter extension, a stroke which extends an existing stroke of the letter. The extension can be applied to many letters, most successfully A, K, L, M, N, Q, R, S, T, V, W, X, Y, Z. It is most commonly used with capital letters.

    The swash is a very flexible device, not necessarily confined to extending any one particular existing letter stroke. With some thought it could probably extend any of the strokes. In common with flourishing, swash letters must be included in rough layout to permit proper consideration of the

ANNIE MORING
A small work produced as a personal
insightful gift. The words are written with
metal nib and Chinese stick ink, with a
decorated background of a profusion of
raised gold commas on vellum.
76 x 76mm
3 x 3in

Selection of simple punctuation marks
found in early manuscripts. Since most of
the texts were read aloud, these marks
served as a guide to suitable places for a
pause. Variation in the marks themselves
reflected the suggested length of pause.

One or more swash letters in headings and
title sequences gives prominence and can
set the tone for the work. Experiment with
different permutations - it may not be
necessary to use the same stroke to extend
- look for less obvious possibilities. There is
a 'natural' inclination to draw a stroke down
to the right, try extending a stroke upwards
instead.

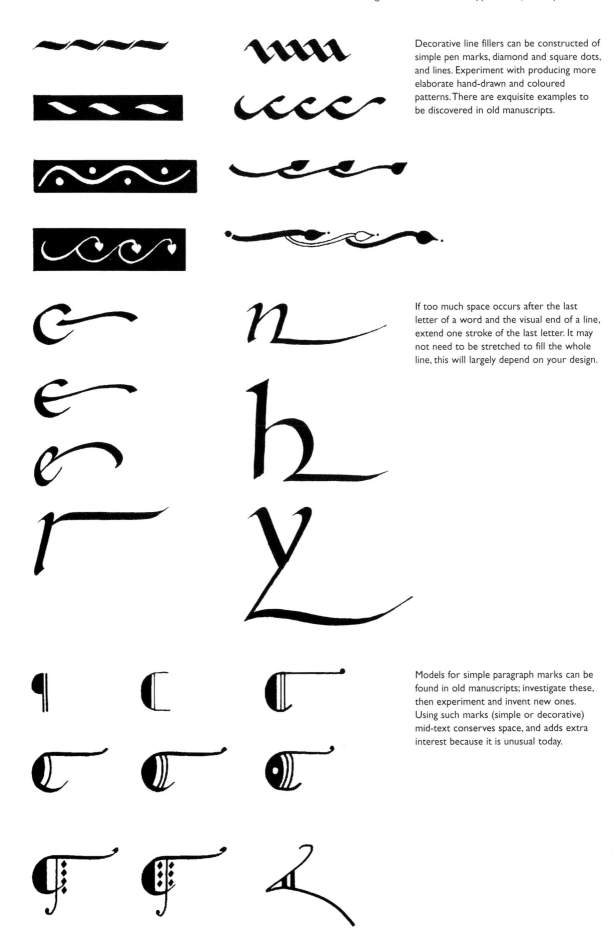

Decorative line fillers can be constructed of simple pen marks, diamond and square dots, and lines. Experiment with producing more elaborate hand-drawn and coloured patterns. There are exquisite examples to be discovered in old manuscripts.

If too much space occurs after the last letter of a word and the visual end of a line, extend one stroke of the last letter. It may not need to be stretched to fill the whole line, this will largely depend on your design.

Models for simple paragraph marks can be found in old manuscripts; investigate these, then experiment and invent new ones. Using such marks (simple or decorative) mid-text conserves space, and adds extra interest because it is unusual today.

required space and balance of the work. Although obvious, accepted and recognised options exist, some of the finest examples of swash letters are the creation and expression of an individual calligrapher. Breaking into the surrounding space, making a connection with other letters in the same word, or providing a unity with other words in a heading, typify some good usage of swash letters.

The use of swash letters, like flourishing, will not disguise or mask badly formed letters, nor should they obscure any words on the page.

## Line fillers

Writing out the text of a work often results, sometimes inadvertently, in an unwanted space occurring between the last word of a line and the right hand text alignment or margin (depending on the layout). Whether the space is created by accident or design, it is not necessary to leave it blank, unless that is part of your plan.

Several solutions can be found in ancient manuscripts to address this problem. Decorative strips of calligraphic marks, often using colour, would fill the line to the depth of the body of the letters (x-height). Similarly, a simple or complex ornamental arrangement of pattern, sometimes enclosed in a box, would suffice. A most expedient method is a simple line extension to the last letter of the word, but be aware that this works better with some letters than others. Used occasionally they can be very effective, but too many occurring in one work can look like bad planning in copyfitting from the beginning unless the overall design incorporates them as a specific feature of the work. Good examples of a profuse use of line fillers can be found in many old manuscripts, where they are often balanced with elaborate border designs.

## Paragraph Marks

If space is at a premium, or to create interest in a prose work, paragraph marks make an attractive solution. The best source for good examples is in the

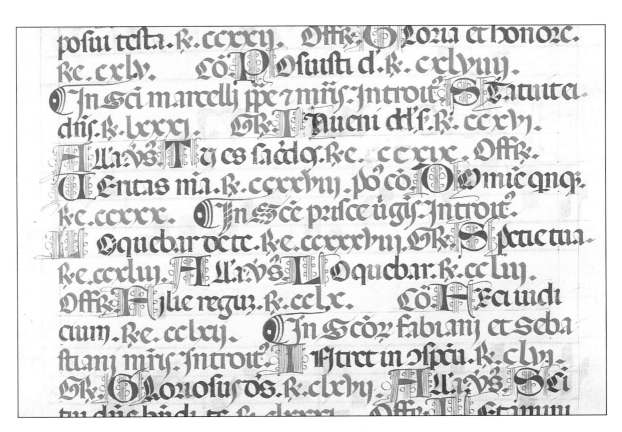

SIXTEENTH CENTURY
This detail from an antiphonary or gradual provides a splendid illustration of several elements of contemporary practice. Letters are decorated with simple, repetitive marks (lines and circles) and the succeeding letters are tinted with colour, a further means, along with the enlarged initial, to indicate a change in the text. The letter shapes can be studied for their construction. There are several Roman numerals which clearly show the 'x' constructed of a small arc stroke with the strokes for the letter 'c'. The mark used to indicate a new paragraph is rendered in blue.
CBL.WMS 212

THIRTEENTH CENTURY
c.1250
This small, 162 x 114mm (6.37 x 4.5in)
Psalter is from the Flemish area of northern
France, with the Latin text rendered in
'liturgical hand'.

Each text page has a three-sided border
in gold and colours. In the margin which
forms part of this border are bold, enlarged
initials interspersed with delicate
decoration in the Flemish tradition.

On page after page there are splendid
examples of elegantly styled line fillers,
created with colour and pen marks.
Although the volume suffers from severe
bleed-through on almost all pages, the
quality of the illuminations defies the
passage of the centuries.
CBL.WMS 61. f137r
218 folios with 19 lines per page

old manuscripts (see page 39). With some imagination and inventive pen play, simple marks can be constructed to serve this and similar purposes. The use of a single dot in the centre of the writing line is very effective. This was the method used particularly by the Romans on their monumental works with incised lettering.

## Other Devices

The application of modest or elaborate ornament to an initial letter must be done with care. Plenty of space must be allowed for the decoration to fit on the page with the accompanying text and still evoke visual harmony and balance. The actual decoration of the letter may be applied, or the letter may be constructed from the decoration (see page 23). Decide whether the decoration is going to be confined solely to the initial letter, or if it will encompass the first word, words, line or paragraph. Alternatively, you may wish to extend the decoration from the letter into the space around the text block, but not interfering with the words. The decoration could project across the top of the work, down the left hand side and/or across the bottom of the page. Some ornamentation can be used to construct an entire border totally enclosing the text. If this is the chosen solution, consideration must be given to the corners.

The three most useful corner joints are: square, oblique and joggled mitre.

## Corners and borders

It is important to consider the structure of any border, whether it is ornamental or simply linear, and whether it frames a work entirely or partially. The particularly pertinent part is the composition of the joining and mitring. The corners of any frame are crucial to the whole and may provide the basis of the design, so you would want them to be incorporated in the work, not concealed or crudely accentuated.

In any frame, the corner joint is seen as the weakest part of the structure, so when composing a border, consider these joints first. As a guide, there are three kinds of joints worth considering: (1) square, (2) oblique, and (3) joggled mitre. Addressing the corners first, then applying ornament, should strengthen their appearance. The vertical and horizontal components of the border will then appear to be well secured by the joints. The chosen treatment of the corners may suggest the design for the whole border decoration.

Spend plenty of time working through a selection of roughs, exploring many combinations before making your final choice for a border design. The corners may have been constructed using the square framework, with your design within this shape. The accompanying border may be a series of repeat patterns echoing the marks used in the corners. Choosing the oblique joint may inspire the use of spiral shapes flowing from the corners along the border.

The border does not necessarily need to be confined within parallel lines or constructed with straight edges. It could have one straight edge and one irregular, or two irregular. Allow extra space for the border and note its relationship to the surrounding space, in particular its distance from the margin area and the edge of the page.

Borders can be used to separate components on a page (text and image) or used to enclose or partially enclose an entire work, confining attention to the information within the border. A border composed of linear elements can make irregularities appear neater, but it should not detract from the most important information on the page, nor should it compete. A border can enhance, substantiate, balance or draw attention to information. It can pull a work together, and should work with rather than against the textual matter.

## Practical design considerations

| Purpose | Physical | Size (*untrimmed:mm*) | Format margins text layout | Calligraphy style | Decorative devices & additions |
|---|---|---|---|---|---|
| advertisement | flat: work on | A0  841 × 1189 | landscape | carolingian | border |
| announcement | one side | A1  594 × 841 | portrait | copperplate | colophon |
| book | on both sides | A2  420 × 594 | square | foundational | colour |
| book cover | folded: once | A3  297 × 420 | circular | gothic blackletter | corners |
| bookmark | twice | A4  210 × 297 | irregular | gothic cursive | decorative letter |
| bookplate | multiple | A5  148 × 210 |  | half uncial | dots |
| brochure | fold into envelope | A6  105 × 148 | 1·5 : 2 : 2 : 4 | humanistic italic | enlarged letter |
| business card | fixed fold: stapled, | A7  74 × 105 | 2 : 2 : 2 : 3 | italic | flourishing |
| business stationery | sewn, glued, |  | 1·5 : 2 : 3 : 4 | lombardic | gilding (flat gold) |
| estimate | bound, accordion | envelopes: | 2 : 2·5 : 2·5 : 4 | modern uncial | illustration |
| greetings card | personal: handheld | DL, C6 | off centre/ | roman capitals | letter extension |
| information bulletin |  |  | irregular | rotunda | line fillers |
| invitation | display: large |  |  | rustica | ornament |
| invoice | small |  | ranged left/ | textura | paragraph marks |
| label |  |  | ragged right | uncial | patterns |
| leaflet | framed: mounted |  | ranged right/ | versals | punctuation |
| letterhead | unmounted |  | ragged left |  | raised gold |
| manuscript book | 'frameless' frame |  | justified |  | sponged ground |
| menu |  |  | centred |  | swash letter |
| newsheet/letter | laminated |  | asymmetrical |  | washed ground |
| personal stationery |  |  |  |  |  |
| postcard | photocopy |  |  |  |  |
| poster | printed |  |  |  |  |
| price list | thermography |  |  |  |  |
| programme | colour copy |  |  |  |  |
| sign | photograph |  |  |  |  |
| table plan |  |  |  |  |  |
| wedding stationery |  |  |  |  |  |
| with-compliment slip |  |  |  |  |  |

Thank you all at No 11 Tessa Street Chatswood and those that visit: for a rare time of hugs and music pavlova & soufflés (were there truffles too?) 2 x furry four foots on a kitchen stool and tinkling wind chimes, birthday celebrations and more pavlova & daphne (is that a ballet yet?) for dancing feet and restless legs, for bushwalkers and hockey players, pumpkin soups, vegetables & pasta, brainstorming sessions, sunflower & barley bread, pots of tea & clean clothes, tasmanian cheeses and washing line, cups of tea, mugs will do, coffee too, chocolates and clarinet, flics, trumpet concertos & choral works, exams, cleaning kit, testing no papers, tutoring, nursing, more champagne, hugs & tissues, homebaking & cryptic x-words and target words with T & breakfast lunch and elevenses (& afternoon tea if needs be) teraco to turramurra & beach of pearls and knitting boys and stitchery sheets and subtleties with fortune cookies, rocking chairs & dictionaries, thesaurus, solutions also, aiding captions for lightbox bound pictures, visiting people & more tea with birthday bathers and nursing last night till 5, and duly despatched with more hugs 'n so much love for which: infinite thanks and hugs with love & tea anyone?

# Creative Aspects
## *From First Insight to Evaluation*

The creative process is well documented and argued in academic and specialist texts, where stimulating debates frequently challenge its very existence. These arguments and debates are indicators of the unpredictable nature and elusive character of the process.

In the late-nineteenth century, the German physiologist, physicist and mathematician, Hermann Helmholtz, kept a record of his own methods of working. Observing a pattern of three stages in his own creative work he recorded these as:

(1) a time of investigation and research that became a period of total absorption, which he named saturation,

(2) a time of rest away from investigations, which he called incubation,

(3) and a final stage identified by the often sudden emergence of an unexpected solution, which he called illumination.

Early in the twentieth century, Jules Henri Poincaré, a French mathematician, physicist and philosopher, made his own personal observations. He confirmed Helmholtz's concept but added a final stage which verified or evaluated the insight provided by illumination. This fourth stage was also advanced by Jacques Hadamard, another French mathematician, in his study of creativity in mathematics.

In 1926, Graham Wallas advanced his theory of these four stages of the creative process. He confirmed the work by Helmholtz and Poincaré and provided a basic model from which many have since worked. Wallas wrote of the first stage, preparation, as a time of clear and unhindered free thinking alongside acute observation by all senses - a time to seek out and do all preliminary work.

Incubation, Wallas noted, was that time between the two conscious periods: the very active phase of preparation and the sudden inspiring spark of illumination. The time span, he noted, could be anything from minutes to years. The clear insight of illumination might be followed by a frantic rush of activity to record the idea. Alternatively, there could be a quieter response, just a feeling, a notion of an idea giving direction towards the problem's solution. A time of critical evaluation follows in the verification stage. The seeds of the idea found in the illumination are taken and tested, tried and experimented upon.

Throughout the twentieth century, thinkers and scientists have continued to investigate the creative process and publish their findings. Some authors have expanded the number of stages, drawing on their own research using interviews with and questionnaires sent to scientists, musicians, artists, writers, poets and inventors. These have proved valuable in taking the debate beyond the realms of science. The American psychologist, Jacob Getzels suggested a stage preceding the saturation phase, which his colleague George Kneller called 'first insight'. Before a final visual artwork is begun, many rough sketches are produced and often

DIANA HARDY WILSON
A personal message expressing heartfelt thanks, written on Saunders Waterford Series watercolour paper with Hot Press surface. The words are a composition of observations and events pertaining to the recipients and the bestower. The knitted red wool 'T' on black wool ground recognizes a specific achievement of one recipient.
370 x 160mm (image and text)/14.63 x 6.25in

JOHN SMITH
There are many things which make
calligraphy an extra special discipline. One
must be the availability and accessibility of a
seemingly endless rich vein of material - the
building blocks of any language: letters
endlessly rearranged into words and these
in turn rearranged to make everything from
forceful statements to tender sentiments. A
calligrapher can create many works without
even resorting to using words by just
playing with the letter shapes, and then
arranging and designing with them on a
page - the possibilities are truly limitless.

Here letter shapes are used as a
background to words about writing. Large
letters appear on the distant ground of
pergamenata paper, over which *With the Art
of Writing* is written with Japanese ink and
gouache. All the components are visually
and literary complementary to one another.
400 x 300mm
15.75 x 11.87in

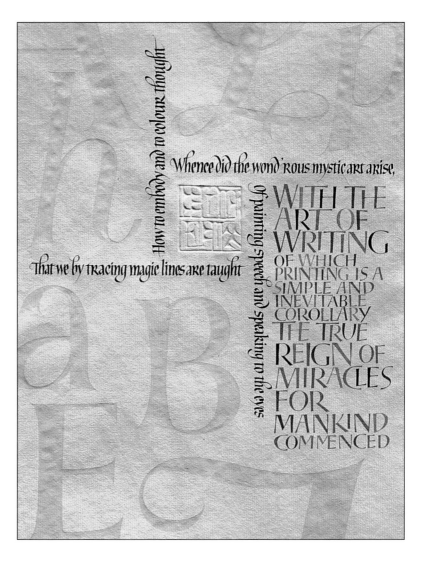

comprehensively developed. W. Edgar Vinacke
drew attention to this and suggested that it
constitutes several illuminations and that the
incubation phase is therefore constantly present,
rather than occurring succinctly between two other
stages. In contrast the Gestalt psychologists argue
that, like all structures, the creative process is a
whole and cannot be described as a sum of its parts.

The creative process is an abstract concept, so its
parts are difficult to define. However, it is useful to
make an attempt, because doing so can shed light on
your own creative process. The main thing to
remember is that creativity in all its stages is
different for different people. Before evaluating the
stages of the creative process it is worth noting that,
despite these well-charted stages, any creative
person knows there are times when the creative
process stalls. Writers are not the only ones who
suffer. The quintessence of creativity is embodied in
originality, inventiveness and imagination, all of
which qualities are elusive, to say the least.

Whatever the level of interest, an insight into the
creative process may prevent the abandonment of a
project by enabling you to change current working
practices. This may mean selecting an alternative
method of working, or using the same method but
approaching the work from another direction, or
recognising the need for more research.

The ability to change your working practice and
the type of changes involved may have a
fundamental impact on the way you work. It is
possible, for example, that at a recurring point in the
working procedure further progress is hindered.
Learning to manoeuvre around this point can
advance the work, but recognition of this recurrence
can enable you eventually to eliminate this 'sticking
point'.

Before you realized that you were getting stuck
at the same place, you may have tried to ignore your
difficulties and persevered. The probable result of
this strategy is growing disillusionment and the
eventual abandoning of a potentially successful

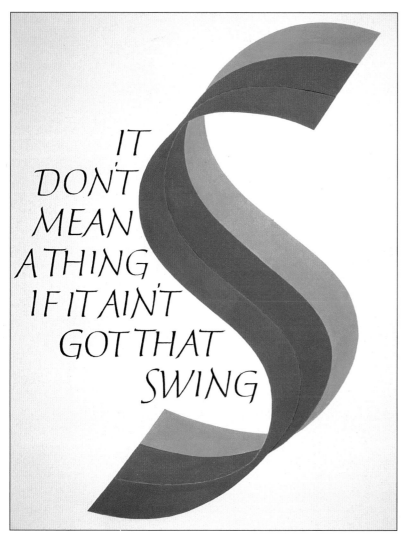

MICHAEL HARVEY
*It Don't Mean A Thing* a large exhibition piece linking jazz and calligraphy, produced with Plaka paint and ink on Canson paper. A keen interest in anything, from gardening to a particular music form, can enhance the work you produce. This calligrapher's delight in and love for jazz is much in evidence in his work.
600 x 400mm
22 x 15.75in

concept. Being able to see that the working method is wrong, not the idea, allows you to select another method and complete the work successfully.

However, it is not always the working method that causes the disruption, so changing it will not necessarily eradicate the 'sticking point'. The 'block' may surface every time a conscious action triggers something lodged in the subconscious mind and related to personal experience. In such a case, some personal investigation or analysis may provide the answer.

To help with this, try to find at which point the flow of work is interrupted. It is quite common to feel unable to complete a piece of work. This seems to occur when there is not much more work to do and, even though what has to be done is planned, it is put away unfinished. Sometimes, actually beginning a piece of work can be the main hurdle, even when there is a finished rough from which to work. For people who experience either of these, or any other related symptoms, work can be a fraught

business. Realisation of what is occurring can free an individual and allow work to proceed. The following suggested guidelines may be helpful.

Refocus on the important, elementary formulation of the original problem. Reaffirm for yourself that this is what you want to do and that the work in front of you complies with the original intentions. Broaden this analysis to ask why you are doing the work, who is it for, what do they expect from it, and what do you expect from it? Continue this process, adding more questions of your own. The answers you give to these questions should be examined for further keys to understanding. One identified source of the problem of stilted production is simply that, having created the idea and produced a finished rough, the artist can feel that the work is complete. On one level this is correct. The creative act has been performed. The production of the creation is now perceived as mundane and merely a reworking of all that has come before. It holds no interest for the creative

RODNEY SAULWICK
These italic letters are arranged into a
coherent and balanced group, forming a
motif to be used on a calligraphy book. The
coterminous stroke of the 'A' and 'B' is a
space saver; it also illustrates how in this
design, repeating the second vertical (or
near vertical) stroke for the 'B' would be
superfluous. The work was produced by
metal nib and ink on A6 Bond paper.

spirit, which restless creature has moved on to the next invention.

If this is the problem, ways need to be found either to deal directly with the situation or circumvent it. Since employing another person to do the job of production worker is probably out of the question, it will have to be performed by its creator. One approach which may help initially is to conjure up some excitement and anticipation at the prospect of seeing the final, completed work, and experiencing the resultant satisfaction. You could even organise a celebration.

Further investigation may produce a connection with those occasions when you are unable to complete a work. In this event, it is quite possible that the reason may be more deeply rooted. Our experience clearly illustrates we can easily do the work. The problem lies in what happens after the work is completed. If our expectations of what should happen upon completion can be identified and reviewed, they may be found to be ill-defined, confused or even unconsidered. If so, it makes perfect sense to the creative person neither to begin nor to complete a work; it is much more comfortable to stay safe and secure within the domain of our own experience, and not to take the risk of sending the completed work out into the world.

After the recognition of a 'sticking point', finding out why the impediment exists can be a difficult process, but its discovery can infinitely benefit ourselves and our work. Knowing even a little of the creative process, in tandem with personal exploration of individual experience, may help identify factors impeding your progress.

If we continue to work and leave the problem unaddressed, it is probable that, whether it concerns a method of working or is more deeply-seated, it will stay with us. A little analysis of the situation could teach us when to stop, take a rest or abandon an idea; and having this choice is more rewarding than being held back by a lack of knowledge.

The point of breakdown in a method of working is most frequently identified as a feeling of frustration. Frustration is the result of not knowing. It can manifest itself at any stage, but usually with the same result; it impedes further progress. How we react will depend on our individual experience. For some people, at this point the frustrations will connect with an inner voice whose 'mantra' recites how useless they are; for others, a decision will be made very swiftly that this pursuit is not for them. The result is the same in both cases; we give up.

If we know what is happening and learn our own routes through, we can make better use of our personal resources, break through, survive and grow. With this knowledge and its attendant understanding we can choose what to do, which action to take and put it into practice, freed from any stubborn sense of duty, inhibition, or just plain fear. This concept of movement and change may not sit comfortably at first, but it improves with practice. When we first learn to tie shoelaces it is an incomprehensible knotted struggle, but later it becomes almost automatic and we do not even notice how we are doing it; except when there is a knot. Then we must focus on, update and review our actions.

# The Creative Process

For the purposes of this work the creative process will be considered in five stages: first insight, preparation, incubation, illumination and evaluation. The names given to the stages can differ slightly and some choices are shown in the table, which also indicates the nature of actions and moods which may accompany each stage. The underlying progression from one stage to the next does not alter significantly, whatever the problem or discipline involved. It is the time span which is wholly unpredictable. Any of the phases (except illumination) could take from hours to weeks, months or even years.

## First insight

The beginning of the creative process can be heralded by a single thought or idea, or the realization that a problem can be resolved in a new way, or a solution improved upon. It may be stimulated by a commission or being asked to

## Creative process

| First insight | Preparation | Incubation | Illumination | Evaluation |
|---|---|---|---|---|
| observation realisation conceptualization recognition idea brainwave | saturation research choices alternatives | letting go rest | germ of idea can solidify into concept, stimulated by hunches which will in turn give: flash of insight birth of idea(s) | verification consolidation confirmation test experiment |
| **mechanisms of concept** | | | | |
| identify, formulate and define problem; recognition and acceptance of challenge | gathering data analysis, survey, collate, sort and reject data and ideas | maelstrom of ideas; 'normal' artistic phenomena, do not be depressed by it; various built-in artistic mechanisms can help: sleep on it, forget about it, and use short periods of diversion | Eureka! Ah-ha! out of the blue great relief release of tension excitement anticipation | trying out - mechanics of concept referred to in first insight; putting together; implementing |
| —— conscious —— | | —— subconscious —— | | —— conscious —— |
| conceptual commentary of pros and cons | acceptance and rejection of ideas and stimulants may lead to intellectual overload; from concept of idea to possible solution can be an exciting route, then difficult progress may be encountered; too many and too much: log-jam, refining of concept; artistic saturation cured by rest; switch off | *word of caution:* do not take friends 'and colleagues' ideas on board - this leads to confusion - confuses the concept being formed in your own subconscious; immediately preceding illumination the following may occur: greyness, sadness, restlessness, agitation, anxiety, staleness | embark on adventure | judging results |

DEIRDRE HASSED
It is not always the calligraphy which begins a work. A presentation style may inspire an idea which is used immediately, or at a later date in combination with other concepts which evolve. A colour, a shape or format, a method of folding paper or, as in this work, the paper itself, may furnish the beginning. *Psalm 103* provided the appropriate text for this exhibition piece. Metal nibs were used with gouache on the beautiful French hand-made paper. The small triangular marks used to indicate word spaces are further employed to decorate both the words and the paper in a harmonious and complementary manner.
240 x 320mm
9.5 x 12.63in

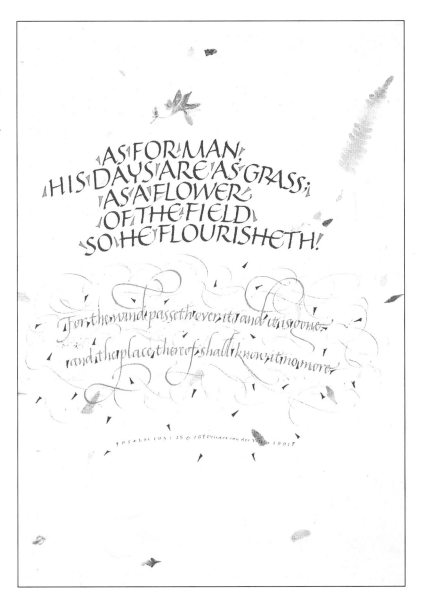

produce a design solution for a specific occasion.

For some visual artists it may be a state of mind, a feeling followed by an emotional reaction to something seen or perceived. The moment, if it is a moment, can be almost as potent as the illumination which should follow, with similar reactions, such as the one connecting the perception of something outside with something that is stored in the memory. There is a chain reaction of curiosity, intrigue and questions, which can come out in a rush, totally disordered and all requiring immediate attention. There could be an impulse which demands action or feelings which must be expressed, perhaps with an urgency which makes it difficult to settle down to the more mundane process of organisation and finding a path to a solution of the problem provided by the task ahead. A period of great activity is beginning, one of investigation and research which at times can even feel like a pursuit.

At this stage, ideas often need clarification, so a thorough definition and evaluation of the problem are paramount, as seen in The Design Process. Spend as much time as required on this task. Do not rush, or attempt its drafting without all the necessary information, or rewriting and reworking. Any unanswered questions must be dealt with before proceeding with the next stage of preparation, where the importance of an accurate, clear and concise formulation becomes evident.

Make a positive declaration to go ahead so you can progress with diligence and a firm belief in success. Without this attitude, doubts may surface and hinder progress. Acknowledge and accept the challenge which you have been offered, or have created for yourself.

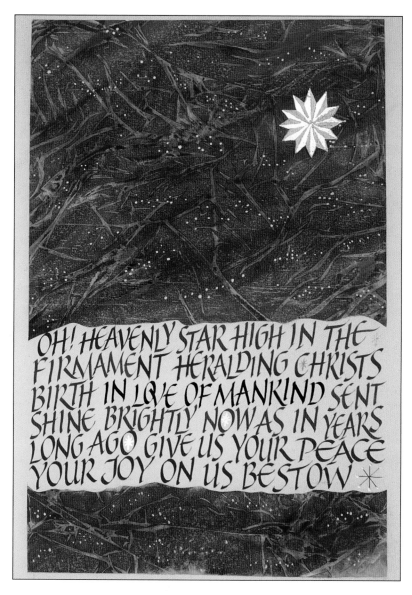

OH! HEAVENLY STAR HIGH IN THE FIRMAMENT HERALDING CHRISTS BIRTH IN LOVE OF MANKIND SENT SHINE BRIGHTLY NOW AS IN YEARS LONG AGO GIVE US YOUR PEACE YOUR JOY ON US BESTOW

JUNE FRANCIS
For calligraphers, joy is found in many places and has many facets. One is the search through literature to find delectable morsels to inscribe. Another is the opportunity and encouragement to render one's own words. Such is this piece of work designed as a cover feature for a Christmas newsletter. The ground was prepared with a watercolour wash technique using plastic wrap to create texture for the night sky. The words were written by metal nib with gouache. Gold paint alternating with gold leaf was used to create the two-tone effect of the star. Further interest is brought to the work by allowing the white ground beneath the lettering to bleed into the margin area.

## Preparation

Preparation requires a conscious effort to saturate yourself in the problem, when it must be viewed from all angles, and have all its good and bad points assessed. This is an active phase as information is gathered; it is time-consuming but absolutely necessary. All the collected data must be collated and reviewed. Reviewing the data demands the ability to recognise and reject irrelevant information, even when considerable time and effort have been invested in acquiring this data. However, the gathered material will be useful for another problem; so file it safely. The time and effort spent should be regarded as useful experience. (Experience is an essential factor in solving problems and possibly makes up the greater part of the less well defined section of the creative process.)

Initially, past experience will evoke many all too obviously recognized and clichéd solutions. This is natural, and useful as a freeing-up method to get rid of the obvious and allow your own less obvious ideas to surface. However, do not dismiss obvious solutions entirely, they may yet prove useful, or serve as inspiration. A re-working of a recognised solution may provide the answer.

The conscious mind may reject all the possible solutions (even valid ones). At this critical point we declare 'can't do', 'won't do', 'impossible', and frustration sets in. Another cause of frustration is the use of an inappropriate second-hand solution for a problem which closely resembles something we have previously encountered. Recognition of this frustration brings understanding so that action can be taken to prevent the onset of a potentially destructive phase. Thus, understanding brings

peace of mind and the ability to act positively.

Often, the harder we work at chasing the solution, the more elusive it seems to become; in other words the saturation point is reached and no more work is possible. Much has been said and written about this state. Among the most common recommendations are, 'sleep on it', 'do something completely different', or 'put it aside'. These are sound words of advice. They all direct you to concentrate on something other than the problem, so that efforts to find a solution now shift from the conscious to the subconscious mind, from preparation to incubation, a fascinating but little-understood stage in the creative process. This is a very important point in the process. It would appear that alternating periods of rest with concentrated efforts may be critical. Often an illumination may occur during these transitions. You may like to experiment by interrupting your work with planned breaks, to see if it helps the search for a solution.

## Incubation

The incubation period is a resting time between the two conscious phases of preparation and illumination. It is a period of subconscious consolidation much needed after the great activity and saturation of the preceding phase. This is a time to allow ideas to come, to be receptive and ready for illumination. The most positive actions you can take to help this are ones which take you away from all tangible evidence of the problem - the drawings, the rough workings, the research notes. All these can be set aside.

The most fundamental lesson to learn at this stage of the process is trust. The conscious actions of preparation, research, investigation and all efforts to determine a solution have been conducted thoroughly. They provide the extensive information required by the subconscious mind for its contribution. If the preparation is scant, half-hearted, incomplete and desultory, then what comes out of the subconscious mind will match that input. (This can happen even though a main contributing factor to the work done by the subconscious mind is, of course, the cumulation of years of learning, experience, gathered images and conscious thought.)

Before the incubation period, a decision must have been made to stop looking for a solution. Recognition of when to stop all research and preparation is a signal to the subconscious mind to begin its work.

Find and adopt methods to enhance this process which work for you. Acknowledge that not all work will include a noticeable incubation period, while some may require incubation for months or even years. If the nature of your work requires a more

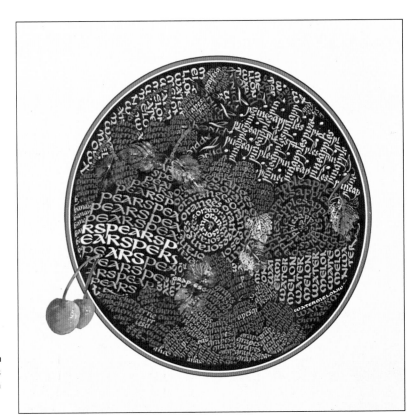

**HELEN WARREN**
The calligrapher is spoilt for choice when searching for subject matter, particularly ideas with a theme or naturally occurring groups: seasons, elements, days, months, places, flora, fauna and food. *Fruit Salad* is the result of a search for a design concept involving shapes and calligrams. Gouache on Canson paper provided the sought-for tints and tonal gradations. Additional decoration in the form of dots of 23-carat gold was applied using acrylic glue.

LUDO DEVAUX
For the quotation by Friedrich Neugebauer,
Ingres paper was first prepared with a
multicoloured wash. The words were then
rendered in a gothic hand by Brause nib and
ink. The foreground was then worked on
and altered with gouache using a variety of
tools, including the application of the white
alphabet by ruling pen. The sharply angled
gilded line is raised gold and creates a
dynamic focal point.
500 x 700mm
19.75 x 27.5in

immediate resolution, then give all the assistance you can to this part of the process.

One method is to do something completely different. Some people will opt for physical exercise, other people perform routine and menial tasks and others rely on a form of meditation. These three activities are very different but have one thing in common: they all avoid any conscious effort to resolve the problem.

The problem solvers who seek total absorption in physical pursuits and the people who occupy their time with small, less demanding chores or relaxation do so in the belief that their actions require little or no conscious mental effort and are therefore less likely to disrupt the mental processes involved in the incubation process. There is no guarantee of this, but the individual's belief in these actions is what is important. The actions are harmless distractions, they divert conscious attention from the problem.

It is also useful to become more aware of moods and feelings. Before the birth of any idea, plan, scheme or solution, there is often a time of listlessness and unease; perhaps a sense of staleness, even hopelessness. When you have learned to observe this in yourself, it is possible to prevent yourself succumbing to its vagaries, and to turn the mood into a celebration, anticipating the birth. Be aware too, that there are any number of ideas incubating at any one time, so any mood of greyness and restlessness could be regarded as the portent of an illumination, even if you are not consciously preparing a work.

Identifying this specific phase of the creative process and noting one's actions and reactions can be a fulfilling and liberating process on its own.

## Illumination

Illumination is a clarification, an enlightenment, an insight and understanding. It can occur at any time and in any place. Suddenly, after a period of staleness, with no end in sight, an idea, a solution, a flash of inspiration bursts into consciousness. It is a revelation after what has gone before.

The phase is well represented in the stories of Newton seeing the apple falling, and Archimedes leaping from his bath crying 'Eureka!'. There are many examples of people puzzling over a problem,

RODNEY SAULWICK
Designing an initial letter or enlarged capital letter to accompany a specific text can be extremely satisfying. This swash initial was destined to be used as a drop capital. A useful exercise is to investigate unusual swash extensions and methods of manipulating letter shapes to introduce chapters and verses. This example, which pulls the swash out to the left of the letter and into the margin area away from the text, suggests a good direction for exploration. This letter was drafted with a Coit 3/8th pen and ink on Bond paper.

then setting it aside and going about their other affairs, only to find that, suddenly, with no warning, an idea or possible solution occurs. Typically, they are preoccupied by other thoughts and activities, perhaps day dreaming, travelling to work or taking a shower. Illumination may also occur during the curiously powerful time just before going to sleep or waking. Illumination consistently takes place when conscious thought is not directed towards the problem. Many people can recount memorable moments when an incubation period was finally ended and illumination burst forth. However, the illumination can also arrive in a quieter, more subtle way. It can begin with just a feeling about something, the beginning of an idea, a suspicion, an intuitive notion about a possible solution. It may also be the entire solution - for an artist, a vision of a complete picture.

As the illumination phase is brief we must be constantly alert and ready to respond. Where all the other phases of the creative process may occupy varying amounts of time, this one is short, sharp and succinct. It is the artist's 'Eureka', usually accompanied by an enormous release and relief.

## Evaluation

Evaluation succeeds illumination. The tentative solution revealed by illumination is now put to the test, moulded and manipulated, experimented with and brought to life. The illumination does not necessarily produce the end result, but may provide potential solutions. These can be worked on, developed, even rejected. It may have been a long or a short journey, but the rewards and excitement of

renewed progress can be quite overwhelming. Savour them.

A period of concentration and hard work follows, whether the revelations brought were dynamic and complete or a series of ideas to develop. If it is a single idea or series of possibilities, a great deal of exploration and manipulation must be accomplished to determine feasibility.

Not all potential solutions or hunches are going to provide the sought-for answer to the problem. If there is no solution, acknowledge the failure and use the new information to begin the journey again. You and your work will be richer for these first efforts. Sometimes the illumination may barely be recognisable in the completed work, but it will have set the pattern for a new train of thought or visual manipulations, or provided the basic framework for the final design. This illumination is to the completed work as a kernel is to a fruit. It is the seed of the idea, it allows you to make the completed work grow from it. Though it does not appear important in itself, it is the springboard for everything else.

As you work out the logistics of the potential solution, checking it against what you set out to do and evaluating its success, see the work both as its constituent parts and the whole.

The action of creating is subjective, but evaluation of our work requires an objective stance. This is difficult because we have been so involved in the making process that the work has become a part of us. Learning to step back from a work takes time. The most practised method is to put the work away out of sight for some weeks. On returning to it, it will be seen more objectively and with renewed insight. If you do not have several weeks, place the

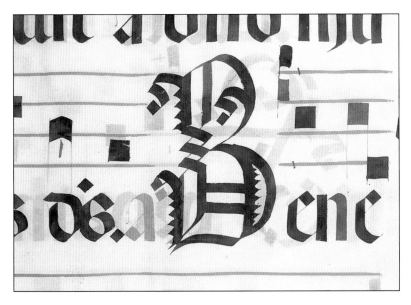

work where it will catch your eye occasionally as you walk past (but not in your direct line of vision).

For the calligrapher, after all the final adjustments and evaluations are complete, the painstaking process of planning the production and identifying equipment, materials, techniques and methods now begins. However, the homily that creating something is only 10% inspiration and 90% perspiration does not need to be regarded as an immutable truth.

## Nurturing Your Creativity

Although an attempt to define creativity is bound to lead to contention, it can elicit stimulating and interesting debate, which in itself is creative.

When we embark on solving a visual design problem, new material will inevitably be researched and collected. All this new information is assimilated and filters down to the subconscious mind where it interacts with already existing images and facts - everything from early learning and individual idiosyncrasies to something we saw yesterday. The solutions we finally present are the result of this interaction between memory, recent data and the total of our personal experience. Even when confronted by unfamiliar or unrecognisable information, we try to find something similar in our memory which will promote our understanding of the new material through association or perhaps analogy.

The breadth of our experience as creators will be richer if we consciously attempt to contribute to it. To do this we must raise our level of awareness of our immediate environment, keep our senses alert and constantly ready to identify, absorb, analyse and sometimes just appreciate. The restless, creative spirit pays no heed to the nine-to-five working day. Being creative is a twenty-four-hour, seven-day-a-week job. Everything we do, all the information we glean, everything seen and heard is sorted and stored. It is not necessary to analyse every incident, action or visual stimulus.

Excellent examples can be short-lived and occur by happenstance. You may notice the colour of the sky on a particular evening, the shape of a cloud. These occurrences are never repeated and they may be only vaguely remembered but, most importantly, they have been seen and experienced. Seeing, touching and hearing, plus our feelings about what we see, touch and hear, must never be neglected. Sometimes the occasion demands a revelry of delight and celebration; at other times solitude and peace are in order.

One emotion has an extremely negative effect on creativity; that is fear. It can arise from anxiety about whether you are able to respond to the challenging demands of a problem. Often all that is required in this situation, once the fear has been identified, is a relaxed approach and proper preparation. Some of the most recognized fears include: fear of failure, fear of being considered out of step with those around you (they see you as a threat to them, so it is not your problem), fear of being perceived as a fool, fear of being criticized or ostracized, fear of being different and fear of success.

Learning to trust our own responses and set aside fears is a priority, especially when truly innovative ideas develop. The attendant fears may be associated with previous occasions of speaking

ANGELA SWAN
It has already been observed that inspiration is everywhere, but sometimes the calligraphic eye is alerted by a single event. Something specific fires the imagination and, in the subsequent effort to capture an impression of the moment, new ground can be covered. An extraordinary evening watching a group of whirling Dervishes was one such occasion. The work was produced as an acknowledgement of the person who extended the invitation. In the production of this poem by Rumi (the medieval founder of the whirling Dervish order of Sufis) flourishes, which hitherto were considered alien to the calligraphic nature of this calligrapher, were found to be the best way to express the beauty and purity of the Dervish movements. The work was written on Fabriano Roma paper using gouache and opaque bleed-proof white.
297 x 190mm
11.75 x 7.5in

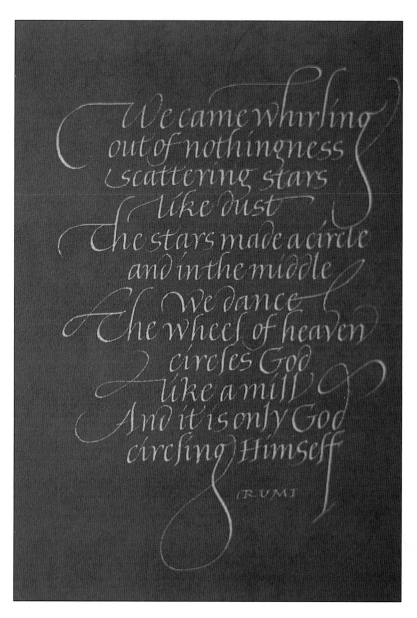

out strongly on a subject and standing out from the crowd. Nurturing a belief in what you are doing, in your capabilities and in yourself is an honest and direct route to flourishing development.

Be reassured that even though conscious progress on a work may appear to have stopped, the ideas will continue to incubate in the subconscious mind (see pages 52-3). Your working area is very important in this context. Try to have a specific space permanently set aside for your work. Creative work will not flourish if every time you want to address it a space has to be cleared and at the end of the session all your tools, equipment and materials have to be packed away out of sight. Make a space, however small, which is just for you and your calligraphy. For centuries, writers and artists have written or commented on their working

environments. Some employed almost ritualistic methods which they believed would encourage their work, including sharpening pencils, setting goals for the day, putting fresh flowers on the desk and arranging the tools of their discipline in a particular manner. Experiment and explore possible indulgences or rituals which might work for you.

Determine how you would like to further develop the design and creative processes, and see if you can recognize how they manifest themselves in your present working practice. If change is warranted, or if you decide to alter the way you approach your work, do it in a methodical and organised manner. Change cannot happen overnight. Identify the areas of your working practice that you would like to improve. Decide what alterations need to be made in each area and

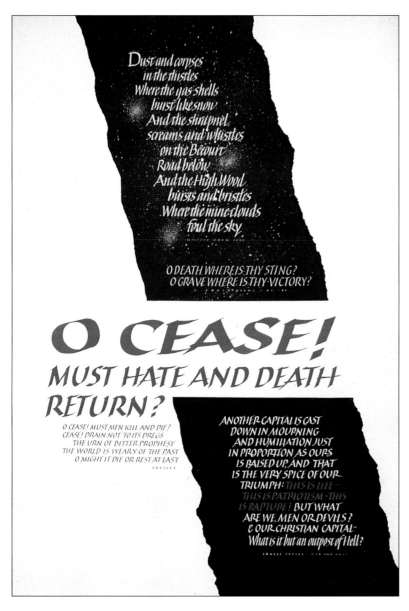

Dust and corpses
in the thistles
Where the gas-shells
burst like snow
And the shrapnel
screams and whistles
on the Beaumont
Road below
And the High Wood
bursts and bristles
Where the nine clouds
foul the sky

O DEATH WHERE IS THY STING?
O GRAVE WHERE IS THY VICTORY?

O CEASE!
MUST HATE AND DEATH
RETURN?

O CEASE! MUST MEN KILL AND DIE?
CEASE! DRAIN NOT TO ITS DREGS
THE URN OF BITTER PROPHESY
THE WORLD IS WEARY OF THE PAST
O MIGHT IT DIE OR REST AT LAST

ANOTHER CAPITAL IS CAST
DOWN IN MOURNING
AND HUMILIATION JUST
IN PROPORTION AS OURS
IS RAISED UP, AND THAT
IS THE VERY SPICE OF OUR
TRIUMPH: THIS IS LIFE –
THIS IS PATRIOTISM – THIS
IS RAPTURE! BUT WHAT
ARE WE, MEN OR DEVILS?
& OUR CHRISTIAN CAPITAL–
What is it but an outpost of Hell?

**MARY NOBLE**
This bold work was created as a personal response to hearing a news report that yet another war had started. First, white paper was fixed to a sheet of hardboard, which was later painted to match the writing. After writing on black Canson paper, this was cut and torn and pasted onto the white paper. The large, red letters were made by automatic pen and gouache. To obtain a good density of white writing, bleed-proof white was used with metal nibs. The fine splattering was applied after the writing by flicking paint from a toothbrush.

Personal reactions to world, or local community events often produce most powerful work.

work out a method of approach to make these changes. You could set their implementation as a goal and proceed one step at a time. This may prove the most effective method because you may be attempting to break long-established habits. Use your intuition, but do not rely on it solely – it, too, is quite capable of misdirection.

Nurture your innate creativity by becoming more aware of some of the practices in your life. Being creative is about you, yourself, as much as the elements which foster your competence. Adopting revised working methods, achieving new skills and making additional endeavours will enrich your life and, in time, emerge in your visual work.

Start with yourself and your own behaviour, reactions and customs and take positive action by changing something in your daily routine. Do

something in a completely different way. Alter the running order of an established schedule; walk instead of drive; take a bus instead of walking; listen to a different radio station; watch no television for one evening and then for a week. Spend an hour in a good reference library; do small tasks using the hand you do not usually employ. Do one main new thing per week and make it something you have been promising to do just for yourself.

Keep the interventions small at the beginning, acknowledge what you have decided to do and set realistic time limits. For example, if you go to a museum, decide before entering how much time you are going to spend there. These undertakings need to be regarded as interesting little challenges. However, if you identify an important change you wish to pursue, consider it as a goal and determine

to achieve it in a series of small, manageable steps. Some of the actions you decide to take should make you more aware of yourself. Notice how you occupy your time and then how you accomplish daily tasks.

Many everyday deeds are performed fairly automatically, they demand little or no conscious consideration. It has not always been thus; remember that there was a time when what is now regarded as a menial chore was undertaken with difficulty. Without returning exactly to this stage, take notice of both the way you do things and what tools or equipment you use. Interrupt your activities and actually observe what you are doing and how it is being done. For example, stopping to consider how to knot a tie or do up buttons, you may find you cannot do these tasks so well as when you do them more automatically. Compare this with learning calligraphy, when we seem to forget the fact we have spaced words perfectly legibly for many years.

In time, direct your attention to your surroundings and examine things you have taken for granted or never really inspected. Look at shapes, colours, tones, textures, notice sounds and smells and include the taste, texture and colours of the food you eat. Food, raw and prepared, provides a wonderful source for investigating texture and colour, both individually and in juxtaposition. Playing with food can become a conceptual experience, whether it is organising dried pulses of varying hues and sizes into an arrangement or discovering mashed potato is an excellent medium for decorative patterning, applied or manipulated with a fork.

How is the food arranged on the plate? Try presenting the food in different ways. Using a circular plate, place the food in circles from the outer rim to the centre, or in strips across the plate. Consider and select the food for its colours and textures. Eat and drink from vessels not usually associated with the chosen foods.

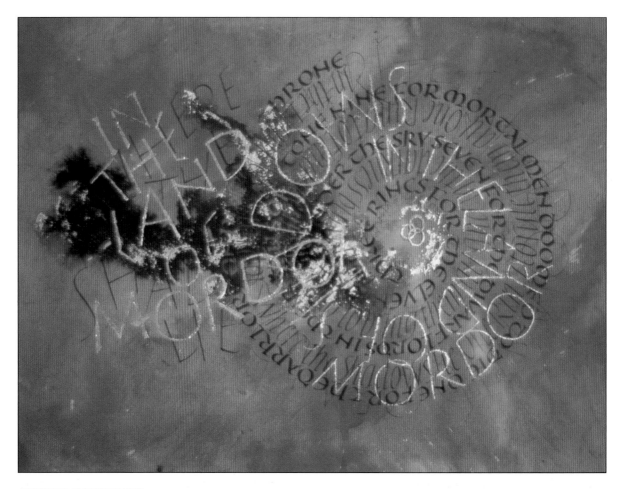

CATRIONA MONTGOMERY
This experimental work began with hand-made paper being stained red. Staining the substrate has a long tradition, as early manuscripts were frequently stained a rich, dense purple before brilliant illuminations and lettering of gold were applied. The letters and the decorative elements of this vibrant work entitled *Land of Mordor* were produced with ink, gouache and gold leaf.

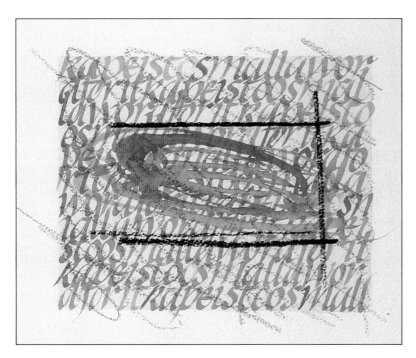

REILTÍN MURPHY
Reacting angrily to world events, but feeling powerless, artists frequently use their work to express their feelings of rage. (Similarly, work will be produced in recognition of a happier, celebratory occasion). This work, *Rape is too small a word for it*, with its sense of urgency and anger, is a response to the rapes in Bosnia and elsewhere. The exhibition piece was perfected using Brause nib, brush, oil pastel and watercolour.
400 x 320mm
15.75 x 12.63in

Experiment and play with other areas. Wear different clothes in combinations which are unusual for you, selecting them for colour, pattern and texture. Move the furniture so you have a different aspect on your space. Challenge your existing behaviour patterns and preconceptions with other changes. The overriding criterion (after avoiding grief or injury to another party) is simply to have fun and enjoy yourself. A little so-called 'outrageous behaviour' rarely hurts anyone, the sky does not fall, life goes on and you may have freed a little more of the creative spirit within.

Do not apply a stopping and observing process to everything, and do not attempt it all in one day. These are things to do over a long period of time, think of it as a nibbling-away process. Just try to become more aware, remembering to negotiate a little at a time. If you feel any resistance, do not venture any further. Stop and change direction, try something else. If you continue learning to observe what you are doing, to know why and how you do things, eventually the awareness will, like the activities you have been scrutinizing, become semi-automatic. You might even begin creating small challenges for yourself while completing even a boring task.

What might you discover, or be prompted to recall, doing these exercises? They will range from an instant reaction, hopefully of delight, not unlike the illumination phase of the creative process, to a longer-term realisation of the many interesting and beautiful things that occur around us all the time.

There may be some personal realisations which

are highly liberating. For example, you may find you can abandon long-established modes of behaviour and their inherent preconceptions. Connections may be made between solving visual design problems and life problems, which will make you more effective and resourceful. You may find yourself walking down a street, as you have on many previous occasions, but suddenly aware of things that you had never noticed before.

Experimenting and playing, just as we did as children, can be instructive and constructive and produce interesting results. The liberation felt, which may amount to a quietening of the doubting voices which seem to dwell in us all, is perhaps the greatest reward. The contributing factor is, of course, that trust and belief in ourselves is now growing stronger.

To further encourage creativity and promote understanding of the processes involved in visual design, you could embark on the following research project. Start by choosing an object, make it one you like and one you would be happy to know more about. It may have connections with a concept in which you are interested. Consider an egg, a hand, a chair, a tree, a candle, a cross, a pebble, a sock, a flower, a sponge, a wheel. The only essential criterion is that it is an object, not an abstract concept, for example, a watch, not time. Alternatively, or on another occasion, you could use the same criteria to select an action, such as sitting, opening, closing, flying, moving, seeing, growing, lifting or writing.

The aim of this exercise is to collect information

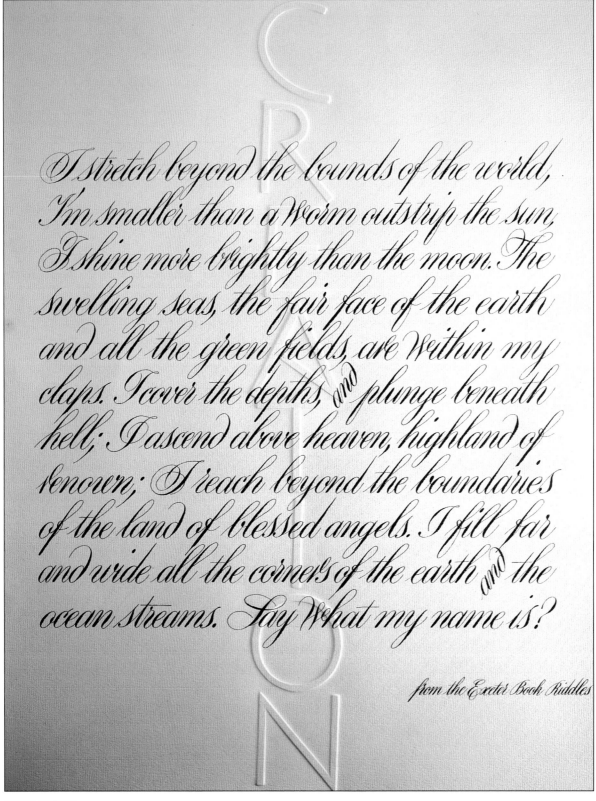

I stretch beyond the bounds of the world, I'm smaller than a worm outstrip the sun, I shine more brightly than the moon. The swelling seas, the fair face of the earth and all the green fields, are within my claps. I cover the depths, and plunge beneath hell; I ascend above heaven, highland of renown; I reach beyond the boundaries of the land of blessed angels. I fill far and wide all the corners of the earth and the ocean streams. Say what my name is?

from the Exeter Book Riddles

**JEAN LARCHER**
Taken from the *Exeter Book of Riddles*, this extraordinarily elegant work was produced by pointed pen on Ingres D'Arches MBM paper. The script flows smoothly, uninterrupted by the hand-embossing of the answer to the riddle. The quirk of placing the word 'and' twice at an oblique angle to the writing line does not interfere with reading pleasure and adds to originality. Small insertions, decorative devices, and various nuances, particularly innovative ones developed by individual calligraphers, add a finishing touch to a work and certainly provide more than just added interest value.
500 x 650mm/19.75 x 25.63in

about your chosen object or action. The sources of material are limited solely by your imagination and resourcefulness. However, references may be found in any of the following, noted here purely as examples: fiction, poetry, myths, legends, cinema, theatre, newspapers, magazines, brochures, television, radio, manufacturers' catalogues, advertisements, overheard conversations, museums and books.

The first words written could be the definition of your subject taken from a good dictionary. Follow this by looking up your object or action in a thesaurus and a dictionary of quotations. Collect and collate as much information as possible and always date and give the source of every acquisition. Be thorough in your search and you can become an expert. Consider telling friends and colleagues what you are doing and ask them to pass on any relevant material. Remember to tell them to indicate the source and date of all references. Initially, the collection will consist of unrelated data, but in time, associations can be made. These will usually arise when, on receipt of a new reference, you discover it relates in some way to something already collected. This association may be the beginning of a file or system of presentation. The length of time spent on this project is entirely up to you; six months is a recommended minimum, given the other demands on time.

The benefits of this work include an enhancement of research capabilities, increased self-confidence and greater awareness of the value of research. It should also make you more familiar with the broad range of resources in which answers lie. These can be found in everyday events and places often so obvious they are overlooked. Locating more obscure sources of information can also be interesting and, at times, an adventure. Remember to keep a comprehensive list of all the contacts you make and places you discover. These written notes could include: address, telephone number, opening times, contact name(s), admission charge and details of other subjects that may be available at the same location.

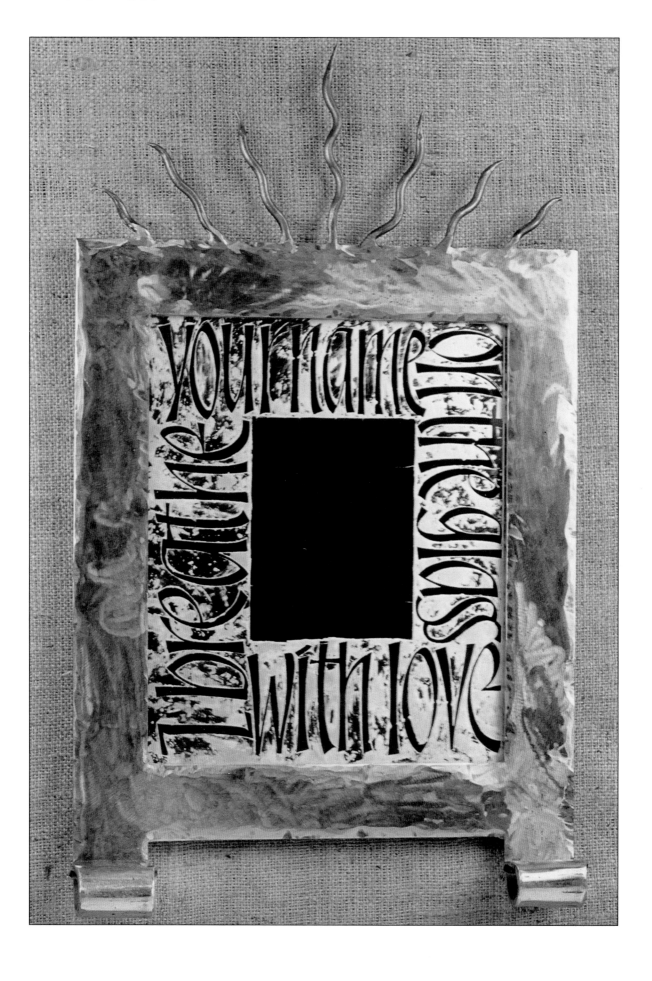

# Nurturing Visual Awareness
## *Open Your Eyes*

The intention of this section of the book is to encourage you to open your eyes: to see and enjoy, to appreciate fully the richness of available sources and develop a working language for dealing with them. The first reaction to a work of nature or of art, can be one of pure pleasure. We should never lose the ability to revel in this first shiver of pure joy of looking at something beautiful.

The converse is true too, when we are discomforted by an item whose lack of symmetry, cohesion, colour or general interest repels our inner sensibilities. Both these reactions are perfectly valid and worthy of being noted. They may be regarded as intuitive reactions, which can make a contribution to (any) further analysis, or be confirmed in a future summary.

After the first look, the process of seeing proceeds. This is the real visual perception, an analysis conducted by the eyes, which can be more enjoyable if we have a language to apply to what we are experiencing. It does not have to be exercised on every occasion, sometimes just letting go and giving ourselves over to the beauty is the best creative move to make. At other times, we can be frustrated by our lack of a working vocabulary to explain or recall sufficiently what we saw or experienced.

There is a basic lexicon we can use when exploring visual material containing letters and words, indeed all written material. The language of typography and graphic design is most applicable, because examples of these two disciplines are more easily accessible than, for example, thirteenth-century manuscripts.

In conjunction with learning to see, adopt a method of recording the material visually for future reference. There are different methods but a good one is the use of an ideas book, a combination of sketch and notebook (see page 84).

Becoming truly adept at seeing requires continual vigilance until it becomes a way of life. Wherever you are, whether travelling, walking, reading or listening, be keenly aware of everything that is going on around you and scrutinize every scrap of printed paper. Even walking down a local street of shops and looking up above street level can reveal another world of visual stimuli.

A fundamental support of good calligraphy practice is building your own reference library and collection of ephemera (see page 79). Include items which excite or dismay you personally, as it is important and helpful to provide contrast, especially when developing your own working language. At this stage, all choices are subjective. Later, your work may be developed and executed to the specifications of another person, or under the constraints of commercial viability or other considerations. The ability to differentiate between a work's relative success or failure is gained on a long and continuous journey, but it is never too early nor too late to begin.

DAVID PILKINGTON
By close observation - watching, looking, seeing - sources of inspiration and ideas can be identified all around, but individual receptivity plays an important role. This eclectic work evolved from the simple act of writing with a finger on a steamed-up mirror. The dimensions of the work include the specially crafted, wrought-metal frame by Tom Lockington.
457 x 330mm/18 x 13in

# Anatomy of letters

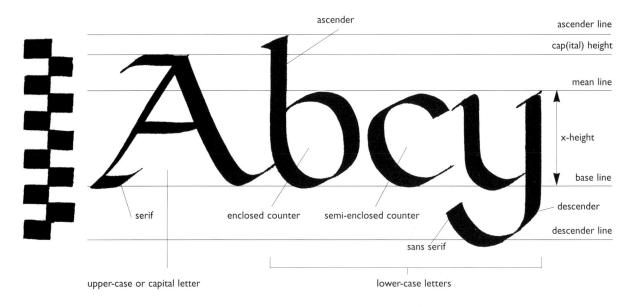

ascender — ascender line
cap(ital) height
mean line
x-height
base line
descender
descender line
serif | enclosed counter | semi-enclosed counter
sans serif
upper-case or capital letter | lower-case letters

| Calligraphic/ *Typographic* description | Definition |
|---|---|
| majuscule<br>capital<br>initial<br>*upper-case* | The typographical name for capitals, upper-case comes from the case which holds (the) metal type. The lesser used capital letters, small caps, figures, reference marks and accents reside in the upper case of the traditional wooden type trays placed next to the typesetter or compositor.<br>Abbreviation: u.c., cap., caps. |
| *small caps*<br>*capitals (small)* | These letters are either two-thirds the size of large capitals or approximately the x-height of the lower-case letters. Often used for the first word or line of a passage after an initial large capital letter.<br>Abbreviation: sc., s.cap., s.caps |
| minuscule<br>small letter<br>*lower-case* | Small letters, as distinct from upper-case, capitals and small caps. The name lower-case comes from metal typesetting, where the small letters were kept in the most easily accessible lower compartment.<br>Abbreviation: l.c.,lc |
| stem<br>main stroke<br>spine | The vertical strokes and full length oblique strokes. |
| counter<br>counter shape<br>counter space<br>enclosed counter | The space enclosed by the strokes of a letter (inside shapes of letters). |

| | Calligraphic/<br>*Typographic* description | Definition |
|---|---|---|
| C c | open counter<br>semi-enclosed counter | The space semi-enclosed by the strokes of a letter. |
| D | bowl | The curving stroke enclosing a counter; the oval and circular forms complete as in 'O', 'o', and modified as in 'B', 'D', 'a', 'b', 'd'. |
| g | loop | Special rounded form, not circular or formal oval, as in 'g'. |
| d | ascender | The stroke of a minuscule letter which projects above the mean line.<br>'b', 'd', 'h', 'k', 'l', and some styles of 'f' |
| q | descender | The stroke of a minuscule letter which descends below the base line.<br>'g', 'j', 'p', 'q', 'y', and some styles of 'f' |
| H | cross-bar<br>bar<br>cross stroke | A horizontal stroke which either joins two others or crosses a main stroke or stem.<br>some styles of 'e', 'f' and 't'; 'A', 'H', 'J', 'T' |
| E | arm | A projecting horizontal or short, upward sloping stroke from a main stroke or stem of a letter.<br>some styles of 'e', 'f'; 'E', 'F', 'K', 'L' |
| n | arch | The arch of a letter is formed as a stroke goes up and round to the right, before proceeding downwards slightly, or to make a complete stroke. Many minuscule letters have an arch, including 'h', 'm', 'n' and some styles of 'r'. |
| r | ear | An ear is a small stroke attached to a superior stroke, such as that from the bowl of some styles of 'g'; and from the stem of 'r'. |
| T | hairline | A fine line in a letter and a fine line extension to a stroke; also a fine line serif. A hairline extension can be added to ascenders and to some cross-strokes and arms. They create a pleasing finishing touch to these strokes and enhance the overall appearance of the writing. |

| **Calligraphic/<br>*Typographic* description** | **Definition** |
|---|---|
|  ligature | The stroke connecting two or more letters. In typography, it is also the name given to two or three letters joined together when they are cast as one unit of type. |
|  ascender height<br>ascender line | The height of the ascender is measured extending from the mean line; it is usually more than the cap line. The ascender line is the imaginary visual horizontal alignment of the tops of ascenders. |
|  cap line<br>cap height | The height of capital letters is measured from the base line and projects above the mean line. The top may be just below the ascender height or in some styles the same. The cap line is the visual alignment of the tops of capital letters. |
|  mean line | The mean line is the mean height of lower-case letters not including ascenders or descenders; it also refers to the visual horizontal alignment of the tops of these letters. Some letters- particularly ones with curved tops - must project slightly above this imaginary line to appear in the correct proportion with the remaining letters. If they do not, they will appear slightly smaller than the rest. |
|  x-height | This is the measure of a letter from base line to mean line. |
|  base line | The line on which the upper-case letters and lower-case letters with no descenders, rest and align; the line from which the height measurement of these letters is calculated. It is from this line that measuring line intervals is determined - called the base line-to-base line method. |
|  descender line | The visual line which horizontally aligns the bottom of the descenders. |
| interlinear space<br>*leading* | The space which separates lines of words, or text and image. The name derives from the thin strips of lead used when setting metal type. The strips are smaller than the type they are separating. |

sans serif

hairline serif, unbracketed

## SERIF, SANS SERIF
Serifs are the small extension strokes at the end of stems, arms and tails of letters. Not all styles have serifs, those without are known as sans serif.

hairline serif, bracketed

slab serif, usually same thickness as stem

wedge serif

bracketed slab

cross-stroke serif

diamond serif

clubbed serif

swelled stroke

beaked serif

barbed beak

barbed beak

sheared terminal

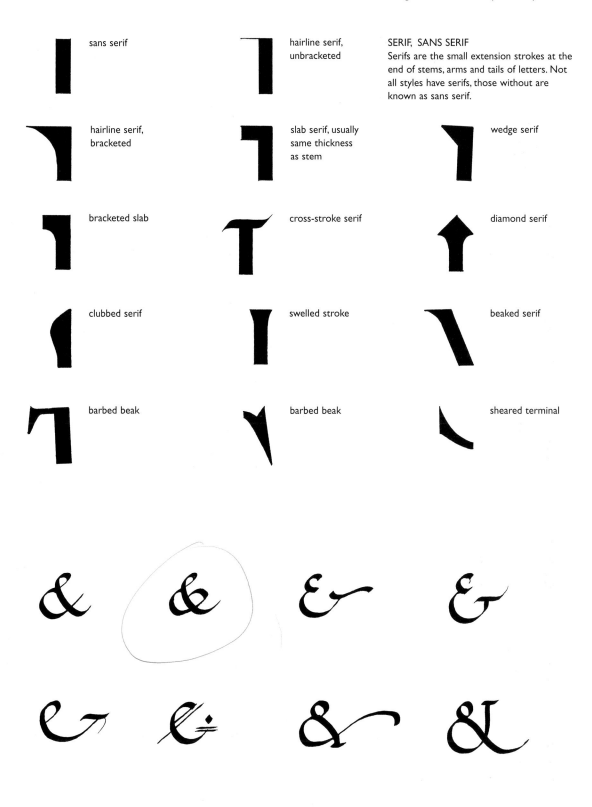

## AMPERSAND
Derived from a combination of 'E' and 'T', the Latin word for 'and', this symbol is extremely useful in calligraphy. It is reasonably flexible and adaptable, therefore it can be designed to complement individual style and presentation.

I  SPREAD
Two facing pages of a publication. Care must be taken to allow for binding and gutter when designing a spread, to prevent any text/image being lost down the centre. Double-page spread is two facing pages containing matter which is continuous across both pages; often the centre pages of a publication.

2  RUNNING HEAD, RUNNING FOOT
The title of the book or publication may be repeated on every left-hand page (verso). Chapter headings or the name of an article may be repeated on the right-hand page (recto). The position may be at the top or the bottom of the page, hence the names.

3  FOLIO
The folio is the page number; it is also the whole page. The numbers may be at the top or bottom, and some book design places them in the foredge margin. The preliminary matter at the beginning of a book is numbered in roman numerals. It is usual for Chapter 1 to start on page 1, which should be on the right-hand page.

4  VERSO
The verso is the left-hand page of an open book. It is usual for these pages to be numbered evenly.

5  RECTO
The recto is the right-hand page of an open book. It is usual for these pages to have the odd numbers.

6  SPINE, BACK
The part of a book or publication which clasps the pages together. The binding may be sewn, stapled, glued or fixed by any other method or device which gathers the pages at one edge.

7  SPINE MARGIN, INNER MARGIN, GUTTER, BACK MARGIN
The spine margin is the inner margin on a page of a bound book or publication. The gutter or back margin usually refers to the space down the centre of a double-page spread.

8  FOREDGE
The front edge opposite the binding or spine. Books used to be placed on the shelves with this edge facing outwards. The title was painted, scorched or inked on this edge.

9  FOREDGE MARGIN
The margin that runs down the foredge.

10  FOOT, TAIL
The edge at the bottom of a book, publication or page.

11  FOOT, TAIL OR BOTTOM MARGIN
The space which runs along the bottom edge between the bottom of the text and image area and the edge of the page.

12  HEAD
The edge at the top of a book, publication or page.

13  HEAD MARGIN
The space between the top of the page and the text and image area.

14  HEADBAND
A narrow, decorative band, fastened inside the head and tail of the spine. On old manuscripts they served a distinct purpose as a constructional item, protecting the binding. They were sewn in, using coloured threads worked around a core. On many contemporary bindings the headbands have become a mere decorative addition; ready-made headbands are sold by the metre, and strips cut to size are glued into position.

# Developing a Working Language for Seeing

Inhibitions may make us hesitant to comment on creative works. We may feel our remarks could imply a lack of knowledge on the subject, or our early social education might have instilled a belief that because something exists, therefore it must be good, or at least passable. If we feel less than enthusiastic about a visual presentation, announcing this may expose us to ridicule. A combination of these factors can make giving our personal views on visual matters an uncomfortable experience. Gaining the self-confidence to remedy this situation is partially a matter of discovering a language with which to communicate our feelings and viewpoint, which are valid regardless of their nature.

When looking at work in the public domain, we need to be aware that we do not know the full story behind such works. The commissioner, or client, and economics often dictate the requirements and suppress the designer/artist's innate sensibilities. Hence, establishing what is right and what is wrong, what works and what does not, in the visual arena, can only be subjective.

However, individual reactions are important and their existence is a product of personal experience. In the same way, even professional critics are bound by their own experience, including preferences and prejudices, but their language of comment is frequently enriched by a knowledge of the field in which they are writing. What matters is personal interpretation and what you do with it. If you establish and maintain a constant awareness of your surroundings, along with a flexibility of attitude, as you become more adept at seeing, opinions can be changed, reviewed or updated. There is nothing wrong with that and it is healthier than maintaining an entrenched position.

Therefore, the spontaneous personal reaction must be respected, it provides a starting point from which to move on, and on which to build. This intuitive, or gut reaction is frequently confirmed as accurate after the visual material has been examined. You may have already been making close observations of words and images and, to do this, developed and applied your own method and language. Do not abandon this, but continue to work and observe as you have been doing. It is more than likely that you have been drawing on personal experience to make connections, associations and analogies. This is a good method to use. Omit nothing when attempting to make sense of something, even including very personal predilections.

Learning to look and see is also about personal development. The comments of another observer can be learned from, but do not allow these to muddle your own convictions if they are strongly held. However, there must always be time to listen to a variety of opinions and effect change in our own attitude, but only if we wholly understand and believe the new interpretation. Never be afraid of voicing your own opinions or using your own specialised knowledge - sharing your way of seeing may help another person.

A wealth of manuscripts and other calligraphy works is housed in museums, national, university and private libraries throughout the world. Unfortunately, access to these magnificent collections is sometimes limited, because of the inaccessibility of the institutions, or the fragile nature of the collections themselves. Many of these can only be viewed by arrangement and some are inaccessible to all except a handful of researchers. Make visits whenever possible, particularly to those institutions which have an exhibiting area. Only a very small amount of the material which is suitable for exhibition will be on view at any one time and, therefore, displays may change frequently. Fortunately however, important exhibitions will be thoroughly researched and material carefully selected before being displayed, normally for a number of months.

The curator, or keeper of manuscripts will choose pieces which address a specific theme, for example, 'The Decorated Letter'. In-house experts or invited scholars will contribute to a catalogue explaining the great works on exhibition. These catalogues make a valuable addition to your own reference library. They often contain full-colour reproductions of works on display and provide a record of those pieces you have seen, which may not be exhibited again during your lifetime.

Confronting a splendid manuscript in a museum is completely overwhelming, just as it should be. After we have marvelled at the sheer beauty before us we can reflect on the less obvious nature of its production. All the materials used had to be meticulously prepared, mostly by laborious and convoluted processes. Fascinating recipes for and references to these ancient processes can be found in specialist texts, and make an illuminating read in themselves. Though the texts were produced without electricity, modern materials and equipment, and were painstakingly transcribed (we can relate to that), we are astonished by the brilliance of the colours, as dynamic as if they were applied yesterday, still gleaming, after how many centuries? Eight, ten, fifteen...

When attending an exhibition or visiting a

FIFTEENTH CENTURY
A detached, vellum folio from an antiphonary, this single page provides a richness of elements to study. The enlarged, decorated initial 'S' dominates the page and catches the eye. In the block of text, three red paragraph marks have been inserted to indicate new passages. There is extensive use of abbreviation marks above the words, which, used in conjunction with the single, bold vertical red line, provides quite a measure of emphasis on the content. The same bold, red stroke is repeated on certain letters in the song text.
CBL.WMS 195.81

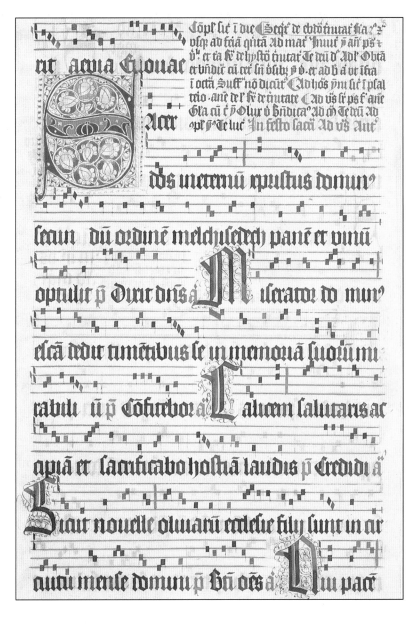

collection, take a note book and pencil to make copies of interesting letters and arrangements. If you are fortunate enough to be viewing a collection by arrangement, only take pencils into the viewing room, as ink pens are usually banned. A soft lead will make the copying easier, and double-point, that is two pencils strapped together, will prove most useful for rendering larger letters. Next to the renderings write the name and date of the manuscript source and any other details known about it.

Apart from museums, libraries and galleries, there is a plethora of other material available, the products of (mainly) typography and graphic design which provide readily accessible visual sources. Any printed ephemera and more lasting examples of print are suitable for investigation and analysis.

Begin by scanning the whole format, the arrangement and style of writing or type, size, colour and treatment. Recognise and identify the letter or type style and its particular characteristics. One advantage of examining old manuscripts is that, because we cannot easily comprehend many of the texts, our pleasure is not usually distracted by their meaning. However, most manuscripts contain some recognisable letter forms, which we can study closely to see their construction. Some pages are totally dominated by an enlarged and extraordinarily decorated initial letter, whose ornament extends well beyond its original confines. It may be beneficial to follow the progress of the decoration through the work before concentrating on the text and its style.

The approach to the study of more

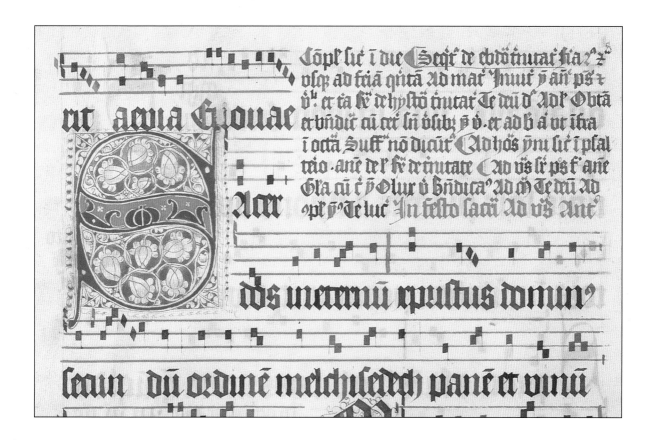

Details of CBL.WMS 195.81
The four line stave and square notation of plainsong in these enormous choir books was usually styled after fourteenth-century models.
These details show more clearly the fine line decoration embracing the enlarged Gothic capitals. It is common to find profiles, faces and
caricatures in this position in many of the volumes.

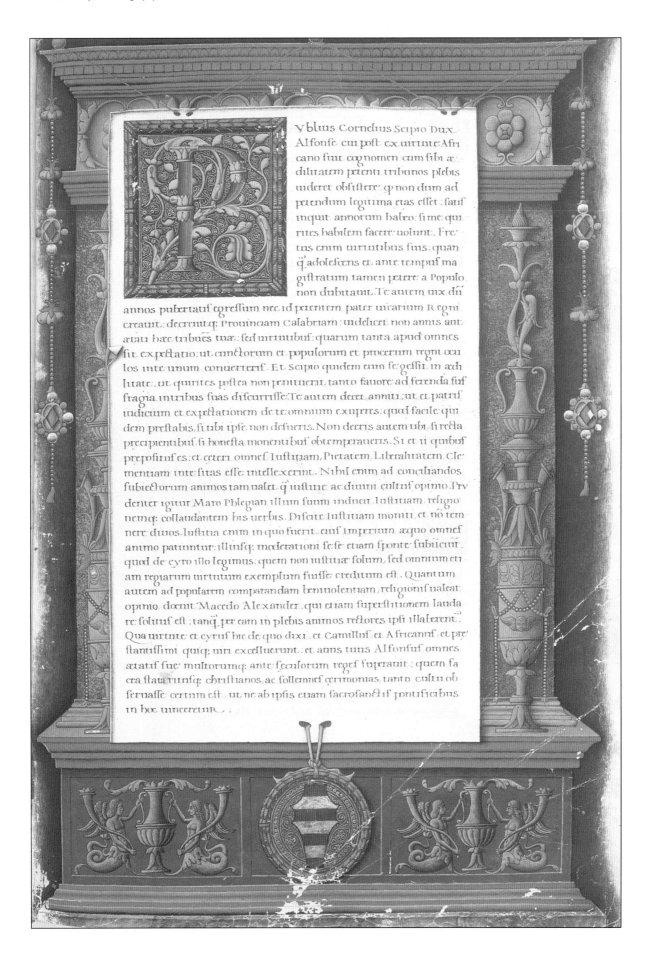

IOANNIS IOVIANI PONTANI
OPERA (PLURAL OF OPUS)
FIFTEENTH CENTURY
This splendid volume written in Italian humanist minuscule on vellum, measures 419 x 279mm (16.5 x 11in). The coat of arms of Alfonso Duke of Calabria is set in the centre at the foot of the page opposite.

The architectural frame, here decorated with classical motives, was a form extensively used in earlier centuries, particularly for Canon tables, Books of Hours and calendar sections of illuminated manuscripts. It was common to attempt to create an impression of the third dimension on the two dimensional substrate, a *trompe l'oeil*.

Every effort has been made to justify the expertly laid out text. Each page has been measured and ruled and the text is written between the lines. On f32r (this page) an elegant decoration in the margin stretches above the first line of text and below the last line, providing a visual anchor. At the very ends of this margin ornament, there are peacock-feather decorations composed of a solid dot in a circle with fine lines of varying length radiating out, a good example of the very delicate ornamentation throughout this volume.
CBL.WMS 108
f2r (folio 2 recto) and f32r
306 folios (pages) 40 lines per page

contemporary calligraphy can follow similar lines. Begin by simply looking at the piece as a whole and attempting to identify its intention. Work through the piece step by step, identifying all the methods the calligrapher has used.

The same process can be applied to printed material. View the overall work and discover why it has been produced. You may not be able to identify by name the specific typefaces used, but their particular peculiarities will be obvious on closer examination. For example, this will reveal whether the typeface is serif (and which shape) or sans serif;

whether the letter shape is based on a round or an elliptical 'o'; and whether the letter, like a calligraphy letter, is constructed of thin and thick strokes. Include the smallest details, including the cross-bar angle of the lower-case 'e', the arch of the lower-case 'r', the style of the lower-case 'a', and similar nuances.

Move on to observe the letter and word spacing respectively. Look at the interlinear spacing and the relationship of the text with the surrounding space, including the image area, if there is one. Examine the different facets of the layout, including the text

arrangement, placement of heading, use of enlarged or decorated capital letters, the margins, use of borders and their corners and any other decorative devices.

The artwork for a substantial amount of printed material is now done on computer with an electronic pre-press (desk top publishing) package. Unless the operator is careful, the resulting letter spacing can be quite unnecessarily appalling in some works. Examples of these can be seen daily in newspaper appointments pages and on leaflets handed out in the street or left in the mailbox.

Many of these computer-set examples also use elements recognised in calligraphy. The enlarged capital letter is one, which is frequently poorly juxtaposed with the remaining letters of the word it begins. This is unfortunate because the technology used in the production, if applied correctly, can produce a finished result with a visual quality that reflects the flexibility of work completed by hand. By carefully kerning (a backspacing technique) on the computer, the letters can be correctly spaced or made to overlap one another. The latter is an arrangement denied the users of metal type, who have to make a second printing to get the same effect.

It is, of course, not enough just to name the components of a piece of calligraphy or printed material, but at the beginning this can serve as a focus. It provides the basis of the specialised vocabulary required to talk about the work and can be used in conjunction with your own feelings about the material. It will expand your vocabulary and enable you to feel more self-confident about the comments you make. Fluency will come with practice.

Whether you like or dislike a design, find it successful or not, is your personal opinion. The types of work you like and those you do not may start to fall into recognisable groups. This recognition may identify the kind of visual material which can influence or inspire your own work. Be aware too, that, because we are continuing to study different works, our interest may change, and what you found exciting one year may not stimulate you the next.

Initially, you may not know what you dislike about a particular arrangement of words, or elements of a work. This does not matter, just respond to it, identify how it has been achieved and think about it. Later you may see it again, and realise it has been produced in the colour of an item of clothing you detested as a child - that is a valid personal reaction. Explore each work using the technically correct terms where possible, then add your own aesthetic judgement. The main point is that you are looking, and with this continual observation you will be able to apply a working vocabulary to what you are seeing and your self-confidence will grow.

Conduct your work in a methodical manner, planning a strategy or devising a check list of items

# TYPOGRAPHY
standard kerning

# TYPOGRAPHY
selective kerning

# CALLIGRAPHY
standard kerning

# CALLIGRAPHY
selective kerning

An example of standard kerning which clearly illustrates the irregular letter spacing produced by some electronic pre-press packages. This is what happens if you leave the computer to perform the task automatically. Spacing corrections can be made by kerning on the computer, by small degrees, but the best results are obtained by selective kerning, where the operator arranges each space, letter by letter.

to be investigated. This could be composed in a generic form so it is suitable for a variety of works. The main headings of areas for study which could form the basis of your 'seeing list' include: format, shape, size, margins, general layout, calligraphy style or type, general features of the upper and lower-case letters, heading(s), style or type of headings, text arrangement, capital letters and text, text and image, decorative details and materials. After repeated applications the list will become more familiar. You will progress through your analysis of a work calmly, confidently and secure in the knowledge that you know what you are doing.

## Looking at Space

One of the best ways to assess the use of space is to spend time looking at the patterns made by the unoccupied space. This area has a shape of its own which complements the text and image area. The empty space can be regarded as negative space, the text and image areas as positive space.

The famous and oft-quoted Chinese Taoist philosopher, Lao Tsu, drew our attention to the fact that what is not there is what renders a thing of use. In the visual field this is absolutely true. Take one of the smallest elements of a work, a single letter. Consider what use it would be without its inherent counter space. If there was no shape, either closed or open, would there be a letter? What would the letter 'o' be without its enclosed counter space? Or the letter 'w'? Elimination of the counter spaces would reduce the alphabet to only a few recognisable shapes.

This information highlights the essential role played by the counter shapes. Until now, you may have thought of letters as consisting solely of the strokes with which they are constructed. However, the strokes depend on the shape of the spaces they enclose or semi-enclose.

Careful consideration must be paid to these shapes. Lack of attention can produce misproportioned or misshapen letters. We know immediately when the pen wobbles on an ascender or descender that the stroke is wrong. Similarly, we should be aware of any misspacing. For instance, the two vertical strokes of a lower-case 'n' may be too close together, thus creating a counter shape and letter that is compressed or condensed. Watch and observe the shape of the counter space as it is being formed.

Understanding the basic shape of any style is necessary before beginning to transcribe it. A lower-case italic hand, for example, is based on an elliptical 'o' and the main body of all the letters will fit exactly on this shape, except the ascenders and descenders and the letters 'm' and 'w' (see diagram below).

It is important to investigate the quality and quantity of counter shapes and letter spaces. Here are some suggested ways of doing this.

When writing letters pay particular attention to the space(s) the strokes enclose. Are the strokes of the first 'n' too close together? Or is the counter the 'wrong' shape? Compare this with the second 'n'.

This is a 'skeletal' version of an excellent exercise which clearly illustrates letter shapes and the space they occupy in relation to each other. Do the exercise twice; first with an italic (elliptical) 'o', and then a round 'o'.

ELLA POS
If the counter shapes of letters are removed, almost all letters would cease to exist in recognizable forms. This entire work is composed of the counter shapes of letters - inner forms which have separate identities and structures of their own. Some of the shapes are more instantly recognizable than others, but the patterned piece has a most effective form of its own.

## Exercise 1

Find a copy of the entire alphabet, both upper and lower-case letters, preferably set in type with a san serif face. Choose a letter size of at least 72 point (19.3mm). If you cannot locate anything that is approximately 20mm in height, enlarge it on a photocopier. Take a sheet of tracing paper and place it over the letters. Using an HB pencil, or an automatic pencil with a 0.5mm lead, carefully trace the counter shapes of the letters, then fill them in. Take care with your rendering and do not miss any relevant areas, such as the tiny spaces above the arches of the lower-case 'm', 'n', 'p' and 'r'. Study the resulting shapes, keep the sheet as a reference and admire the final arrangement of shapes as an interesting pattern in itself.

## Exercise 2

Assemble some newspaper and magazine headlines, again set in a large size. Place a sheet of tracing paper over a line of type and repeat the first exercise, but this time extend the tracing to embrace the spaces between the letters. Observe how the open counter shapes merge with the spaces and create their own shapes. Try this with lines of upper and lower-case letters, and upper-case only.

## Exercise 3

Repeat the exercise using two colours, one for the counter shapes and the other for the spaces between the letters. See if there is a visual balance between the space within and the space without the letters.

In your own work, do not be afraid of space. Its existence is important for legibility. Resist any temptation to fill all the available space, unless it is to create an effect in a particular piece of work.

The blank sheet which greets each new idea can be seen as an integral part of the proposed work - it is one of the components. It could be considered as a 'moveable' element, like the text, heading and image you are going to arrange on it. Or are you arranging *with* it? To work *on* the paper is to regard it as a utility. To work *with* it is to see it as a component. If you can perceive it as a component to be exploited, rather than just as a surface on which marks are placed, you can use it in a more creative and constructive way. Apart from the outside perimeters of your format, think of the substrate as being equally as flexible as the information to be arranged on it. To achieve unity, consider the entire work as an organisation of component parts, including the space. You may have a heading, some text and an illustration to position on a layout. If you were to simply drop these items at random on the page the result could be chaos. To reach

equilibrium, organise the words and image into a coherent structure with the surrounding space.

Look for these factors in other works. See if you can determine why certain arrangements exist and if it is possible to discern the reason for the choice of a particular layout.

## Exploring Spatial Relationships

The visual nature of something which is partly obscured can be very powerful. Looking across any road, passing vehicles will permit you to see a fragment of lettering on a billboard, perhaps for only a few seconds, revealing an unexpected and interesting configuration. These are often splendid contradictions with which you can create a mental montage. They also show the value of being able to 'zero in' visually, that is, to cut out the peripheral vision. It can take quite an effort, but it is a skill well worth obtaining. An exciting range of interesting relationships between shapes, colours and textures can be discovered with this practice. Encourage your perceptive eye to look at the juxtaposition of objects. Stop looking solely at objects only as a whole and try to concentrate on a section of one and its relationship to another.

### Further Exercises

To assist with this, try some simple exercises which block out areas. Make a mask by cutting two L-shaped pieces of board, which can then be moved over a piece of work in order to discover a diverse series of spacial relationships. (This is the same concept as the L-shapes made from mounting board

and frame samples used to help customers in framing shops choose their mount colour and type of frame. It also serves to determine the depth of the mount and how much margin to leave around the image area. You can use this method with your own finished work.)

There are other visual exercises which can further assist your spatial awareness and can give you a better idea of how to place elements on a page. It is not just a matter of random selection, or of aligning everything, although these are two spatial organisations which impart their own visual sensations. Basic design is composed of four elements: dot (point), line, shape and colour. These are the tools for the following visual exercise.

Using a B pencil, rule lots of squares, 40mm in size. (You may find it expedient to create a single page of squares to serve as a master from which you can make photocopies. If so, use a black-ink, fine line technical pen, no smaller than 0.3mm point size, to rule the squares.) Using a B pencil, begin by placing a single dot in the centre of the first square, which represents a picture plane. This single dot in the centre of the picture plane could be said to be in a 'commanding' position, whereas a dot placed off-centre would create another sensation. Below the square write what you feel about the sensation created. Each particular relationship generates a particular sensation. Is it confrontational, isolated, dynamic or negative? Does it convey movement, or is it static? Move on to the next square and place a single dot in a different position. Continue working in this manner, placing a single dot in each of the squares and recording your sensation beneath it. Aim to complete at least twelve squares per exercise.

Starting with a new sheet of squares, introduce a second dot into the square and repeat the process as many times as you like. Try the exercise with a third and a fourth dot. The same can be done with a single line, then two lines and many lines. For the first

Two L-shaped masks can be used to great effect to explore spatial sensations, and help determine the depth of a mount and frame for a work. A mere millimetre added or subtracted can increase the visual impact of a work.

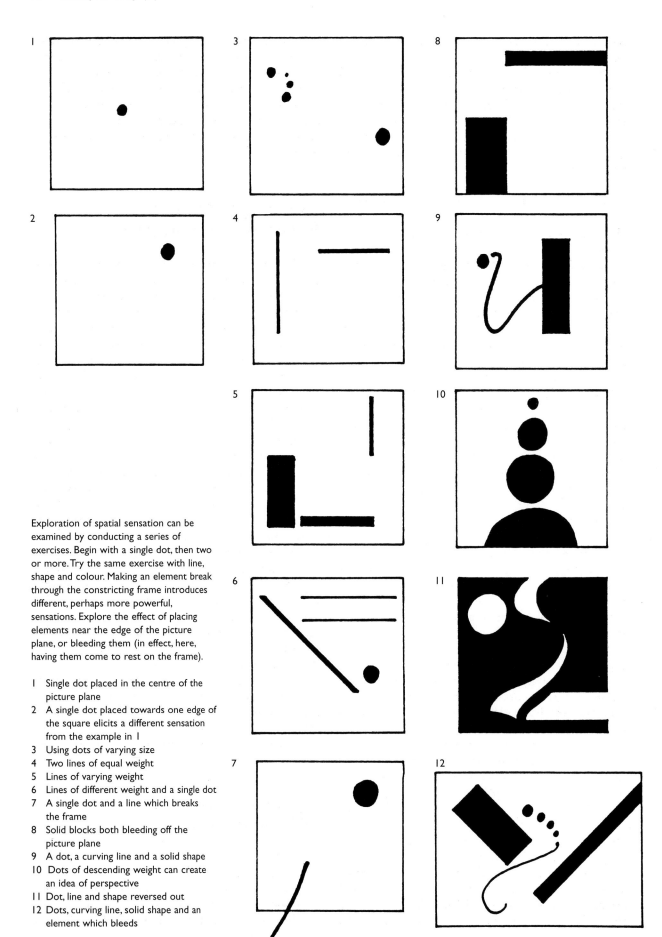

Exploration of spatial sensation can be examined by conducting a series of exercises. Begin with a single dot, then two or more. Try the same exercise with line, shape and colour. Making an element break through the constricting frame introduces different, perhaps more powerful, sensations. Explore the effect of placing elements near the edge of the picture plane, or bleeding them (in effect, here, having them come to rest on the frame).

1  Single dot placed in the centre of the picture plane
2  A single dot placed towards one edge of the square elicits a different sensation from the example in 1
3  Using dots of varying size
4  Two lines of equal weight
5  Lines of varying weight
6  Lines of different weight and a single dot
7  A single dot and a line which breaks the frame
8  Solid blocks both bleeding off the picture plane
9  A dot, a curving line and a solid shape
10  Dots of descending weight can create an idea of perspective
11  Dot, line and shape reversed out
12  Dots, curving line, solid shape and an element which bleeds

series of exercises, keep the dot and line elements the same size and density.

After you have conducted these initial explorations, the nature of the dot or line can be varied. Try different sizes, weights and lengths in the same plane. Try combinations of dots and lines and vary their tonal quality. Using differing tonal qualities will introduce a degree of depth and perspective within the picture plane.

Experiment further by allowing the elements to break through the edge of the square. Piercing a constricting frame or border in this way can be very powerful, creating tension and adding interest to a work.

Try bleeding some elements, so only a portion is retained in the picture plane. One way of doing this is to draw the whole element straddling the edge of the frame. To appreciate the final effect, you will need to mask that section outside the plane (frame) using two L-shaped masks. The second way is simply to draw the part of the work to bleed so it comes to rest on the edge of the frame.

Further exploration could include reversing out the image to create white marks on a black background, and including shapes, curved lines and colour. Try whole and fragments of one, two and many letters. The whole or any part of the exercise(s) can be repeated as often as you wish - you will find that your responses will develop and change. After you have experimented with squares, try other formats, such as a rectangle, circle and an irregular shape.

Working through these visual arrangements within the picture plane, you will recognise the different effects, and changing levels of impact, and you will see that the marks you are making could represent letters, words and images placed on similar planes.

Complement these discoveries by further experimentation with black paper shapes on a white base sheet. Cut a black shape the same proportions as, but smaller than the base sheet. Cover the white page with the black shape. Try this with both the portrait and landscape formats.

Experiment further by trimming the black shape so that it is still in proportion to the page, but smaller, so it reveals more white space. Also, try a bigger black shape which covers more of the white ground. When these explorations are completed, cut the shapes into smaller regular shapes and move them around the page. Use shapes which are in proportion to the base page.

This experiment should make you even more aware of the effects created by different spatial arrangements on a single picture plane, especially the value and strength of margins and the importance of good layout. This is an effective method for exploring various layout options for a work with several blocks of information of varying importance. Introduce colour to represent different 'information' areas on the page. Some arrangements are visually dynamic, others are only bland. Try experimenting with other shapes, colours and torn paper.

# Building a Personal Reference Collection

The building of a personal treasury of information is a valuable aid to improving visual awareness, and enlarging your sources of inspiration. You can start collecting material from a wide range of sources.

Travel and everyday pursuits expose a wealth of material. The collection's contents are only limited by your imagination, and could include anything from books to business cards, from packaging to rubbings of incised letters on monuments. The collection will need to be updated and reviewed periodically.

A valuable reference collection will contain a variety of visual material with good and bad examples. Choose items for their calligraphic solution or nuance; typographical arrangements; general layout features; use of colour, logotype or symbol; originality of concept; interesting paper engineering, or use of materials, including unusual papers; or a particularly interesting use of text and image. Look for works which range from exquisite to ridiculous, or which are amusing and quirky, interesting or utilitarian. Try to cover as broad a spectrum as your observation, imagination, travels, awareness and sensibilities will allow. Find samples of visual solutions which you find inspiring and put them somewhere to be enjoyed.

To help you begin your collection, the following examples may prove useful. The search should cover the breadth of printed ephemera with a dash of calligraphic trivia. The list has some specific and some general examples and could be especially helpful when travelling.

## Suggested sources for a reference collection

**Advertising** Look for use of typography and calligraphy; presentations which include original use of text and image, an exploitation of paper engineering, perhaps a three-dimensional element; look in markets and second-hand shops

for old newspapers and magazines and other old advertising ephemera which often used typography and hand-drawn lettering to good effect; compare what you find with the advertising in contemporary newspapers and magazines

**Books**  The books do not always need to be the latest editions. Visit second-hand bookshops and seek out the older editions of volumes about the craft of lettering.

**Bookmarks**  Bookmarks were once crafted by every school child; these same bookmarks can sometimes be found in second-hand shops and antique markets. Contemporary versions are readily located in bookshops, libraries, art galleries and museums. The surface design is frequently used for some form of advertising or promotion, but many illustrate a fragment of a fine painting, good typography or calligraphy.

**Brochures**  This category is limitless, providing examples ranging from typographic solutions to ingenious paper engineering. Market stalls, second-hand shops, antiques and printed ephemera fairs, are good sources of older examples.

**Business Cards**  An unusually rich vein of examples of good design; particularly noted are the cards of design partnerships and consultancies, lettering artists, architects, artist and craftworkers, calligraphers, typographers and illustrators. This is an important first, and sometimes only, level of promotional material. Cards from all over the world can build the foundation for a collection of stunning, ingenious typography, calligraphy and lettering design.

**Coasters**  Some hotels, bars, breweries, restaurants, cafés, produce their own designs.

**Envelopes**  Market stalls are a source of old envelopes addressed in interesting handwriting scripts; look inside envelopes to discover interesting patterns made of repeated marks - these are used to stop the matter inside being read from the outside.

**Invitations**  Copperplate-scripted, gilt-edged, letterpress-printed invitations can still be found in markets and second-hand shops. Many contemporary examples still follow the same 'traditional' layout, but some typographic designers and calligraphers are creating exciting, different designs.

**Labels**  Old baggage labels from trunks and luggage; fruit boxes; food containers; special presentation labels.

**Leaflets**  In addition to brochures, leaflets and flyers have provided scope for ingenious designs.

Often printed on one side of an inexpensive but bright substrate, these information bulletins can be quite interesting collection items. Accessible and inexpensive production provides even quite small and specialist groups with a medium to broadcast their interests or events.

**Letterheads**  Business and personal stationery.

**Maps**  Some areas, towns, villages of particular historic interest produce their own maps, often designed and prepared by a local artist; look for facsimiles of old maps.

**Matchbook Covers**  Although the need for matches may be dwindling, match books and boxes are still used as promotional material. It is still possible to build up an extensive and fine collection exhibiting good typography and design solutions on a small surface area.

**Menus**  All manner of idiosyncratic design solutions occur on menus; these may reflect the culture, the cuisine, the architecture, the interior design, the geography or topography of the location, or specific interests and passions of the owners of the establishment.

**Napkins**  This is an under exploited surface (partly for cost reasons) but some delicious examples exist; many do not simply reproduce a logotype or symbol of the establishment; some may reflect and provide the only legitimate, removable source of a good design.

**Newspapers, Magazines & Journals**  Material printed in unknown foreign languages allows the content to be read as a series of patterns and shapes and provide access to new sources of interesting logotypes and symbols.

**Packaging**  There are many different sources; labels on containers, interesting configurations of paper engineering; individually packaged goods, for example, chocolates, fruit.

**Paper Bags**  Some retailers produce their own with good-quality graphics.

**Photographs**  Frequently photographs provide the only (or the only sensible) means of recording something inaccessible, temporary, too large or immobile (see page 85).

**Postcards**  Museums, galleries and libraries print details from the works they hold, especially manuscripts.

**Programmes**  Old programmes can be found among printed ephemera. They contain interesting typographical solutions which reflect style and design of their day. Sometimes the best evidence of this is in the advertising which was included to pay for the programme production. Smaller venues and amateur productions may include calligraphy in their programmes.

**Rubbings**  When travelling, take some light-

An elegantly scripted letter dating from 1869 is an example of the kind of ephemera to be found in markets, antiquarian booksellers and good second-hand retail outlets. Evidence of the extra pressure required to slightly part the points of the nib to ensure a minimal flooding of ink, and hence thickening of the down strokes, is clearly discernible. In our technologically dominated society, with ease of access to creating printed material, there are fewer examples of beautifully written letters. As a result, even a roughly drafted calligraphic form elicits responses of interest and delight. Thus, a calligrapher's public relations are greatly aided by beautifully written personal correspondence - letters, cheques, invoices, etc.

weight paper and a few thick, wax crayons. These can be used to take rubbings of interesting incised letters and textures.

**Sugar**  Individual servings of sugar are often packaged in wrapping printed with the host restaurant or café logotype or symbol.

**Tickets**  Buses, metro, subway, underground, rapid transport, airline, trams.

**Type**  Wooden blocks, metal type, stencils, plastic and brass letters and numerals; all these can be found at markets, second-hand outlets and auctions. Purchases can be made on the grounds

Indentures and mortgages, such as this example, can be found in specialist stores and collectors' fairs dealing with printed ephemera. Painstakingly copied by hand, by clerks and apprentices, on large sheets of parchment, they are not always great works of calligraphy style; they were (and are) working documents. When viewed with this in mind, some contemporary ephemera pale by comparison.

Many old documents are resplendently adorned with seals (of wax) and the corded ribbon which held them in place (see bottom right). This deed, dated 1892 and 1899, provides a generous example of a working script. The document was produced during a time when fine handwriting, lettering skills and good draughtsmanship were taught, revered, and valued by employers.

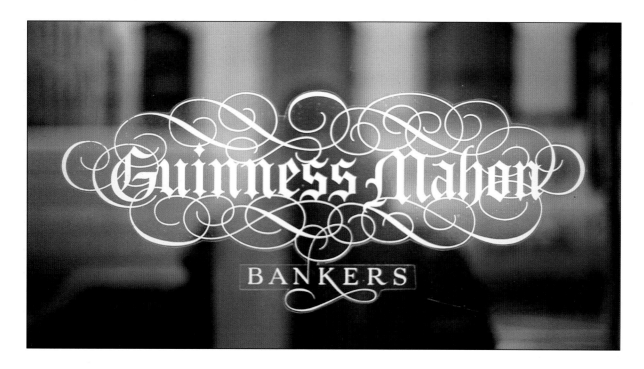

The life of a calligrapher is filled with unexpected pleasures and delights, some self-generated or initiated, some shared or introduced. Continuing practice to nurture visual awareness almost guarantees enrichment, as little discoveries and excitements are made even in places of great familiarity. Walking down any business district street may not reveal effusive flourishing such as this on every glass entrance door - but that is what makes this practice even more special.

This corporate identity was commissioned by a Dublin office for its stationery and publications. The image is usually printed with lettering in black and the flourish and word 'bankers' in green. The central and main flourish is tonally darker than the layer below, which extends the furthest. Note the extension to the letter 'n' in 'Banker' which merges with the main flourish, forming the ground for the company name.

of pure aesthetics or by individual letter and specific style. Printing blocks and metal type are not used much except by small and specialist presses, therefore most of these items are no longer manufactured; for this reason they should be 'rescued'. They make a valuable addition to a collection, and can be used in many creative ways.

**Wrapping Paper** Wrapping paper may be collected for many reasons, such as a particular design for a specific company; a design favoured for its magnificent colour and overall pattern; papers on which the work and words of calligraphers have been printed; a reprint of a specific text, image or both; combinations of print and substrate.

Whether the collection is kept in shoe boxes or folders and files, its organisation is a personal choice and will largely depend on the amount and the type of material collected. It could be sorted into categories of visual work or format, that is, all the postcards together, all the business cards together, and so on. The collection requires care, management and updating but should prove inspirational.

The examples should be dated and their place of acquisition noted, along with any other information known about each piece. For example, if you discovered it at a local festival in a small village in the Alps, note the occasion, the location and time of year.

For several reasons you need to be circumspect in your collecting. Do not steal. Always ask if you may have a copy, or an item, and explain clearly why you want it. This approach is prudent and polite and often elicits much more information, an entertaining conversation and helpful suggestions.

The amount of material available means you must acquire a certain ruthlessness, particularly when travelling. You will have to determine if you really need a specific item in your collection. Do not collect for collecting's sake, but seriously examine each item, and consider its merits and value as a visual source. Some items which provoke excitement at first glance turn out to be disappointing on closer inspection. If you are undecided, you could ask yourself if you will regret not adding it to the collection. This often provides the answer. The alternative is to leave it behind, and then remember it with regret.

TIMOTHY R. BOTTS
The production of a word picture about Chicago might draw some conclusions that there may be little to distinguish it from other big cities, but that is to reckon without Grant Park. This is home to many of the city's most famous museums, some identified in this work, and the famous Blues and Jazz Fests. It is also where the spectacular Buckingham Fountain can be found, after which this work is titled. (The fountain has the capacity to throw 135ft-high jets of water, and in the evenings concealed lights turn these jets blue, yellow, green and pink to stunning effect.) Much of this experience and inspirational source has evolved into this picture, its words written with gouache. The image in gold leaf is inspired by a Picasso sculpture.
381 x 508mm/15 x 20in

## Creating Ideas Books

Ideas books are a fundamental part of any reference collection. Select a suitable notebook or sketchbook, with non-ruled pages and of a companionable size, no larger than A4, but preferably between A5 and A4, or A5. For some occasions, such as when travelling, an A6 size is ideal.

To note your observations, select from the following writing instruments: technical drawing or automatic pencil with a 0.5 or 0.7mm B lead (which has the advantages of not requiring sharpening, storing several leads in its body and usually having a built-in eraser), fibre or felt-tip calligraphy pen and, when appropriate, a fountain pen with a calligraphy nib, minimum size broad; two B or 2B pencils, either taped or joined together with elastic bands. All these are perfect travelling tools for copying interesting lettering arrangements or making notes. (Remember to remove the ink from fountain pens when travelling by air.) A carpenter's pencil is very good for sketching lettering, but it does require

sharpening with a knife and it is not advisable to carry one of these when travelling.

Every day, or as often as practically possible, try to record something, anything. It may not always be visual in origin, you may be fascinated by an overheard conversation, a chance remark, a news headline, a word or saying you have never heard before, or it could be the price of petrol or the cost of a train fare. Date every entry and, where appropriate, note its source and its place of origin.

Try to have your book with you at all times, or at least something on which you can jot down your observations. Do not worry about whether you have the 'right' book with you. The priority is to make the recording. Some of the greatest painters have produced a plethora of notebooks in their lifetime, regarded by some as almost superior to their paintings. These books contain a wonderful mixture of important sketches with everyday trivia such as a shopping list, and a line from a poem or even a note on the weather. Such notebooks can provide inspiration for years to come.

There are some sources of visual interest which fall into the category of 'cannot be taken home'. These include three-dimensional lettering, lettering which is carved, etched, incised, moulded, painted or in relief, and all lettering attached in some way to another surface, or an integral part of something else. All these can be copied into an ideas book and, if possible, photographs taken. If photography is permitted, but immediately out of the question, make a note of the location and return as soon as possible with a camera. Do not leave it too long - it is surprising how even the most solid and permanent looking examples can disappear overnight.

Append the date, the address of the site, and a few words describing what the purpose of the lettering is and how it has been achieved, as you perceive it. It may be a company name, a monument in honour of an event or person, a signpost to a place or site, or an advertising billboard. The lettering may be wholly constructed of neon lights, incised, painted (sign writing) or printed. If there are a lot of words, it is not necessary to painstakingly copy the entire work. Study it carefully and select the sections which you find of particular interest. You may identify the shape of the whole, a juxtaposition of letters, a single letter shape, or a decorative device.

## Further sources

Architectural decoration & detail
Billboards
Brass plaques
Building sites
Bus stops
Carved stone
Cast & Wrought iron
Door furniture
Enamel signs
Gable graffiti
Glass
Graveyards
Illuminated signs
Letter boxes
Manhole covers
Monuments
Posters
Road signs & markings
Shop entrances, doorways & fascias
Signage systems on public buildings
Sign writing
Transport, including packaging & containers

The shapes, tones, patterns and materials found in architecture, industry and nature all provide sources to investigate. Whether making a recording in the ideas books or just exercising your visual eye, try to become more aware of how you perceive what you are looking at. This is particularly relevant where an attempt is being made to record a three-dimensional object on the two-dimensional page, a difficult task. Talk yourself through what you are looking at, using a language based on shapes, lines and angles rather than naming the parts. Referring to the points of a compass or an analogue clock face helps description and notation, making it easier to transfer what you see to the page. You can practise this anywhere, even without a pencil in hand.

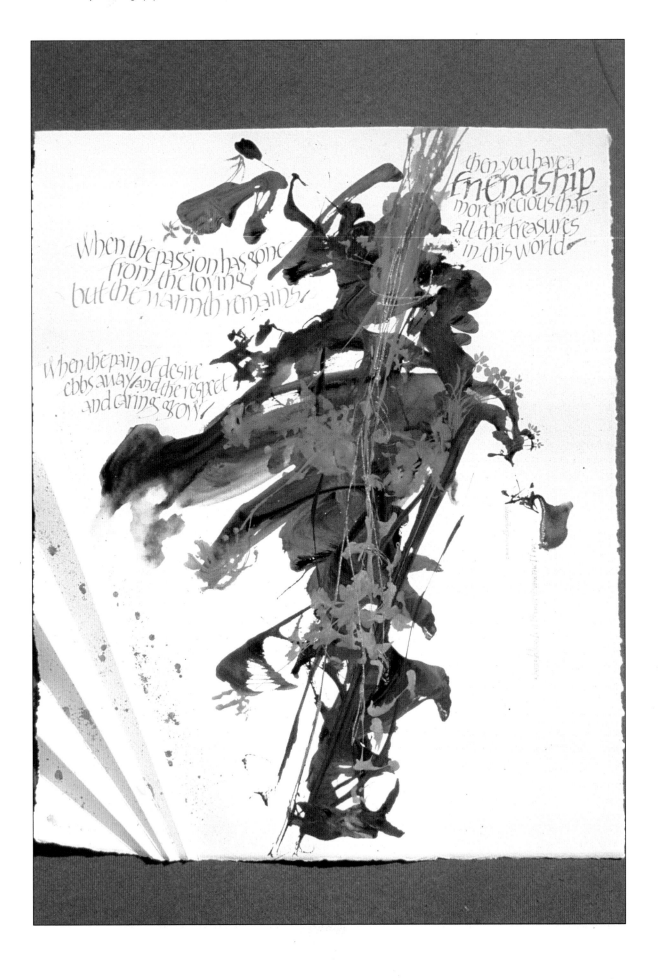

then you have a
friendship
more precious than
all the treasures
in this world

When the passion has gone
from the loving
but the warmth remains,

When the pain of desire
ebbs away, and the regret
and caring grow,

# Practical Considerations
## *Planning Production*

Before embarking on any piece of work, the final selection of materials, equipment and techniques must be made to suit the purpose of the work, the nature of its design, the budget, and the calligrapher's individual practical abilities. At this stage, remember that certain techniques require specific materials and equipment. Use check lists to ensure that nothing is forgotten and that materials and equipment can be acquired in good time. Organisation and management of time are fundamental in establishing good working practices.

If you are unable to identify the requirements of a piece easily and immediately, look at the finished rough and draw up a list of the techniques that will be used to produce the final work. This will make selection of the materials and equipment easier. Then use the finished rough to devise a comprehensive running order of the proposed production so that the project proceeds smoothly and enjoyably with no fear of missing something out or worry about what comes next. This list can also assist in calculating a time schedule.

While proceeding with the rendering of any work, but particularly a final piece, some inner voice may begin to nag: 'It's not right'. Never lose sight of the fact that you are not a machine able to produce identically finely tooled letters. It is easy when surrounded by so much ephemera produced by metal type, typesetting machines and computers to subconsciously compare our own work with their products. To help to quell this often inevitable inner struggle, make conscious efforts to prevent problems during the production stage. In particular, make sure that your chosen materials and equipment complement the words and images, the literary and visual nuances, of each work. Use the list of practical considerations overleaf in order to promote a more dynamic approach.

## Preparing to Work

For all calligraphic production, always work with some padding beneath the writing surface. It is extremely difficult to use steel nibs and other calligraphy equipment on paper which rests directly on a hard surface. Placing several layers of clean scrap paper underneath the working sheet will provide a slightly cushioned surface which makes writing easier and more pleasant.

Measure and cut the padding material to fit the whole drawing board or working surface, not just the writing area. It does not matter if the padding

DAVE WOOD
A simple question posed by a friend can elicit diverse discoveries about methods of working. On this occasion, a casual inquiry, asking if the calligrapher had ever written with cotton wool, produced this extraordinary result. The inquirer supplied the fact that in Chinese calligraphy, the pointed brush is regarded at the commencement of a work as being as stiff as a nail.

Cotton wool was wound around a chop stick, teased in and out, and worked to a fine, stiff point. In Chinese brush style, working commenced with black acrylic paint making the first marks. The flowers and decorative detail were added in gouache and variegated gold. The page was then inverted, and the text written by steel nib and gouache. The corner of the piece was carefully folded to emphasise the Chinese quality by suggestion of traditional fans. This also added a linear element to contrast with the painted form. The original inquirer, on viewing the work, turned it upside down and remarked that the form was very close to the Chinese character for 'love'.

## Practical Considerations : check list

| Substrate | Medium | Instruments | Equipment |
|---|---|---|---|
| *paper* | *ink* | nibs | plastic ruler |
| hand-made, machine-made | calligraphy, chinese stick, | (and reservoirs) | metal straight edge |
| parchment | drawing, fountain pen, | nib holders; | set square |
| layout | indian, technical drawing pen | round, square cut, | protractor |
| typo-paper | | pointed, poster, | compass |
| cover | *paint* | automatic, specialist | |
| tracing | acrylic, gouache, oil, poster, | | *cutting knives* |
| fine-line | watercolour | *pen* | scalpel, craft |
| cartridge | | fine-line | blades |
| line and wash | pastel | brush | |
| watercolour | graphite | fountain | blue pencil |
| special and decorative papers | colour pencil: aquarelle | quill | pencil eraser |
| | chalk | reed | block eraser |
| *board* | metallic ink and paint | technical | dry-cleaning pad |
| backing | charcoal | fibre-tip: pointed, | masking tape |
| feather-light | wax crayon | round | double-sided tape |
| corrugated | chinagraph | square-cut | |
| mounting | felt-tip/marker | | dividers |
| line-art board | | *brushes* | palette |
| | gold leaf | pointed, | correction fluid |
| *others* | varnish | square-cut, round, | opaque white paint |
| acetate | masking fluid | chinese, flat | T-square |
| fabric (silk, canvas) | gum arabic | | scissors |
| glass | | *pencils* | bone folder |
| stone | *adhesives* | double-point, | burnisher |
| acrylic sheet | rubber cement | carpenter's | ink stone |
| metal | spray mount | | sponges |
| resin | wax | found or made object | magnifying glass |
| vellum | | | paper towel |
| | | | wiping cloth |
| size | | | |
| weight | | | |
| colour | | | padding |
| surface: finish and texture | | | scrap paper |
| conservational qualities | | | |

falls short of the actual edges, as long as it is bigger than the work which will be done on it. Large sheets of newsprint can make up the basis of the padding, but use clean, blank sheets for the top few layers.

The padding can also be used to mark off the measurements for guidelines instead of indicating them on the finished artwork. This will prevent unnecessary damage to the paper surface. The padding protects the work surface and may serve as a note pad, although it should be kept reasonably clean. Replace the top few sheets as necessary.

Ruling guidelines requires total accuracy. The use of a parallel motion on a drawing board or a T-square used on an accurately squared board makes this task easier. However, if these are not available, there is another method.

For camera-ready artwork, use a blue lead, otherwise an HB or B pencil, or a fine lead 0.3 or 0.5mm in a mechanical pencil. Do not use a hard lead because it will dig into the paper's surface, be difficult to erase and leave score marks on the surface.

Confirm that the padding is firmly fixed to the base board. Attach the substrate which is to be ruled squarely and securely to the board with small pieces of masking tape, either at the top and bottom, or at the four corners.

Rule horizontal lines onto the padding sheet, extending from the top and bottom edges of the paper. On the left-hand side, measure and mark onto the padding the required position of the guidelines. Repeat the process using identical

measurements on the right-hand side. Place a ruler across the page and join these marks to create the guidelines. (Write the distance between the marks as a guide for marking up the opposite side.) Use this method for both millimetre measurements and nib widths marked on a paper depth scale (right).

To draw any vertical pitch lines, repeat the process, but mark off the required measurements along the top and bottom edges. A set square can be used to insert vertical lines. The measurement marks will have to be made very lightly towards the bottom of the page. Place a ruler along the bottom edge of the paper, rest a set square against it and rule the lines in position.

If, for any reason, there is no padding extending beyond the working area, the measuring marks will have to be made directly on to that surface. Traditionally, manuscripts written on vellum had holes pricked into the foredge and spine margins which were used as guides for the placement of guidelines. Vellum was lightly scored to provide vertical alignment for columns. There are still some occasions when the pricking method is useful, particularly when transferring information from one opaque sheet to another.

In the absence of a ruler with reliable markings or for a diverse range of situations, a paper depth scale is a useful tool. For measuring off marks for writing, work out the letter height of the style to be used and its adjacent interlinear space. Write these marks near the edge of a strip of paper and using a pencil and ruler extend the heights to the edge of the paper. It is sufficient to indicate one interlinear space and one letter height, although with practice, individual preference may be to include more. Mark the head-margin depth above the letter-height mark; for some work, it may be necessary to work up from the base margin. Whatever the work demands this would be your Initial Point.

Place the paper depth scale in position at the left-

A paper depth scale, the indispensable tool of calligraphy, tailor made for each occasion. Make the marks of the number of nib widths and add the necessary interlinear space. Indicate top or bottom of page for a starting point.

You can make your nib width marks on a scrap of paper and transfer them direct, indicating their depth with pencil marks on the paper depth scale. Insert the required interlinear space.

hand side of the page and mark off the margin, a letter height and the interlinear space. Move the scale down the page and align the letter-height mark with the last line, which now becomes the mean line (x-height) of the letter. Continue working in this way until enough lines have been indicated. Repeat the process working down the right-hand side until the required depth is achieved. Then place a ruler or suitable straight-edged instrument in position and join the marks with a line.

A paper measure is useful for checking the distance between any two points. It is particularly helpful when lines of copy appear crooked. Take a slip of paper and mark the distance between the base lines of the two offending lines. Do this at one end of the lines then place the paper at the other end of the lines and see if the distance from mark to mark is identical.

RODNEY SAULWICK
A request for a logo for a particular paper range required that the quality of the paper be reflected in the final design, and that the calligraphy should complement and work with the existing typographical form. The paper being addressed is 'laid', which has a ribbed appearance caused by the parallel wires in the paper making mould. Using the split nib echoes this recognisable quality of the paper. The original artwork was prepared by metal nib, technical pen and brush, with ink on A5 Bond paper.

# Paper

The practical considerations of paper choice must include size, weight, texture, the medium to be applied and the physical presentation of the work. This latter can have significant bearing on the selection. For example, different papers may be needed for works which will be folded, freestanding (display), framed or posted, (see also pages 12-15).

Before proceeding with the final presentation, always test the paper or board, especially if there is any uncertainty about its suitability. It must be checked for compatibility with the medium to be applied. This is essential when using paint or any medium which can involve excessive moisture, and is particularly relevant with some techniques which could result in liquid collecting or pooling, such as when constructing bold letters, or filling in ones

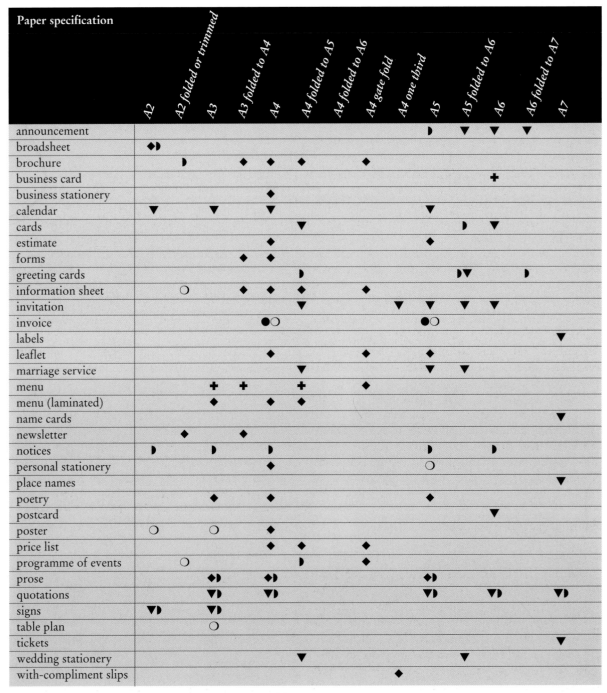

| Paper specification | A2 | A2 folded or trimmed | A3 | A3 folded to A4 | A4 | A4 folded to A5 | A4 folded to A6 | A4 gate fold | A4 one third | A5 | A5 folded to A6 | A6 | A6 folded to A7 | A7 |
|---|---|---|---|---|---|---|---|---|---|---|---|---|---|---|
| announcement | | | | | | | | | | ◗ | ▼ | ▼ | ▼ | |
| broadsheet | ◆◗ | | | | | | | | | | | | | |
| brochure | | ◗ | | | ◆ | ◆ | ◆ | | ◆ | | | | | |
| business card | | | | | | | | | | | | ✚ | | |
| business stationery | | | | | ◆ | | | | | | | | | |
| calendar | ▼ | | ▼ | | ▼ | | | | | ▼ | | | | |
| cards | | | | | | ▼ | | | | | ◗ | ▼ | | |
| estimate | | | | | ◆ | | | | | ◆ | | | | |
| forms | | | | ◆ | ◆ | | | | | | | | | |
| greeting cards | | | | | | ◗ | | | | | ◗▼ | | ◗ | |
| information sheet | | ○ | | ◆ | ◆ | ◆ | | | ◆ | | | | | |
| invitation | | | | | | ▼ | | | ▼ | ▼ | ▼ | | | |
| invoice | | | | ● | ○ | | | | ● | ○ | | | | |
| labels | | | | | | | | | | | | | | ▼ |
| leaflet | | | | | ◆ | | | | ◆ | ◆ | | | | |
| marriage service | | | | | | ▼ | | | ▼ | ▼ | | | | |
| menu | | | ✚ | ✚ | | ✚ | | | ◆ | | | | | |
| menu (laminated) | | | ◆ | | ◆ | ◆ | | | | | | | | |
| name cards | | | | | | | | | | | | | | ▼ |
| newsletter | | | ◆ | | ◆ | | | | | | | | | |
| notices | ◗ | | ◗ | | ◗ | | | | | ◗ | | ◗ | | |
| personal stationery | | | | | ◆ | | | | | ○ | | | | |
| place names | | | | | | | | | | | | | | ▼ |
| poetry | | | ◆ | | ◆ | | | | | ◆ | | | | |
| postcard | | | | | | | | | | | | ▼ | | |
| poster | ○ | | ○ | | ◆ | | | | | | | | | |
| price list | | | | | ◆ | ◆ | | | ◆ | | | | | |
| programme of events | | ○ | | | | ◗ | | | ◆ | | | | | |
| prose | | | ◆◗ | | ◆◗ | | | | | ◆◗ | | | | |
| quotations | | | ▼◗ | | ▼◗ | | | | | ▼◗ | | ▼◗ | | ▼◗ |
| signs | ▼◗ | | ▼◗ | | | | | | | | | | | |
| table plan | | | | ○ | | | | | | | | | | |
| tickets | | | | | | | | | | | | | | ▼ |
| wedding stationery | | | | | | ▼ | | | | | ▼ | | | |
| with-compliment slips | | | | | | | | | ◆ | | | | | |

● =90 gsm²      ○ =100 gsm²      ◆ =100 to 130 gsm²      ◗ =130 to 160 gsm²

▼ =250 gsm²      ✚ =250 to 300 gsm²      ❑ =340 gsm²      *grams per square metre (gsm²)*

which are hand drawn. The excess moisture swells the paper which, on drying, buckles and distorts the work, so substrate made to absorb this moisture must be used.

Cartridge, and some thin paper can be stretched, that is, soaked, so it will be less likely to cockle after a paint medium has been applied. Thoroughly soak the paper and hold it vertically to allow the excess water to run off. Place the sheet on a clean wooden board. Do not use board covered with plastic veneer because the wood helps to absorb some of the water. Using sweeping gestures, force out any air trapped between the paper and board, at the same time wiping away more of the excess water. Using gummed brown-paper tape, fix the sheet of paper to the board and lean it somewhere to dry. It is advisable to work on the paper while it is still taped to the board, though this is rather difficult in calligraphy, where it is essential to have some form of padding below your working surface. However, if the work you are doing includes painted decorative borders or similar detail, this could be executed first. The paper can then be removed from the board and the calligraphy applied.

Watercolour paper is manufactured for this type of work. Some of this paper, however, is too rough and absorbent for work done with steel nibs, so testing is important. Keep a record of substrates with which you like working and which give good results. Note any particular characteristics, both ones you like and dislike, and append to your notes the name of the supplier or source of the substrate. (It is exceedingly frustrating to be unable to locate a favourite paper or board that you have found to give excellent results.)

If a work is to be folded, ideally the fold should be made in the direction of the paper's grain. The grain should run parallel to the fold to prevent any tendency for the work to flare open, and to encourage the folded paper to remain flat and compact.

## Finding grain direction

When paper is being made, the fibres tend to align themselves in one direction. To determine this grain direction, place the sheet of paper on a clean, flat surface. First, take the long side of the sheet and gently lift it, bending it towards its parallel edge. Do this with the minimum amount of pressure, so the paper does not crease. Repeat this act with the short side. The folding which meets with the least resistance indicates the grain direction. On the other side, it is difficult to bend the paper towards its parallel edge and the paper will spring back. This

illustrates how difficult it is to fold against the grain. You may have to repeat this exercise several times before making a final decision on which way the grain runs. Finding the grain direction will become a little easier with practice, so experiment whenever you can on odd bits of paper which are free from creases.

To find the grain direction of thinner papers, make a small tear in the paper from adjacent edges, that is, one from the long side and one from the short. The tear with the grain will be relatively straight because it follows the direction of the fibres. The tear against the grain will prove more jagged, because it goes against the direction of the fibres. This method can be tested with broadsheet newspapers where the grain direction will run parallel to the central fold.

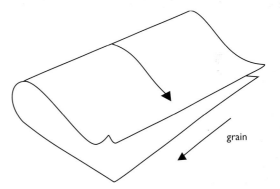

Finding the grain direction. Testing the long side.

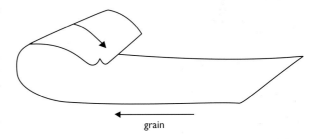

Testing the short side. (If the paper will not bend easily and resistance is felt, you are trying to fold against the grain.)

Grain direction can be determined by tearing the paper on adjacent sides. The tear with the grain will be easier to make and straighter.

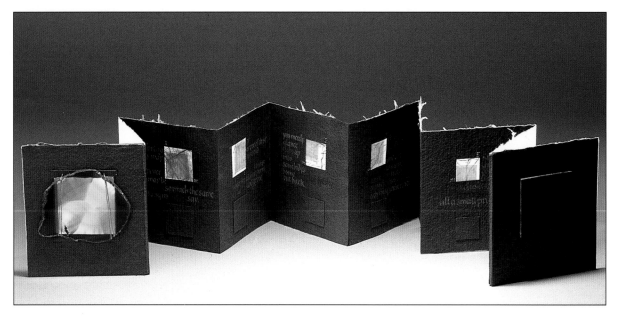

GRETCHEN WEBER
Manuscript books are a natural and excellent format for calligraphic experimentation and formal presentations. There are several basic formats for which it is not strictly necessary to have access to bookbinding tools and equipment. A favourite is the concertina or accordion style, whose arrangement of pages is ideal for many calligraphy solutions. Using the format as a considered vehicle for experimentation can produce exciting, sometimes unexpected, results, especially during exploration with different media and making marks with a calligraphic eye. *Through Two Windows* includes hand-made and Japanese papers, silk threads, finely sliced agate, and paint, the latter applied by pen and brush. 146 x 127mm/5.75 x 5in

## Folding, lamination and bleed through

When folding paper, first determine the grain direction. Unfortunately, to make economic use of a particular paper the grain direction will sometimes have to run perpendicular to the final fold or, for a manuscript book, to the spine. If you expect to be folding paper often, the acquisition of a bookbinder's bone folder (now usually made in plastic) will prove most useful. These handy tools are available in a variety of designs from bookbinders' suppliers.

Place the paper on a clean, dry and flat surface. Lift the edge of the paper to the position across the sheet that will give you the required fold. Let us assume you are folding the paper in half. Lift the edge, and match the two respective corners to the two on the other side of the paper. Do this with as little handling and pressure on the paper as possible.

To fold a large sheet, you may rest the pads of your fingers on the uppermost part of the paper and push the lifted section away from you until all the corners of the sheet are aligned. Place the knuckles of your less dominant hand firmly in a central position near the aligned edges. Take a bookbinder's bone folder or plastic ruler in your other hand and, starting at a point near the hand holding the paper down, carefully draw the instrument towards the centre where the folded edge will be. This will create a depression in the centre of the folded edge in front of you. From this central point, move smoothly and firmly along this edge to the end, first in one direction and then the other. Consider this action as less of making a creased fold and more as an expulsion of air from between the now folded sheet. Repeat the action several times with firm, light strokes and finally run along the entire edge to achieve a firm crease.

If you are folding a single sheet into one with eight surfaces, it is possible to have the grain direction running parallel on the final fold. This will entail making the first fold against the grain. Make the first fold as previously described and follow the same procedure for the second. Depending on the bulk of the paper, or lightweight card, the second fold may prove more resistant, so you must persevere, but with care. If you are making multiple folds, for example, for a manuscript book, and meet too much resistance making the second or third fold, take a sharp knife and slit along half the folded edge before proceeding with the next fold.

When you are making even the simplest of folded cards, booklets, or even a small manuscript book, always make a full-size dummy or mock-up of the proposed final item. This serves a similar function as a finished rough, giving a much better

This plan is very helpful when designing and making a manuscript book. Using a full-sized dummy is essential to determine placement and arrangement of material. This plan should eliminate any confusion over which pages are adjacent when working on the artwork.

Imposition: this plan needs to be plotted in advance, so when the sheet is folded the pages will be in the correct sequence. Although this scheme is primarily used for printing books, it has some viable applications in calligraphy. This example is for 16 pages.

- – – – – – – –  first fold/cut
...................  second
– · – · – · – ·  third

idea of how the final work will feel and look. Begin making this with any size of scrap paper, working up to the proposed full size.

The finished work may need extra protection in order to survive a great deal of handling or being displayed. Lamination is a relatively inexpensive process which encapsulates the entire work in protective, clear sheet plastic. It is sometimes regarded as having little aesthetic appeal, but it has sterling qualities for certain jobs, such as menus, table mats and bookmarks. A medium-weight (125 microns) plastic is sufficient for items of this nature. For signs and other display work, a heavier weight (250 microns) plastic is best. The laminations can be made with clear plastic on both sides, or on one side with the reverse backed with an opaque plastic. Businesses which provide lamination services can also insert eyelets and round off corners.

The lasting quality of your work is partially determined by the nature of the paper you choose. There are many acid-free, conservation-grade papers available and all of them should be thoroughly investigated before making a final choice.

An important factor affecting selection is bleed through, which means being able to see what is on preceding or succeeding pages. Bleed through can impede legibility and hence the pleasure of reading.

Even many of the fine old manuscripts written on vellum suffer considerably from bleed. Further examples of this can be seen in daily newspapers and some writing paper. The medium applied to the paper is sometimes the culprit, indeed on a few papers, particularly very fine air-mail paper, it can be difficult to find an ink which will not show through.

Bleed through may occur when making any work which has the artwork positioned back-to-back, that is, written on both sides of the paper. Even if it is only to be written on one side, there is a risk of bleed on the reverse side. If the final format involves this style or similar, the paper must be checked for bleed through.

There are formats and designs which can overcome bleed through, but the resulting bulk may prove unsatisfactory, both from an aesthetic and practical point of view. One solution is to produce the work on the desired paper, irrespective of the bleed through, then paste this on another paper or card which will conceal the bleed. This scheme can be used for cards and some manuscript books.

Alternatively, fold the work so the bleed is not revealed when the work is opened or read. This method can be seen in the traditional greeting card format, made by folding a single sheet twice; first, in half across the centre, then again to form the central

Another imposition scheme used in book publication which has admirable uses in planning manuscript books, brochures and booklets. The primary function is to ascertain how many pages the document is going to take: the extent. Make a master sheet which can be photocopied. Starting a new sheet will allow comparisons of page sequences.

a   imposition for a single fold

b   single fold

c   French fold; good for thinner papers and hiding bleed through

d   folding a French fold

e   concertina or accordion fold

f   parallel fold

g   sheets inset to make a single section

h   gate fold

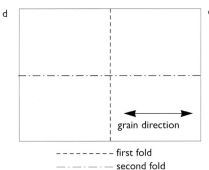

grain direction

------- first fold
—·—·— second fold

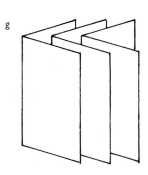
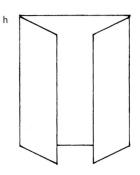

or spine fold. The only precaution required with this method is that accurate measurements are made on the flat sheet to indicate where the folds occur and that these are adhered to. Take special care with this, because linear measurements do not include the amount of paper taken up by the actual fold.

## Other folding styles

If you are planning to make a small manuscript book or work with more sophisticated folding, there are many suitable styles. The single-section book has all the pages folded and collated in parallel with each other.

The concertina or accordion book is, as its name suggests, a single sheet of paper folded back and forth on itself. It can be made longer by neatly fixing several sheets together before folding. A single sheet can be folded several times, or twice to form a simple gate-fold.

## Medium

On occasion, the medium to be used will be dictated by the commissioner, or the nature of the work. It is also partly determined by the equipment which will be used to apply it. The instruments which can be used for writing with paint include a dip nib, brush, reed pen, quill, and a found or made object, such as a piece of wood, felt, cork or sponge. Almost anything can be used with ink.

Fountain pen and some calligraphy inks are made from aniline dye. This group of inks have a short life, may fade and lack strength but are good for finished roughs and general practice sessions. To achieve the best finish for a final work it is better to use an ink made from a pigment. These inks need to be shaken or stirred before and during use and should not be used in fountain pens - they will clog them. Chinese stick ink is made with a little water by grinding or rubbing the stick on a special stone. Only make enough ink for immediate use and throw away any which is left over, as it will not keep. Indian ink should never be used unless it is specified as non-waterproof. Waterproof Indian ink will clog and ruin fountain pens. The solvents used in the non-waterproof variety are included to aid the flow and thus help in the production of fine line work.

If at this stage you are still undecided which medium to use, having been unable to identify it when perfecting the design, experiment with different mediums and equipment on a variety of paper and boards. Use parts of the intended final design as your visual practice material.

After you have made your final decisions and tested them on the paper or board, practise on scrap paper with the medium and equipment you intend to use. This will allow you to gain confidence in using what you have chosen, which is particularly important if you have not used this combination before.

## Other Equipment

When making the selection of equipment to include in your basic calligraphy kit, there is an assortment of items which can make a valuable contribution to your work if they are chosen wisely. Some pieces may not be required for every production process, but are invaluable at certain times.

All equipment must be treated with care and respect. This includes thorough cleaning, careful handling and storage and only using an item for its intended purpose. For example, for both safety and practical reasons, plastic rulers should not be used when trimming work. A sharp blade can easily penetrate the plastic and your fingers, and damage the ruler edge. Look after all your equipment and take pride in its acquisition and care. Do not lend any of your equipment, the next person may not be as careful, or as knowledgeable about its functions and methods of use as you are. With correct care, use and storage, much of your equipment should last for many years.

If you have to take your calligraphy equipment away from its usual home, affix an identifying mark in a position which does not obscure its function. Small patches of bright, identically coloured tape or sticky-back dots make good indicators.

### Ruler

The most useful ruler is one manufactured from high-quality, clear acrylic with metric and imperial measurements. A better-quality ruler gives much more accurate measuring scales. Other features which may prove helpful are a bevelled edge and parallel rules printed along the centre of the instrument to aid alignment. It is worth purchasing a ruler at least 450mm (18in) long, as a longer ruler can eliminate errors which may occur if you have to move it when ruling longer lines.

Always make sure the ruler is clean. Plastic rulers can be washed in tepid, soapy water and

rinsed clean. Do not use any abrasives. Wipe the ruling edge frequently while working, with a paper towel or a soft cloth, to remove any build up of the medium you are using.

For cutting and trimming work, use a metal straight edge to align your cutting knife. For smaller works, use a stainless or carbon-steel ruler. These rulers are produced with imperial and metric linear measurements, often on both faces. Unlike the plastic ruler, the measure usually begins at the very end of the flat-sided (not bevelled) ruler. If the metal ruler has a tendency to slip or move when being used, stick a strip of masking tape to its underside. There are also aluminium rulers suitable for cutting and trimming. These have a non-slip rubber or plastic strip inserted on the underside.

For cutting large sheets of board, a heavier metal, straight edge at least one metre long may be needed, but do not buy one unless you expect to use it frequently - they are expensive. You may find a less expensive model at a builders' merchant suppliers or hardware store. The metal used in their manufacture does tend to rust, so it must be cleaned carefully before use. The more expensive metal rules from art suppliers are manufactured with anodized aluminium and do not rust.

## Set square

Set squares are notoriously not! Nonetheless, this is an important piece of equipment. An adjustable set square may prove of more use than one set at fixed angles. These are usually made from clear, shatter-resistant acrylic plastic and have bevelled edges. The fitting which makes them adjustable is also the weakest point of the design and needs to be handled with respect.

As with all your equipment, treat the square well and, when not in use, close it. Store the instrument in its protective covering, or make your own out of strong cardboard and tape.

## Masking Tape

Masking or drafting tape is a paper tape, usually coloured sandy brown. There are many makes and grades of this tape and it is important to use a good-quality product. The most suitable type, which is marketed as 'easy-release', 'low tack' or 'pressure-sensitive', will not damage a work when it is removed, if it is used correctly and carefully. A tape which does not have these characteristics may lift the surface of the paper when it is removed.

The tape is sold in several widths. The most

useful for calligraphers is either the 12mm ($1/2$in) or 25mm (1in) size. The latter is a suitable size for most purposes and, used sparingly and occasionally re-used, a roll will last for a considerable time, especially if you use scissors to cut off small strips.

The padding calligraphers require beneath their writing surface can be affixed to the drawing or base board with this tape. It can then be used to secure paper and board to this working surface when ruling guidelines to ensure no movement and thus aid accuracy. Further uses include the temporary positioning of work when determining a final layout and holding protective sheets in place to keep your work area clean.

Care is always needed when using masking tape on the paper of the final work. Even after taking all the precautions of only using a tape with an easy-release adhesive, it can still be unpredictable. Do not use too much tape on the surface, be economical.

## Non-reproducing blue leads

Blue lead has the excellent quality of being non-reproducing. It is used in the preparation of artwork for many kinds of reproduction. In the printer's darkroom when artwork is being photographed in preparation for off-set lithographic production, the blue will not photograph. Similarly, for work which will be reproduced on a photocopy machine, the blue lead can be used on the original artwork and it will not be reproduced.

For this reason it can safely be used to rule guidelines and alignments without fear of reproduction and the need to erase these lines. Blue leads can be loaded in an inexpensive mechanical pencil.

## Erasers

The contemporary eraser market is somewhat confusing, with so many different-quality products available, all claiming suitability for a broad range of applications. The claims are not without some foundation, so erasers need to be purchased to match the specific requirements of their user. There are a few erasers which are most useful for calligraphers. For the erasure of pencil marks on paper, a block eraser which will not affect ink lines or damage the substrate is essential.

The same eraser also comes in stick form, held in a holder like a mechanical pencil. The eraser is propelled forward as required, either by a clicking mechanism or by a sliding collar. This pen-style is ideal for erasing guidelines. The eraser is

ROSALIN DUNCAN
The choice of Saunders Hot Press watercolour paper was a necessity for this work. A watercolour wash was applied before using isograph and automatic pens with watercolour to write the words. The shell gold was applied with a brush. The definition and angle of the letter 'e' in 'while' is evocative of the pitchfork used to turn the hay, build the ricks and load the wagons or carts. Note the effective use of coterminous strokes.
200 x 250mm
7.87 x 9.87in

approximately 6mm ($^{1}/4$in) in diameter and can be sharpened to a point or cut to an oblique angle to help control the erasing and prevent unnecessary friction on your work, particularly when you are erasing guidelines used for painted calligraphy.

Always make sure you work with a clean eraser. Rub it on a clean piece of paper and inspect it before use. If this is not sufficient, it will have to be sliced with a sharp blade to produce a clean surface.

A further item in the erasing group is the dry-cleaning pad. This is a small, cloth bag containing finely ground, grit-free erasing powder. It absorbs dirt and will not deposit it back on the work being cleaned. The pad can be used with paper, cloth, vellum and board. Do not try to erase pencil lines with it in the first instance. Regard it as an item to use for final cleaning and finishing. In use, the pad is gently squeezed and twisted, so the powder is sifted through the fine mesh of the bag onto the work. The pad is rubbed over the part of the work which requires cleaning. Use a cleaning brush to remove the debris.

Extra care must always be exercised when using erasers because it is very easy to remove the surface of the substrate and, if too much vigour is used, the calligraphy may be damaged. If you write on a surface which has its coating broken, some problems may arise, especially when using ink. The ink may not stay on the surface, but bleed out from the main stroke into fine spidery lines. If there is any uncertainty about using a particular eraser on a substrate either run a test, or ask the retailer, manufacturer or colleagues. Even when you have the information, it is wiser to test the theory so you know what works for you.

## Glue and adhesives

In calligraphy, a need for adhesives may not arise often. However, if camera-ready artwork is being prepared for reproduction, you will require an adhesive to make the paste-up. Paste-up is the general term applied to a single work composed of various elements. It does not solely refer to work for reproduction, but is most commonly identified as such. Methods of reproduction may include photocopying, laser copying, off-set lithography, or screen process.

For this type of work, the ideal adhesives are

ones which allow the elements to be easily lifted and repositioned. Because this may need to be done several times, the adhesive must be flexible. Rubber-based adhesives, spray mount or hot wax are the best. Glue sticks, acrylic and water-based pastes are not recommended for this job. Water-based glues can distort the porous surface of the paper (just like paint on paper which cannot absorb extra moisture). Waterless rubber adhesives work on the principle of contact adhesion, so surfaces will stay flat.

Rubber or latex adhesives are most suited to calligraphy; they permit work to be lifted and repositioned without damage and will not affect inks or paints. Use a special spatula or plastic palette knife to spread the gum thinly and evenly on the back of the work to be pasted down. Do this on a clean waste sheet, using a new sheet for each application. Old magazines make good surfaces for this job; turn to a new page for each application. Do not use newsprint or similar printed material, as the printing ink may come off the page onto your work. Very little adhesive is required, which is why the spatula is a good tool to use. It enables a very thin layer to be applied and any excess to be easily removed.

The gum adhesives have the excellent property of allowing excess gum to be removed, ensuring clean artwork. This is particularly important when the adhesive is forced out under pressure around the edges of a piece that has been fixed to a base sheet. The gum can be manipulated like an eraser to lift the excess adhesive off the artwork. To make an eraser of gum, put a walnut-sized portion on a piece of board and leave it to dry out, or collect gum from the end of a spatula or your spreading implement. If the adhesive comes in a tin, add gum from the sides of the container to the eraser. The ball of gum will grow as it is used.

If more adhesive is required when repositioning artwork, clean both surfaces before applying any glue to the work to be repositioned. If a rubber adhesive has been previously used, it can be removed by carefully using the ball of gum adhesive. This will ensure clean gluing and receiving surfaces, and result in flat artwork free from lumps of dried adhesive.

Petroleum spirit, in the form of lighter fuel, can be used to dissolve the gum if a piece of artwork which has been in position for some time is proving difficult to dislodge. Use the fluid carefully and sparingly. Pour a little next to the edge of the paper to be lifted so it will seep underneath and dissolve the old gum. Then, using the back of a pointed scalpel blade, gently ease the work off the base board. Do not force it. The moment there is the slightest resistance, stop and apply more fuel. When the work has been removed, clean the base sheet with the gum eraser before sticking anything more to it.

After the artwork has been aligned and placed in its correct position, it will need to be made secure. Place a clean waste sheet over the entire work and use a roller or firm strokes with the side of your hand to make absolutely sure the work is fixed. Never use a roller, hand or any instrument directly on the artwork when fixing in this manner.

There is a broad range of spray adhesives on the market which are very good for specific jobs. However, their use is not recommended in confined spaces because of their fumes and method of application, which is inclined to be messy.

Wax requires an expensive and specially designed piece of equipment to heat and melt it. Although the method is clean and reasonably free from problems, the outlay does not make it an economical proposition for most calligraphers. For great quantities of paste-up work, wax is excellent, but otherwise the rubber adhesives are best.

## Cutting, Trimming and Knives

To cut or trim paper and board, use a knife with a blade which is flat-ended, not pointed. A craft or safety knife has the most suitably shaped blade. (The blade can also be retracted.) The blades used with these knives are manufactured in strips of up to twelve. Blunt blades are simply replaced by snapping off the old to reveal a new one.

Use a metal ruler or straight edge to align the blade for cutting and trimming and always cut away from the artwork or intended working area. Never put pressure on the blade. If the blade is new and sharp, it will cut cleanly. Let the blade do the cutting it is designed to do, you merely have to direct its blade. Consider the task as a series of long, smooth strokes. This is especially important when cutting thick board; never try to cut this in one or two attempts, do it slowly and concisely. This method may take six to ten strokes, but will give better results.

Never skimp on blades. Blunt blades create irregular and rough edges which are unsightly and can ruin a work. Only hand-torn and deckle edges, both possible design considerations, are not clean cut.

Always cut on a special cutting surface. Do not cut directly on to the hard surface of a table, desk or floor, or onto a soft surface, such as carpet. The resultant cut will be ragged and irregular. Use a special cutting mat or strong cardboard. Cutting

mats will last for years if used with care. They are made with a self-healing surface material and some are double-sided, printed with a grid on one side and plain on the reverse. Only cut paper with a light knife on a cutting mat. Do not use a heavy duty knife designed for cutting thick material. If you opt for a strong cardboard mat, replace it regularly. The more the cardboard is used, the more the score marks of previously made cuts will interfere with the cutting process. This will throw the knife blade slightly off-course, creating imperfect edges.

The safe disposal of blades is the responsibility of the user. These blades are extremely sharp, so sensible precautions must be taken when using them, as well as when they are not in use. Even used blades are very sharp. Snap-off blades can be safely disposed of in the special container which comes with a new pack of blades. If the blades have been purchased independently, wrap used blades in scrap paper and encase the package in masking or strong packaging tape.

The knife most commonly associated with the profession of graphic design is the scalpel, consisting of a handle and blade. This is made from high-quality carbon steel and is available in a range of sizes. The most useful for a calligrapher are handle sizes 3, 5 or 9. Although individual preference must dictate the choice of handle style, the most useful blades for these handles are 10, 10A and 11.

Blade size 10 can be used on some drafting films, tracing and art papers to remove incorrect marks. Great care must be taken not to damage the surface of the substrate. If the surface is broken, it is possible that any ink applied will bleed. This blade, which has a rounded end like blades 20, 21, 22 and 22A used in conjunction with handle size 4 (handle and blade sizes do not necessarily correspond), is the correct shape to attempt to make any corrections. Try not to put any pressure on the blade. The sharpness of these blades means it is possible to remove only the medium on the surface. Manipulating the blade may be easier if it is detached from its handle and masking tape wrapped around the handle end.

To trim your work, mark off where the cut is to be made, as a continuous pencil line, or as marks such as dots or hyphen dashes with which the ruler can be aligned. Where possible, place the trim line marks outside the working area. This method is preferable to ruling a continuous line because it is more accurate and is the required method for camera-ready artwork. When preparing to cut the

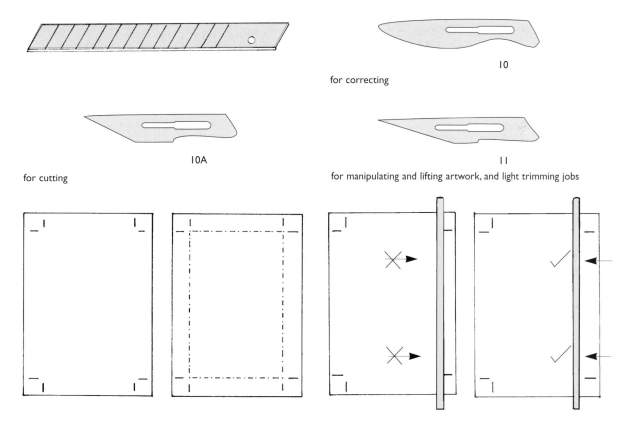

10

for correcting

10A

for cutting

11

for manipulating and lifting artwork, and light trimming jobs

Trim marks in position. Dot/dash lines indicate where to cut and defines edge of (trimmed) work.

When cutting anything - paper, board or a finished work - always cut away from the working area. Never cut towards the working area, except when absolutely necessary.

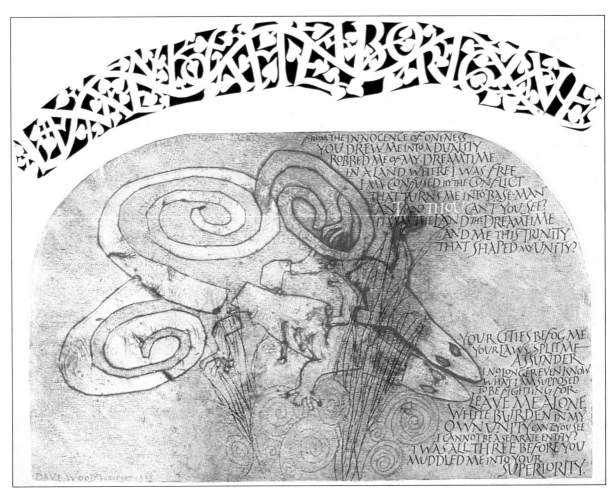

**DAVE WOOD**
*The Lament of the Aboriginal*, a poem by Merlyn Swan, provided an arresting inspiration for this piece, one in a series of four works. Each of the pieces uses a collagraphic image of a goanna, or, as in this one, 'split goannas', which symbolises the confusion which exists between cultures in Australia. The original inhabitants and true Australians see their land in the main picture, but are also surrounded by images like that represented by the cut-out letters. These have been specifically cut in a manner designed to evoke the wooden-lattice and iron-lace work used extensively in nineteenth-century Australian architecture. The words were written by steel nib with gouache.
580 x 420mm/22.87 x 16.75in

work, simply pitch the ruler to the marks and cut from one mark to the other. Do not cut further than the mark, or right to the edge of the paper because accuracy may be impaired and, in some circumstances, the mark for the perpendicular cut can be cut off.

# Cleaning and Finishing

The final presentation of a work is enhanced by careful cleaning and finishing. This will probably involve the erasure of pencil guidelines, vertical pitching lines and other incidental marks required in the production.

Before erasing guidelines, make absolutely certain that the ink or paint on the work is totally dry. Where possible implement the overnight maxim; that which does not dry, set, fix or do what it is supposed to do overnight, will never do so. However, confirm the dryness by inspecting the surface of the medium. This can be done both by close examination and by holding the work towards the light and checking its appearance. Whenever possible, always clean work before trimming so there is less handling of the actual working area.

Then select the most suitable eraser for the job (see page 96). Some erasers are too coarse for certain papers. Work methodically through the piece, erasing the lines. Develop your own formula and method of approach to this task and then keep to it. For example, decide whether to begin at the top of the page or the bottom, and then work through the entire process with the work facing in one direction.

It is usual to start with the work facing the way

it will be viewed. When all the lines have been erased, turn the work through ninety degrees, and it is possible to find all the lines you thought you had so carefully erased, neatly arranged and still in place. Erase these lines, this time working from the side of the piece.

The cause of this phenomenon is simply the texture of the paper and the way it receives graphite as the lines are ruled. Even the smoothest papers have a texture of mountainous proportions when looked at under a microscope, and the graphite collects behind these ridges. When viewed from one direction the pencil marks appear to have been erased, yet turn the work around and the graphite is exposed. Although the work will not be viewed from the side, take no chances and complete the cleaning and finishing tasks correctly and meticulously.

This is only one of many sensible precautions to take when cleaning either a complete work or a rough. Never blow on a piece of work in an attempt to remove scraps of eraser or any other foreign objects, such as a hair or piece of fluff. To remove dirt from a work, use a tool specially designed for this purpose. A drawing board dusting brush is made of horse hair. The brush should not damage the work, as long as it is used with deftness and only on work which is dry - confirm this latter point before use. Use the brush frequently during erasing to remove dirty eraser from the surface of the work. If this is not done you could rub dirty eraser into the surface of the substrate and the calligraphy.

A reasonable alternative may be a small hand-held brush with soft bristles. A paint brush can be kept solely for the purpose of cleaning small areas. A small pair of pointed tweezers should be kept for extracting hair or fluff which may get trapped under artwork during the gluing stage.

# Copyfitting

The typographical term 'copyfitting' is used to describe a mathematical procedure employed by typographers and graphic designers to calculate how much space the words of a manuscript will occupy when they have been set in type. When designing and preparing layout for a work, a calligrapher may find a knowledge of some copyfitting methods useful for determining how best to fit the words into a known space. They also help when choosing which sizes and style of writing to use and when determining the amount of space required for the words. If a specified space must be filled, it may be necessary to write extra copy, add decoration or

manipulate existing copy, for example, by changing letter size. The mathematical computations can sometimes take longer than actually writing out the final work, yet great care must be paid to this part of the production procedure.

Every detail of the work to be copied must be accounted for, so nothing must be missed in the initial calculations which would subsequently throw the final rendering out of alignment. The basic method of fitting copy remains the same, but each work must be calculated individually.

Copyfitting involves counting the characters in a manuscript to estimate the amount of space required for transcription. Most methods of calculation rely on typescript, that is, work produced by a typewriter or other mechanical means, where the characters are produced in a non-proportional way, with each letter, item of punctuation and word space occupying the same amount of space. The marks are afforded equal width and each counts as a single character.

No one method is suitable for every situation, or assures total accuracy, but those suggested below can be adapted and modified. It is possible to invent new ones to suit an individual working style.

## Copyfitting method 1

This method can be used when the depth, width or final overall dimensions are known. It can also be used when no final dimensions are known, to provide an initial overview from which a decision on the final measurements can be made. Adapted for calligraphy, the method relies on the conversion of the letter height to a millimetre measurement. This may not always be a satisfactory method, but to provide an initial approximation of the overall dimensions it is perfectly viable. When the measurements have been ascertained, the final work can be prepared with the true letter-height measurement (if it differs from the linear measurement) without causing too much distortion. The following constitutes the calculation for a poem to be transcribed.

Begin by identifying the longest line of the poem and estimate by eye, as near as possible, the pen nib size which would render the line comfortably in the available width, if known. Using the prescribed nib-width height for the letters of the style in which the rendition will be made, write the line out. If the resulting line length is within the limits of the size of paper you will use, write a few more of the longer lines to confirm your choice.

If the first line written out is too long, change the nib size for a smaller one and try again, reducing the

size and height of the letters accordingly. Similarly, if the first nib-width size was too small, try a larger one, increase the letter height and write the lines out again.

Two or three attempts may have to be made before a nib size produces a line length that looks possible. If no overall size for the finished work is known, use sensible visual and semantic judgement, drawing on the nature of the work, its content and intended purpose. Lines that are overly long are difficult to read (see page 26).

Having selected a possible nib size, measure the letter height in millimetres. The total depth of a poem (in millimetres) will be:

> number of lines of poem in total x mm depth of line
> PLUS
> number of interlinear spaces x mm depth
> PLUS
> number of verse breaks x mm depth
> PLUS
> mm depth of heading (allowing one line)
> PLUS
> mm depth of credit (allowing one line)
> PLUS
> mm depth of space from head to first line
> PLUS
> mm depth of space from last line to credit

If the final depth measurement is known, subtract this total from it. The answer will confirm whether the work will fit. If it does, estimate the depth of the head and tail margins. Determine the margins not as two equal spaces, but aim for a greater depth at the base margin (see page 16). Where no final dimensions are known, this total depth measurement will provide a figure from which to determine the size of the overall format of the final work.

The above formula can be used as a general guideline which can be manipulated to suit specific needs. For example, it can be adapted to a poem of a single verse with a two-line heading. If the work will fit the space quite well, consider whether to increase or decrease any of the space allowances. The smallest change either way can enhance the visual appearance enormously.

If the final total is much too small, or too big, for the space available, consider which measurements could be changed. If the nib size is changed, would this make the alteration in the calculation too great? If so, and the change needed is minor, alter the space between the verses, the heading and first line, or the last line and the credits. If this is still not enough, you could either reduce or enlarge the interlinear space. Some works appear more aesthetically

pleasing if this spacing is increased or decreased.

Using the number of nib widths recommended for a particular style, and with the resulting letter height, fitting copy into a space is a process of trial and error. In time, practice will improve your visual acumen and guesswork will become more accurate. Initially, we have to make an intuitive, but realistic, estimate by eye and then experiment by writing out some of the copy to see if it fits. A rendering of an entire work is usually necessary to ascertain whether our selections of style, size and weight are the best ones for the specific job. This underlines the importance of comprehensive pre-production planning, supported by well finished roughs developed from considered and detailed layouts.

## Copyfitting method 2

Longer works and pieces of prose can be copyfitted by a measuring method. The work will still have to be rendered before the final production, but character counting and consequent calculations provide a clue to the amount of space needed.

Count ten characters on the original copy, counting each letter, punctuation mark and word space as one unit. Measure their length in millimetres. Measure all the line lengths of the copy in millimetres and add them together. Divide this total by the millimetre measure of the original ten characters. Multiply the result by ten (representative of the characters). This final figure is the approximate character count of the original copy.

Now, write ten characters in the size of the proposed style selected for the rendering. Begin with the same letters used for the original character count. Measure this length in millimetres. Multiply this length by the total number of characters and divide the answer by ten. The answer is the approximate number of millimetres required to write the original copy.

## Copyfitting method 3

If one measurement of the final work is known, it is most commonly the width. To determine the depth where the lines of the original copy has lines of roughly equal length, count all the characters in one line. Multiply this figure by the number of lines to estimate an approximate total of characters.

Write out one line to the proposed full measure and count the characters in this line. Divide this number of characters into the total count to find the approximate number of lines required for the overall depth of the work. These are general calculations

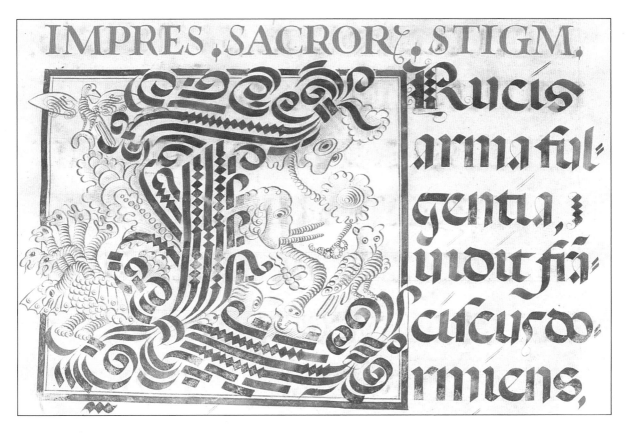

**SIXTEENTH CENTURY**

This 'command of hand' letter 'L', lurks at the bottom of a page of an antiphonary, a large-format choir book, with dimensions commensurate with being seen by the whole choir. Liturgical books such as this originally contained the parts of the Divine Office and Mass sung by the choir antiphonally (two choirs in alternation). Latterly, these two sections were separated.

Close inspection and analysis shows the letter is composed primarily of sets of short strokes, and some of these are interspersed with diamond dots made with the same instrument. In addition, small flourish strokes dance in various combinations to anchor the letter to the picture plane, which is clearly defined by single bold and fine lines. In several places the letter 'breaks out' of this frame to great effect. The whole is further enhanced by an exotic collection of fine line drawings of birds, beasts and man.

In this small fragment from a large book with pages measuring approximately 698 x470mm (27.5 by 18.5in), there is plenty of visual activity created by the pen. Fine parallel lines 'dot' the letter 'i'; and fine hairline extensions and bold use of diamond dots provide an excellent example for stroke analysis, which reveals that the letters are constructed of simple easily made repeated strokes. CBL.WMS 211

and do not allow for paragraph breaks, indentations, sub-heads or any other extra spaces.

## Copyfitting method 4

For short works it is advisable to count all the characters, particularly if the copy has to be fitted into a specified space. Whether this is large or small, achieving accuracy and utilizing the available space in a coherent and sensible way is of the utmost importance.

Handwritten copy, like documents produced by some older model typewriters, is unlikely to have a uniform width of space for each character. Therefore, using copyfitting methods which measure the line lengths and assume that every line has the same number of characters will not give accurate results. Handwriting (and some typewriters) uses proportional letter spacing, where every letter is placed in a space relevant to its size, in contrast with the non-proportional presentation where every character width is identical.

If the lines of the copy are of similar length, count the characters in six to eight lines to obtain an average number per line and assume this is representative of the entire copy or manuscript. Visual judgement can be used to check this. Count the lines and multiply by the average character number per line to find the approximate total number of characters.

Write out some of the copy in the size and style to the proposed full line measure. Count the number of characters in this line and divide this number into the total number of characters in the work to estimate how many lines are needed.

## Copyfitting method 5

A basic idea of the amount of space needed can be worked out by using the average line-length method. This can be done if the copy is formally presented, with characters occupying equal width, that is, non-proportional spaces, and if the lines are of fairly uniform length. The lines should be approximately the same length, varying only by a few characters.

Rule a vertical line towards the right-hand edge of the copy. Place the ruled line where the number of lines falling short balances visually with the lines projecting beyond it. Some lines may not reach the ruled line, while others will project beyond it by a few characters, but this will give you an average line length in characters.

Count the characters of one line up to the vertical line and multiply by the number of lines to find the approximate number of characters. Proceed as for previous methods to find the amount of space for a calligraphy rendering.

## Further copyfitting considerations

In most situations, rendering an entire piece before doing the final copy is seldom a bad idea. It can help solve many unexpected problems which may arise, including those posed by line breaks. Sometimes an awkward line break is inevitable and a sensible decision has to be made on where to break the line or word. Word breaks should occur after a recognisable syllable. If in doubt, consult a word-division dictionary.

If you discern that line breaks are going to cause problems, you could alter the overall format, although be aware that this may only create another range of problems in the revised layout. You may consider using a decorative device or (part of the beauty of writing by hand) subtly alter the spacing of some preceding and succeeding words.

When planning the general layout, always pay careful attention to the visual aesthetic and the work's literary sense. These can be easily flawed by bad line breaks and incomprehensible positioning of words which cause the reader to lose the meaning of the words and the entire piece. The calligrapher's chosen layout must aid rather than hinder comprehension. Lines should not be too long. For good readability in typography, fifty-six to sixty-six characters per line is the usual maxim.

When a work is set in two or more columns, avoid carrying over a single word to begin a new column, particularly if it occurs at the end of a passage.

When transcribing, do not assume you know how to spell the words. Always double check, if necessary refer to a good dictionary, or back to the original source. When copying out a passage, or names from a list, it is easy to glance at the original copy and think you see a word which is similar to, but not, the actual word. Eventually you may develop a habit of seeing a series of recognisable shapes, rather than assumed letters, and therefore words.

It can be difficult to work from handwritten copy, as extra time is spent trying to decipher the writing. Where possible, work from clearly typed copy. The disruption caused by the constant battle to read and comprehend handwritten copy results in broken concentration, and work which reflects this stop-start working mode. On occasion, the original copy may be handwritten in capitals which are to be transcribed into upper and lower-case letters. Before beginning work, confirm where the capital letters are required in the final piece.

Before starting work on any job, evaluate the final size and priority of the words. Brochures, leaflets, posters, signs, and invitations serve a specific purpose, perhaps advertising a forthcoming event. Go through the copy and determine what should be bold and large, and what information can be smaller. A variety of size and weight of lettering is required to impart a lot of information which is promoting an event or item. Some part of the design must stand out. These are the words positioned or rendered to attract attention at first glance. Sometimes this can be done effectively with colour.

Work of this type has lots of information to impart: what the event/item is; who is putting it on; why or for whom the event is being organised; where is it; when (date and time); special attraction; what there will be; code of dress; RSVP contact; price, and what the ticket or leaflet entitles the holder to. Sometimes this must all be included on an A6 card. The best solutions will evolve from first working through all the information and assessing it in terms of priority. Nothing can be cut or eliminated: it is all important, but not necessarily of equal importance.

All design work for printed ephemera requires a similar approach. The lettering style needs to suit the circumstances, and there are functional considerations. Invitations need a space for a name. Letterhead paper can be designed in a bold and eye-catching way, but room must be left for the letter itself. So, when the final design is in finished rough form, photocopy it and type a letter directly on it. This will show if the design is effective.

Any work being designed for printing (particularly colour or tone) should be photocopied

**BIBLIA SACRA, TWELFTH CENTURY, c.1150**

This manuscript from Walsingham Priory is an excellent example of Latin written in English minuscule with English illuminations. The volume renders the books of Genesis through to Ruth on vellum measuring 473 x 318mm (18.63 x 12.5in).

Enlarged initials are placed partially in the margin with unembellished decoration; in the whole volume there are ten historiated or decorated initials. Red numbers indicating the verses are set in the margin and each then begins with an initial larger than the text; these letters alternate blue and red. Careful scrutiny of the folios reveals the scoring of the vellum to create the two columns, and pricking along the spine and foredge margins to provide a guide for scoring the guidelines. This page (f88), also includes condensed, elongated paragraph marks, and line fillers constructed from repeated identical pen marks.

CBL.WMS 22 137 folios set in 2 columns of 42 lines

to see if the design works in black and white. For example, many letterheads are designed and printed in colour, but they are often seen in black and white, on photocopies and faxes.

# Centring

Tracing and typography-detail paper make an invaluable contribution to many facets of calligraphy. They are useful for work which needs to be centred, anything from individual names for invitations to the design for the invitation itself. The guidelines ruled on a printed certificate, invitation or a practice sheet are clearly visible through this type of paper, so, when errors occur at the planning stage, the guidelines do not need to be redrawn, a clean area of the tracing paper is simply moved into position.

Place the transparent paper over the guidelines and write the words to be centred in the style they will be rendered. You need not dot every 'i' or cross every 't' in this rough but accurate presentation. Measure the length of each rendered line and divide the figure by two to determine the centre point of the line. Mark this point in pencil on the trace overlay.

Measure and mark off the centre point of the work on which the words to be centred will be written. You may wish to rule a vertical pitching line as a further guide. To determine where to start writing the name or line on the original, line up the pencil mark on the overlay with the centre line on the original and mark the place for the first letter with a small pencil mark. Alternatively, take the linear measure of half each line and measure that distance to the left of the centre line. Mark the place where the first letter begins. Choose a method to match your ability.

a Example: a printed invitation may have a base line of dots or a fine rule for the recipient's name(s). Determine letter height, and using pencil rule the mean line; mark off the centre point.

b Place tracing paper over invitation and write the name(s).

c Measure name(s) and determine their centre point; mark this immediately above name(s). Place tracing over card again; align centre points (of card and name). Lightly indicate on the card where to begin writing.

d The final arrangement.

a

b

c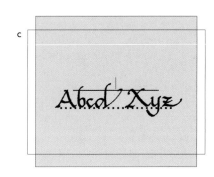

d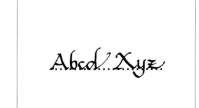

a There are many situations when it can be expedient to use a masking tape template to pitch work against. The measuring marks can be indicated on the padding of the board, to ensure less handling, and possible defacement of a final work, certificates, or in this case invitations.

b Centring lines of text.

a

b

Writing names on invitation cards and certificates which require guidelines can be more easily done using a masking tape template. Place one of the cards or certificates square on your padded working board. Parallel to the base and left-hand edge of the card (right-hand edge if you are left handed), fix strips of masking tape (like the L-shaped mask), extending a few centimetres beyond the length and depth of the card. (For certificates it is not necessary to extend the tape the full length and depth.) Place another strip on top of each of the first strips to create an edge against which the card can rest.

Slip your invitation card or certificate in position snugly inside the right angle of tape. Confirm that it is straight by placing a parallel motion, T-square or ruler along the base of any line, then position the ruler along the line (sometimes printed) on which the names will be written and mark this with a line either side on the padded surface top sheet. Mark the letter height above these lines. Follow the same procedure if there is no printed dotted line, but you must first determine the exact position for the lettering so place the card in position against the tape, then pitch the ruler to the pencil lines on the padding paper and rule the guidelines.

The design of posters, leaflets, invitations, certificates, poems, cards and stationery may require some part or all of the information to be centred. To assist with designing the layout for these items and other similar ephemera, prepare a base sheet by fixing to your board a sheet of layout paper larger than the intended final size. On this, mark up the final dimensions of the piece (if known) and place a vertical line where you want the visual centre point to be.

Using layout paper, write lines of the copy in the proposed letter size. If this is not known, do a few lines in a variety of sizes and styles. Measure the

length of each line and mark the centre point close to the writing with a dot or vertical dash. Neatly cut these lines out individually, trimming close to any capital letters, ascenders and descenders. Place each line on the base sheet, aligning the marked centre point with the vertical centre line. You may find it helpful to position a sheet of ruled guidelines beneath the sheet which contains the vertical pitching line.

Experiment by increasing and decreasing the interlinear spacing until the visual layout has achieved balance and satisfies your objectives and specifications. Complete the work as a finished rough by tabbing down the lines in position either with masking tape or a spot of glue. Use this to ascertain the final measurements of the interlinear space, heading placement, size and relationship with text and surrounding space.

Select the paper for the final work, tape it in position on your board, and mark off the dimensions. To mark off the position of the lines on the paper for the finished work, you can place the finished rough over the paper and using a clean pin, prick the starting point of each line.

# Preparing Camera-ready Artwork for Reproduction

The preparation of camera-ready artwork for reproduction has certain advantages over the production of an original one-off piece of work. This is because it can be prepared as a paste-up, that is, the work is prepared as individual elements and assembled together on one sheet. This allows errors to be corrected and the best rendering to be selected for reproduction.

Artwork for reproduction is prepared as positive, in black and white. There are exceptions of course; full-colour reproduction by off-set lithography and colour laser and photocopier can be presented as a positive in full colour. The best guidance for any printing situation is to discuss the requirements with your printer.

The black-on-white artwork must be of an excellent quality, clean and sharp, suitable for camera reproduction. The words 'line copy' describe work which has no half-tones, while the half-tone process is a method used to reproduce work containing, for example, photographs. Line copy is composed of line and solid areas whose tonal variations are created with dot, lines, cross hatching (lines), grain effects (dots) and solid areas and is the most used form of printing by calligraphers.

Traditionally, a metal plate was used for off-set lithography. This plate is still used to produce superior quality reproduction, particularly for long runs and full colour work. In the darkroom, the printer makes a negative of the artwork using a process camera. The film used is light-sensitive to white areas on the artwork. The black matter is opaque. The printer can paint out any shadows or irregularities using an opaque retouching fluid. Next the metal plate is made. The plate is treated with a light-sensitive emulsion and the negative is placed directly on it and exposed to light which cannot pass through the clear areas of the negative, the black parts on the original. The emulsion then hardens and the plate is washed and treated with chemicals. The image is now in relief on the surface of the plate.

There are also plastic and paper plates which require no negative and are made direct from artwork to plate. The selection of the plate depends on the nature of the print run and composition of the artwork. The most recently invented of these is the paper plate which has sustainable qualities for short runs (two hundred letterheads) and has substantially reduced the overall printing costs.

The artwork can be prepared to the same size (s/s) as the finished product. It can also be proportionally enlarged or reduced at the platemaking stage of the printing process. Caution needs to be exercised on some enlargements because the lines may thicken, begin to break up and become ragged. A reduction is better, but with large reductions fine detail could fill in and lines merge.

Select a fine-quality paper for the preparation of the artwork. For calligraphers, this can sometimes pose problems. The fine-line papers used in the graphic design industry for this task are usually too highly coated and the ink tends to sit on top and not dry. Also there is little resistance on the surface, causing the nib to skid out of control. Use any clean white paper which produces the required results. This is an area worth investigating if you expect to prepare a substantial amount of artwork.

In the beginning, use HP-finished paper which accepts ink and the tools of calligraphy. However, always seek alternatives, because HP can be too heavy for some paste-ups. A thick card or paper used for paste-up will tend to cast a shadow along its cut edges when being photographed. This shadow can be removed by retouching at the platemaking stage, but it is advisable to avoid the extra cost incurred by this fiddly work.

The surface of the paper should be white, smooth and flat. The flatness is important if the photograph of the work is to be sharp because a rough paper surface will break fine lines in reproduction. Even the surface of some cartridge

RODNEY SAULWICK

It is always an encouragement to see calligraphy in action, specifically applied in the market place. The carefully chosen type and calligraphy are totally complementary (with the sophistication of some electronic pre-press packages, it is difficult to discern whether additional quirks, flourishes and letter extensions were created by the hand of a calligrapher or a machine). A request to design a calligraphic form for this selection of wine labels - a range from one estate - required careful research of each product.

The red wines presented different concepts from the white. The brief for the Boutique white wine included acknowledgement of the 'noble rot' process used in manufacture: the solution was a condensed, textured italic form. The Muscat was also 'noble' in origin, and extra condensed Gothic was used. The Vintage Port had traditional pretensions, so a Gothic style to match was selected. All the artwork was prepared with Coit pen 1 or 3/8inch, Higgens Eternal ink on Bond paper. The remaining six labels required a touch of 'traditional elegance', so Copperplate, in a slightly bolder style for the reds and lighter for the white wines, proved acceptable. The camera-ready artwork for reproduction was prepared using mono-nib, sable brush, Higgens Eternal ink on Bond paper.

papers gives ragged edges to the lines of the letters. It may not appear so to the naked eye, but is clearly seen under a magnifying lens and may be visible in the reproduction.

The board on which the artwork will be mounted must be clean, flat and white. If no original artwork will be drawn directly on the board, its surface composition is of less importance. However, if you intend to paste lines of words in position and perhaps rule a border directly on the base board, the surface quality of a substrate must be considered.

The ink or other medium used to produce the images and text should be absolutely solid and dense black. Poor quality, watery ink will appear grey and require a lot of retouching. Avoid this extra work and expense by using a medium which retains its solid character, even for thin and thick applications. This is of paramount importance because of the fine lines inherent in calligraphy letters.

If an error is found after the paste-up has been completed, it can be corrected using several methods depending on the nature and size of the mistake. Individual letters can be amended by placing a small sliver of white sticky-backed paper in position on the artwork and rendering the correction directly on to the artwork. This is not recommended if the surface underneath is uneven because of overlapping paper or adhesive. It is possible to paste the correction directly over some small errors, but check that the surface underneath is clear of obstructions. If the error cannot be amended by either of these methods, remove the piece with the error on it, re-do it and, having cleaned the surface of the base board, paste the corrected work in position (see page 97).

Deciding which method to use to make a correction is mostly common sense. It can be difficult to make an accurate repair to a single letter in the middle of a word because there probably will be some overlapping and shared space between the

(far left)
This artwork is marked up, and shows the trim marks, lines to indicate copy and, the two elements which are to bleed off the page. Allow a minimum of 3mm ($^1$/8in) beyond the trim marks for the bleed.

(left)
The finished work.

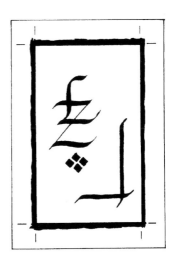

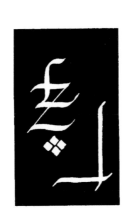

(far left)
Mark up a reversal, either with a thick border around the entire work to be reversed, or, with square brackets (like trim marks) marking off the area.
If the reversal is quite large, it is more sensible to indicate the area with the brackets.

(left)
The reversal.

letters. In this case, replace the entire word. To do this, check first that it will not cause more problems in the preceding and succeeding lines, particularly if the rendering is in lower-case and there are ascenders and descenders in the area of the mistake.

If you have to cut out a single letter or word from a piece of copy that is already glued in position, use a new scalpel blade and very carefully cut around the piece to be removed (see page 98). Use this method whether you are going to replace the word or close up the resulting gap in the line.

## Reversals and bleed

Artwork to be reversed black to white does not have to be prepared as white on black. Simply tell the printer to reverse the image from black to white and correctly indicate the area on the artwork.

To indicate the reversal of an entire work,

surround it with a black border, or draw a fine-line box to the bleed area outside the trim marks. If only one section is to be reversed out, it is best to get a reversed out print of this on its own. When this has been done, paste it in position on the artwork yourself. This will incur less expense and ensure that the final arrangement meets your design specifications.

Reversals can be used to good effect, especially in low-cost work where the budget only covers one colour printing. A reversal instantly creates added interest and works well in conjunction with bleeding an element off the page.

Bleed describes the part of an image or section of a design which runs off the edge of the page after the work has been trimmed. Technically, 'bleed' describes the area on a plate outside the trimmed size of a work. Where this occurs there will be no margin between the printed area and the edge of the sheet. Work with an element of bleed is always

printed on an oversized sheet, so the artwork must be prepared accordingly. Do this by providing a minimum extension of 3-5mm ($^1$/8-$^3$/16in) beyond the trimmed measure of the work, that is, continue your bleed beyond the edge of the trimmed size.

To prepare camera-ready artwork which includes bleed make sure the base board is larger than the final trimmed size of the work. On the artwork the element which bleeds must project beyond the trim marks. This ensures that when the finished work is trimmed the element which bleeds is cleanly cut with no margin between it and the edge of the page. Ensure that the artwork is clearly marked, indicating where the bleed is required.

One interesting example of a combination of these two processes can be seen on some business cards. The artwork is prepared black on white, and reversed to white on black. To make the most of a low budget, and still create an attractive, eye-catching item, the work can be printed in, for example, brown ink on bright yellow card. The areas which on the original artwork are black are now yellow, the colour of the substrate. The white and biggest areas on the original are brown. The reverse side of the card is yellow.

## Same size (s/s) artwork

If you have produced a finished full-size rough, this will furnish the final dimensions of the work, otherwise confirm the final dimensions with your original specifications. Mark these in non-reproducing blue pencil on a base board to which all the artwork will be glued. If the work is not being printed on cut-size paper it will be trimmed after printing, in this case, indicate the trim marks just outside the image area.

Not all work has to be trimmed to size by the printer using an electric guillotine. Some artwork can be prepared and printed directly on to the same size paper or board specified for the final work. However, one edge has to be regarded as the gripper edge. This means that a minimum of 10mm ($^3$/8in) must be left on one side where the paper is gripped and guided through the machine. If compatible with your design, the short edge is best. The printer uses cut-size paper and makes no trim.

For a fine-quality job, and particularly for a long run, the printer will use an oversize (SRA) paper because ink can build up on the blanket of the press, forming a scum which is imparted on to the work, so trim marks will be necessary.

A reasonable maxim for all flat design work is initially to regard the entire 10mm ($^3$/8in) margin area as out of bounds. Obviously this cannot be done where an element in the design is to bleed off the page, but when beginning your design sketches, work to this arrangement.

This sensible practice has other, wide-scale implications in design for print. Few designs appear visually satisfactory if lettering is placed closer than approximately 5mm ($^1$/4in) to any edge, unless this is part of the overall design of the work. This is also a useful rule because it allows for any misregistration that can occur during printing

HELENE SINCLAIR SMITH
DIANA HARDY WILSON

Designing personal and business stationery requires specific considerations to be addressed before a final solution can be selected. The visual impact needs to be memorable; this can be achieved by choice of colour, interesting substrate, lettering, overall layout and design, and the inclusion of a quirk or something unusual which makes the particular piece totally different from any the receiver may already possess. Knowledge of the target audience is essential: who is going to be receiving the letters and cards?

For the freelance worker, economics is a relevant and important consideration and, with this in mind, the final decision was to reverse and bleed the image on the business card. This has the effect of creating an illusion of something 'more' happening, like the addition of a second colour.

The work may appear as a relatively simple arrangement of calligraphic marks, which it is, but that is to deny the hours of initial discussion and subsequent manipulation of the marks before this particular configuration was agreed upon. There were many minute alterations to the angle and weight of the strokes and their length and proximity to each other, each change making a palpable difference, but not initially producing quite the sought-for balance.

Following the final agreement for the layout, a further decision was required to determine the best typeface for the specialist information. The letterhead used the motif printed black on off-white. The business card is printed using its portrait format.

exhibition
&
interior
design

**HELENE SINCLAIR SMITH**
107 GOLDHURST TERRACE
LONDON    NW6    3HA
TEL:    071 - 328  3881

a

b

c

a When appropriate for the work that is to be reproduced, paste the artwork two-up to make most efficient use of paper and plate, save on materials, and (where relevant) the cost of printing. This example has no elements which bleed, and will be printed on over-sized paper. Use this for work of odd sizes which will require trimming to specifications.

b This example of pasting two-up is to be reproduced on cut-size paper, and then a single cut will be made down the centre between the two identical works.

c If an element bleeds, the work can still be pasted-up twice, but will be printed on SRA size paper which will be trimmed when the ink is dry. Two cuts will be made and the artwork must be prepared accordingly.

(although this should not happen, it does). Misregistration can occur if the trim marks are incorrectly placed, causing the cuts to be made in the wrong place and a sliver of the final work to be lost. If there is more than one printing, the second image must fit perfectly within the first. Good registration ensures this.

Begin your preparation of the finished artwork by using fine blue pencil to rule the guidelines (see pages 88-9), indicate vertical lines for alignments, centre lines and any other marks as necessary. Before gluing, trim excess paper around individual pieces of artwork, but not too close to the words or images. Paste the artwork in position on the base board, taking care not to use too much adhesive. Make sure all lines are perfectly straight and properly positioned according to the overall design.

Before cleaning the work, make a final check that all the criteria have been met, that there are no spelling mistakes (literals) or other errors. The blue pencil lines do not need to be erased, but any excess adhesive must be removed. If there are any other foreign objects, such as specks of dirt, hair or dust,

remove them with a small brush or a pair of pointed tweezers. If these fail, or the dirt is engrained in the board or paper, paint out the offending mark with opaque white paint.

Protect the artwork at all times. This includes covering the areas of artwork you are not working on with a clean waste sheet while you are working on another section. The best covering is made by securing pieces of tracing paper with masking tape, thus allowing an overview of the work.

Keep a paste-up covered if you have to leave your work uncompleted. When the work is finished, attach a sheet of detail or typography paper to the back of the base board and flap it over so it covers the entire work. Further protection can be provided by adding a cover sheet of lightweight cover paper in the same manner. This is a standard presentation practice for artwork; it not only protects the design, but also shows your own care and commitment to your work. High quality presentation is very important, even when we only do it for ourselves.

The trace overlay can be used for writing instructions to the printer. These need to be written

clearly and lightly. This is a better method than writing the instructions in the margins because it allows you to indicate clearly specific items which require special attention.

You should talk to your printer about making maximum use of the plate onto which your artwork will be photographically transferred and from which the work will then be printed. It is common practice for a printer to paste, for example, an A5 letterhead '2 up'. This simply means that a photo-mechanical transfer (PMT) is made of your original artwork and pasted alongside the original. This is photographically transferred to a plate and, for a hundred copies to be printed, only fifty sheets of A4 paper need to be fed through the printing machine. When the ink is dry, one cut is made by an electric guillotine down the middle between the two identical images. It is also quite common practice, not to mention economically sensible, for business cards to be pasted-up four or more times. The printer will always make maximum use of a plate and it is in your own interest, especially financially, to be aware of this and utilize it for your own work.

# Proportion, Reduction/ Enlargement and Photocopiers

A work for reproduction can be prepared in any size, provided it is correctly proportioned for the required enlargement or reduction to create the final work. It is easier to prepare an enlarged version if the final size is to be very small. The converse applies: if the final size is large, it is preferable to prepare the artwork in a smaller size. In making these proportionate changes, the width and depth remain in proportion to one another.

To determine the proportional reduction or enlargement, rule an area using the dimensions of the known size. This could be either the final size of the piece, or the one you are working on and need to enlarge or reduce proportionately. Extend the left hand vertical line upwards and the horizontal base line to the right. Accurately rule the diagonal from the lower left corner through the upper right corner of the existing work. Any point along this diagonal line gives the correct proportions of the original work both in enlarged and reduced size. Find the size you require and rule the lines to enclose the plane.

For example, if you wish to determine the proportionally reduced depth of an existing work, fix it to your board with masking tape and place a sheet of tracing paper larger than the work over it.

Rule lines to indicate the exact edge of the work. You may wish to crop off, that is, trim, some of the image area or part of the margin area, so rule your dimensions accordingly. Draw the diagonal as before. Measure the width of the reproduction along the base line, left to right. At this point draw a vertical line up to meet the diagonal. The meeting point of these two lines indicates the depth of the reproduction.

Bear in mind that the reproduction obtained from using a photocopying machine is either minutely smaller or larger than the original from which you made the copy, depending on the machine used. This will not usually affect your work, but there are occasions when it does matter. However, being aware of this saves you wondering what has gone wrong. To gain a more accurate copy, set the photocopier one or two percentage points over 100% (or under, according to the machine).

Photocopying machines can be sensitive and it is common for the cut lines (shadow thrown by cut edges of the paper on a paste-up) to be reproduced. If this occurs you can eliminate the problem by painting the edges of the original paste-up with process white, an opaque white paint, or correcting fluid. Alternatively, take a clean copy of the original, paint out the cut marks and use the photocopy as the original.

The photocopier can be useful when trying different arrangements at the rough layout stage of your design; particularly the facility which makes enlargements and reductions. To determine a percentage enlargement or reduction: divide what the final width measurement is to be by the width of the work you have and, multiply by 100. That is:

$$\frac{\text{what you want}}{\text{what you have}} \times 100$$

The sum can be accomplished using a calculator by doing the division and pressing the percentage button. On a photocopying machine, the percentage enlargement or reduction is keyed in and the machine adjusts accordingly and produces the required work to size. The interpretation of the percentage increase or reduction needs to be read correctly. It is read as 100%, which is the original or same size, plus or minus the rest of the percentage.

For work where size and quality is critical, and to achieve the exactness required for artwork intended for reproduction, it is best to have a bromide made. This is a photograph of the original piece of artwork. It is known as a PMT (photo-mechanical transfer) and is produced in the darkroom on a process camera. This takes a

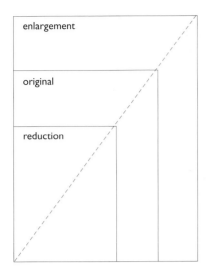
enlargement

original

reduction

The diagonal method of determining the correct proportions for a reduction or enlargement.

photograph of the black and white artwork and gives the excellent quality reproduction needed to produce an excellent quality print. It should assure a dense blackness.

Problems can occur when trying to make a PMT of artwork which has uneven blackness. This could be caused by inconsistencies in the strength of ink, giving a grey tonal quality of the kind sometimes produced when working with a brush. The camera will make compensation for the uneven quality, but this will be to the detriment of something else on the work, perhaps thickening fine lines as the camera tries to attain the necessary dense black.

If your camera-ready artwork to be reproduced by off-set lithography has to be altered in size, just tell the printer to increase or decrease it by a millimetre measure; that is, give the final dimensions. Make absolutely sure the work has been presented in the correct proportions.

It is important to ensure your printer has facilities to handle the actual size of the design. Some machines may not be able to print to the width you want, while other machines will print to the full width but not the full depth. Always confer with the printer to find out this kind of very important detail.

A further word of caution about copiers. The advent of colour and laser copiers has far-reaching and promising implications. One is the production of a colour work proof. A copy can be made of a piece of finished, full-colour artwork to give the artist an idea of how the work will look when it is printed. It must be regarded as only an idea; the copier may produce a bright, light work whose colours do not strictly match those of the original. The original is then used by the printer to make the plates and colour match before printing. The end result is true to the original artwork and not the colour copy, which can cause disappointment if you prefer the copy.

There are similar risks with full-colour artwork produced in paint and inks for print. The original is lively and bright and the calligrapher has been aware during the production process of every stroke, texture of paint and nuance of the work. The mediums on the substrate are in greater relief than when the work is printed, so the result is, in comparison, flat, lifeless and, on occasion, dull. Be aware of this difference.

Take care, also, when using photocopiers and laser printers with thermographed work. Thermography gives printed matter a luxurious raised and slightly glossy finish. It can be used to great effect on invitations, letterheads and business cards. The reproduction is done by the normal printing process and, while the ink is still wet, a powder is applied. The page is then exposed to heat, the powder reacts and raises the ink off the page with a resulting gloss effect. This can be used to highlight selected parts of a work. If a thermographed work is used in conjunction with some photocopiers and laser printers, the fusion rollers in these machines generate heat which can reheat the resin powder and messily repeat the image down the page.

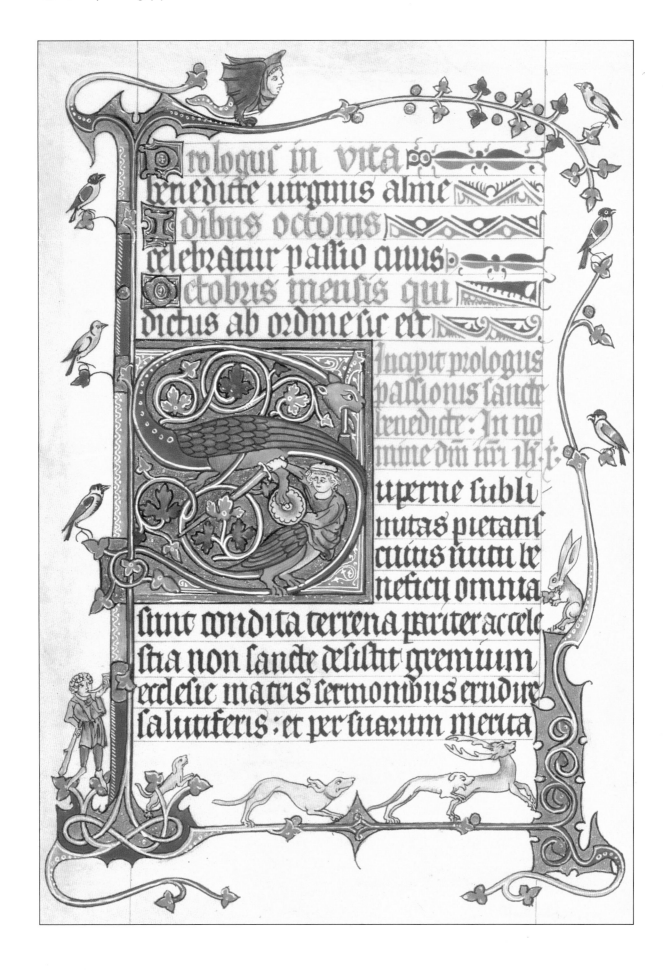

# Calligraphy for Inspiration

There is an enormous pleasure to be derived from looking at fine examples of calligraphy. This is true whether the work is a fragment of an ancient manuscript or an exhilarating *tour de force* by a contemporary calligrapher. The works reproduced in this section and throughout the book are included as an inspiration, to illuminate the adventure that marks calligraphy as both a great art form and a studied craft, to identify both simple and more complex methods and techniques of working with just twenty-six letters, and for the sheer joy of celebrating what many people are doing with these letters.

Learn from and be inspired by other people's solutions for presenting the words of a great poem or a single phrase. Where once there may have been a fear of plagiarism or copying which stunted artistic growth, our ideas have expanded and we can see that our work relies on our individual and very personal experience, the unique factor in each original piece of work. The shackles of conventional constructions must be removed to allow us unlimited expansion of our artistic and intellectual freedoms.

People frequently ask artists, writers, calligraphers, makers and creators 'where do you get your ideas from?' The source is of course our own experiences, but by looking at other work we can be inspired to continue with our own. At best, the resulting delight and excitement encourages us to push ourselves and our own work to our present limits, and then, beyond, to break through self-imposed and perceived barriers.

To be able to recognize and become familiar with all the nuances, quirks and some of the seemingly endless possibilities of calligraphy, we need to gain access to a greater variety of works composed by the greatest number of people. No one person's work can hope to cover the scope of calligraphic designs, arrangements, solutions and treatments. Some of the illustrated styles and idiosyncrasies may influence our own work, though they will undoubtably be altered by being viewed through our own unique perception.

Direct inspiration which does find its way into our own work can be short lived. We may reproduce a particular letter combination once or twice and then develop our own version, a refinement, or one more suited to our individual style and approach. Sometimes we may have a feeling for an arrangement of nebulous letter images which, with our training and discipline, will eventually evolve to a distinct individualistic style, uniquely one's own.

In the works shown, recognizable elements of calligraphy have been brought into focus so that individual discoveries can be made about how the work has been done and presented. Some are old, some use a contemporary method, others offer traditional or radical solutions. Many calligraphic

VIE DE ST BENOITE, NINETEENTH CENTURY
This is a facsimile of a folio from a 1312 volume. The single, hand-coloured page is resplendent with details for consideration. It has a solid border on one-and-a-quarter sides with extensions closing the remaining space to frame the text. The lighter, enclosing border is constructed of foliated branches upon and about which birds and animals play. The border, which begins as an extension to the inhabited initial 'S', illustrates a style which evolved in the thirteenth century.

The abstract line fillers illustrate the elegance that can be obtained by simple marks used in many combinations of shape and line. There are visible guidelines, between which the Gothic black letter text has been carefully placed.
CBL.WMS 196.241

solutions are very basic, almost instinctive. The language of calligraphy is one of marks, making marks and arranging them in a coherent comprehensive and legible manner.

The importance of making the best choice for a given problem and set of circumstances means research into substrate and medium. Learn from looking at how specific problems have been tackled. Think about how you might approach the same problems. Use the illustrations to help identify particular features of calligraphy and then go forth and find your own examples.

These simply decorated letters probably date from the late-seventeenth, early-eighteenth century. Each letter has been cut (an abominable habit) from an antiphonary. These are volumes of antiphons, versicles or sentences sung by one choir in response to another. In comparison with contemporary books, these antiphonaries are volumes of great dimensions because each choir had only one copy (manuscript) which was shared, so all singers had to be able to read the responses. These were frequently written in a colour, red or blue, so no confusion would occur. The substrate is vellum. The letters are reproduced same size as the originals.

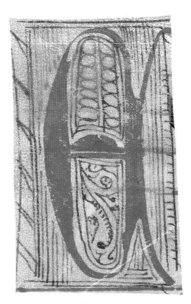

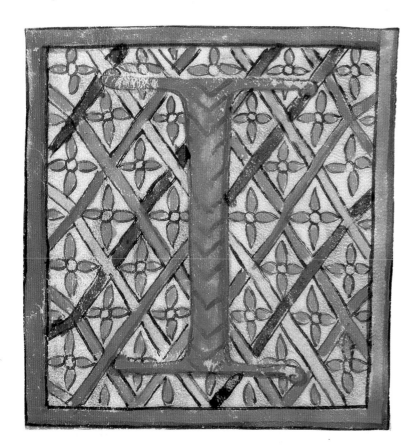

▶ DIANA HARDY WILSON
The labour-intensive qualities of calligraphy make it expensive to produce and, by implication, to purchase, even though its uniqueness makes it attractive. These lettercards were expressly made in a slightly less labour-intensive manner in order to achieve a more realistic retail price at a Kunst-Handwerkermarkt in Germany. 149 x 105mm (postcard)/5.87 x 4.12in

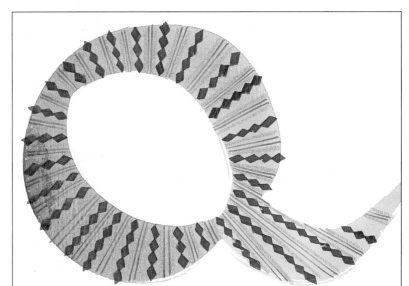

▼ DIANA HARDY WILSON
Close examination of elaborate looking, decorated initial letters in manuscripts reveals that many are constructed of strokes and marks simply manipulated and repeated. At the same time there is a growing awareness that there is no 'right', 'wrong' or 'too much'. Thus inspired, inhibitions may begin to evaporate and an inner critic be silenced. This small 'C' is the result of such exploration.

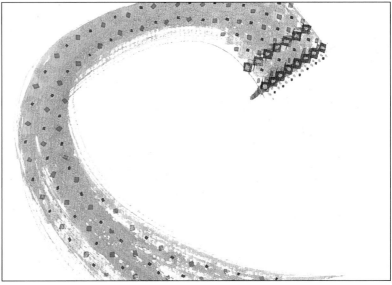

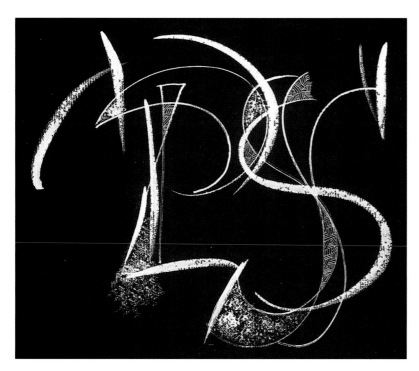

ANNA PINTO
This experimental work is an attempt by
the calligrapher to explore further a
technique already developed - that of using
fine cross-hatching to decorate letters.
White paint has been applied by brush,
bamboo and pointed pen and a cloth was
used to stipple the black, Ingres paper.
230 x 300mm/9 x 11.87in

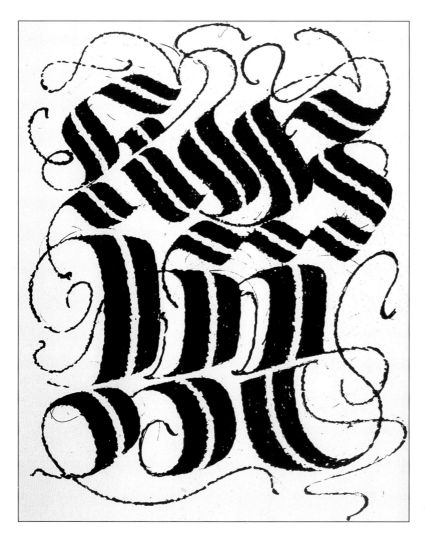

KARL WILHELM MEYER
A picture created in freely drawn Gothic
letters using drawing pen and ink.

▶ PAUL SHAW
Self-promotion mailer displaying a logo
initial letter. The camera-ready artwork was
produced by pen with egg-yolk ink. The final
work was printed by offset litho on UV
Ultra paper. The movement through the
enlarged red 'S' is echoed in the layout of
the information set at a complementary
angle. Initials, either individually or
combined to create a monogram, are good
sources for calligraphic exploration.
254 x 254mm/10 x 10in

▼ JEAN LARCHER
Experimental work entitled *From Calligraphy
to Typography* composed of four hands -
Roman capitals, Chancery cursive, Fraktur
and Copperplate - produced by a pointed
and a broad-edged pen with black Indian
ink and watercolours on Ingres D'Arches
MBM paper. Optima typeface, designed by
Hermann Zapf has been embossed by hand.
The letters of each hand are positioned on
each other to reflect the passage of time,
signifying the evolution of these styles
through the centuries.
500 x 560mm/19.75 x 22in

The letter Z is the most neglected character in the English language
The frequency of its use within 1000 characters is only 1

LUDO DEVAUX
An analysis of the frequency of use of individual letters is depicted in this alphabet work. Written on Ingres paper with speedball pen, gouache and acrylic paint, the concept creates an informative piece of work.
500 x 700mm/19.75 x 27.63in

► MARGARET LAYSON

A calligrapher is never short of subject matter. The alphabet has
limitless possibilities for exploration and experimentation: there is
always a new discovery to be made in presenting just twenty-six
forms. After choosing a basic block shape, these letters were
constructed from two layers of Canson paper. The aim was to have
the alphabet projecting in relief from the background, and to help
in achieving this, the letters were slotted where parts crossed over.
The letters are 1mm high at each end, growing darker and rising to
2mm in the centre of the work. Each letter was carefully moulded
to shape, then glued and set into the base by means of a slot cut
with a scalpel.

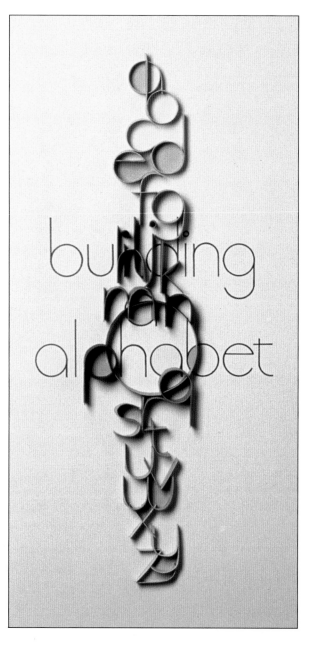

► KARL WILHELM MEYER

Using a hand-cut bamboo pen, this alphabet was hand-drawn very
quickly. The pen permits an agility of movement which results in a
visual rhythm of thin and thick strokes.

◄ DIANA HARDY WILSON

An alphabet showing letters with decorative elements both applied
and used to construct the whole letterform.
205 x 70mm/8.12 x 2.75in

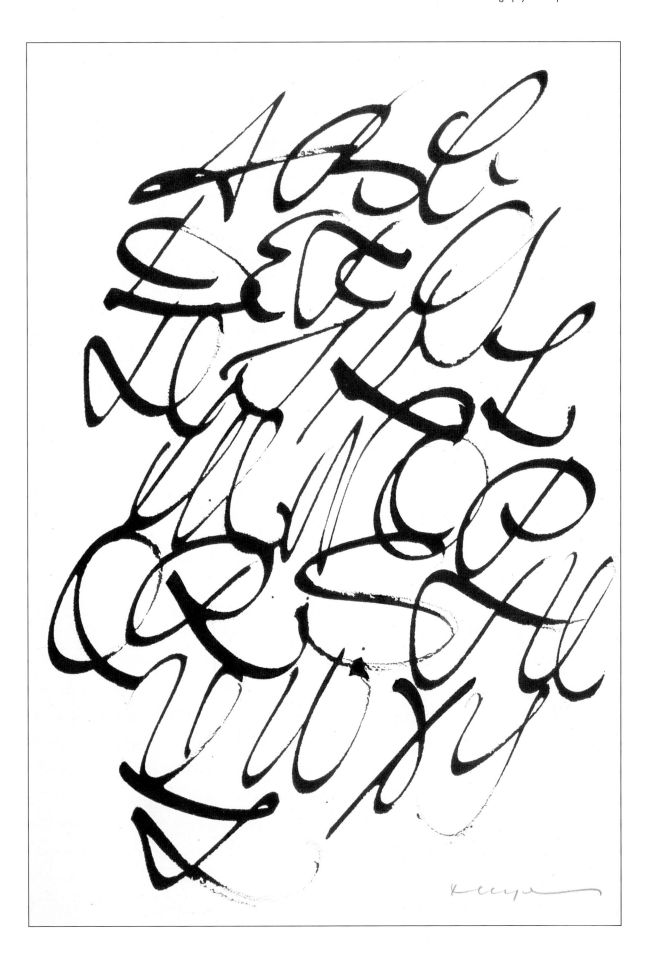

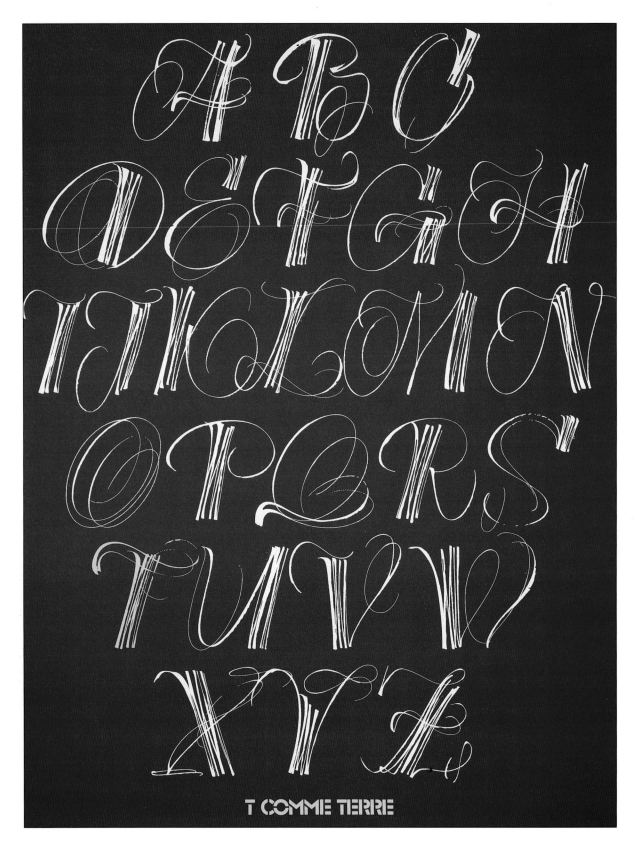

JEAN LARCHER
To celebrate the Earth Day in 1990, this alphabet was produced as camera-ready artwork, using a ruling pen and black Indian ink on layout paper. Each letter was built up, line by line. The image was reversed and printed by silk-screen process in two colours as a signed limited edition of one hundred prints.
750 x 1000mm/ 29.5 x 39.37in

◀ ELAINE WITTON
The *Dance of the Pen* is freely written
Foundational hand capitals using ruling pen
with Chinese ink on paper. The placement
of the red marks echoes the Chinese
calligraphers' and artists' use of a seal as
signature and identification, adding further
interest and acting as an anchor for the
words. If you place a white sheet of paper
over the red marks, the words float on the
page and, although this may complement the
concept of dancing, it lessens the
effectiveness of these dancing letters. They
also reflect the stress, tension and control
of dance; and so it is with the dance of the
pen.

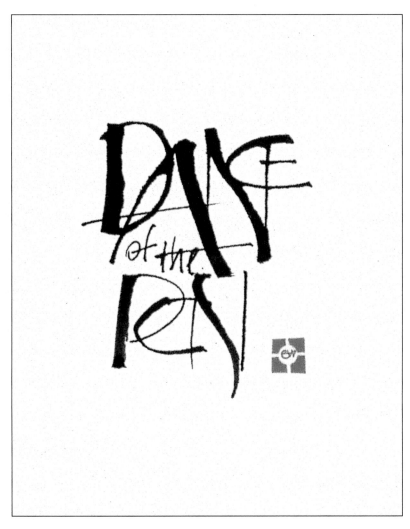

▼ RODNEY SAULWICK
An informal design composed to express
some of the elements found in art and
design. The words were produced by using
metal nib, technical pen, brush and ink on
A6 Bond paper.

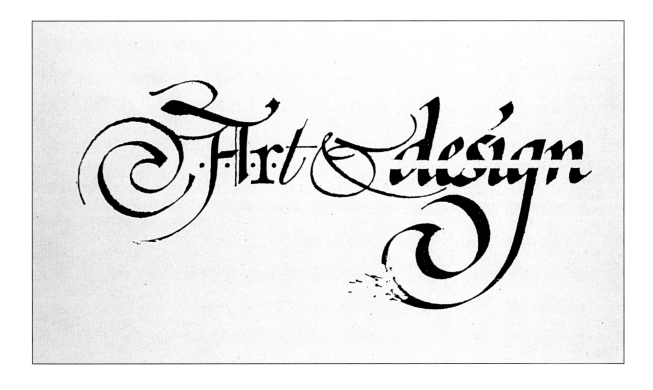

▶ ROBERT BOYAJIAN
Calendars are only one of many functional
items which present exciting possibilities for
designing with calligraphy. This page is from
a monthly wall calendar, written in gouache
using assorted pens  A few dried flower
petals complement the surface and finish of
the hand-made paper.
318 x 406mm/12.5 x 16in

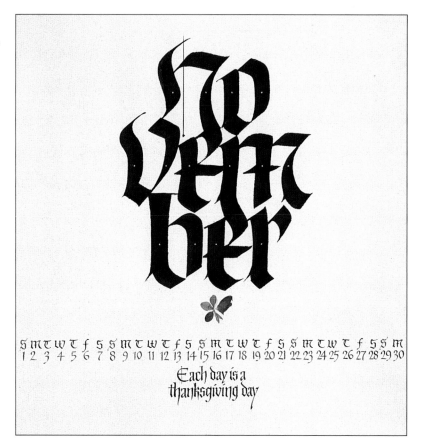

▼ RODNEY SAULWICK
An encouraging occurrence surrounded the
production of this word. It is the name of a
primary school where, with great insight
and foresight, a calligrapher was chosen as
Artist in Residence to introduce some of
the many facets of calligraphy to the
children (and some adults). It proved an
exciting and illuminating time for everyone
concerned.

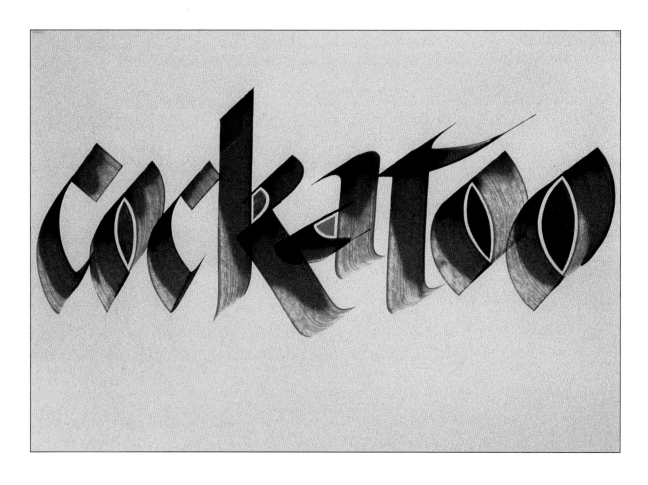

◄ FRANCES BREEN
This work entitled *Bansheanchas* is based on an historical list of Irish women from old Irish manuscripts. The surface of Arches Hot Pressed paper has been painted with walnut ink using a Chinese brush. The lettering was then reworked with water, using veneer and watercolour brushes.
220 x 200mm/8.63 x 7.87in

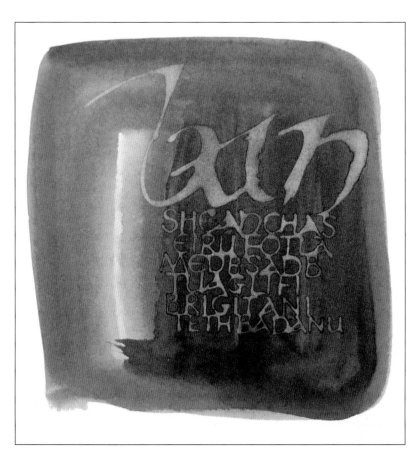

▼ RODNEY SAULWICK
An intrinsic beauty of calligraphy is its flexibility to address any situation. The ability to manipulate the letter-forms with visual design permits evocative productions ranging from terribly serious and rigidly formal, to gloriously grand and flamboyant, celebratory, humorous, informal and totally free. This presentation in a free style to express gratitude was rendered with a Coit 3/8th pen and fountain pen ink on A4 Bond paper.

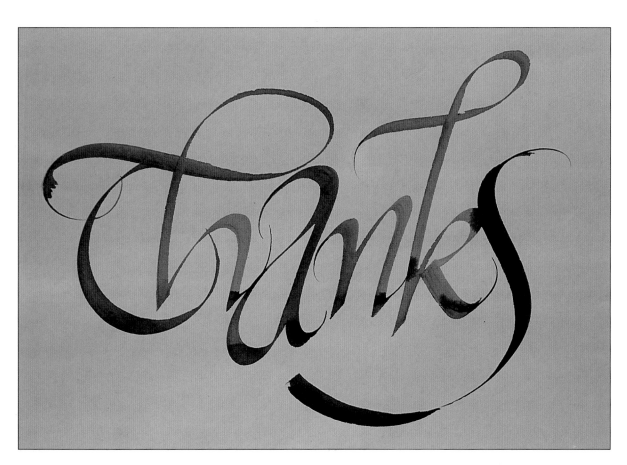

▶ KARL WILHELM MEYER
Making and repeating marks with colour felt
pen has created a decorative ground
reminiscent of woven fabric or stitches of
needlepoint. The white areas left
'unadorned' expose the foundation shapes
of Roman capital letters.

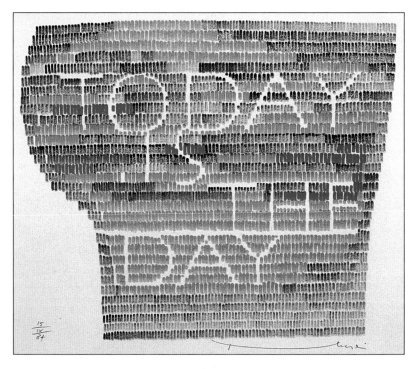

▼ MEGAN McDONALD
This italic sampler echoes the embroidery
samplers of past centuries. The design is
more contemporary than the often painfully
worked samplers of our forebears, but the
concept is still vibrant and viable. Fibre-tip
pens were used for the ground, and metal
nibs with ink were used to write the
various italic forms.
680 x 540mm/26.75 x 21.25in

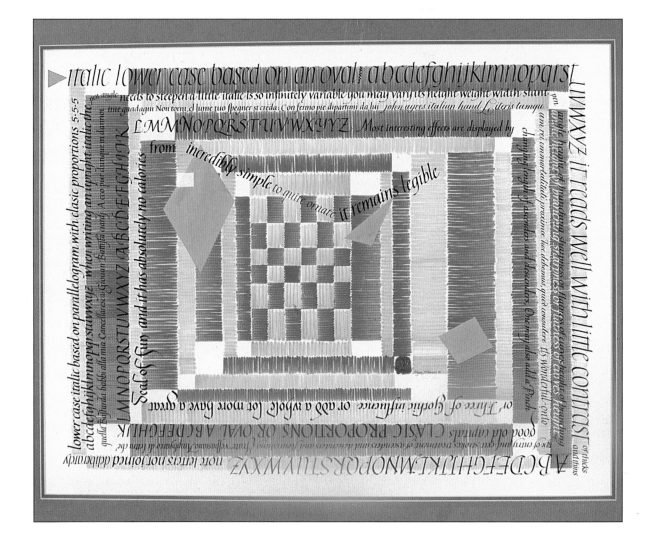

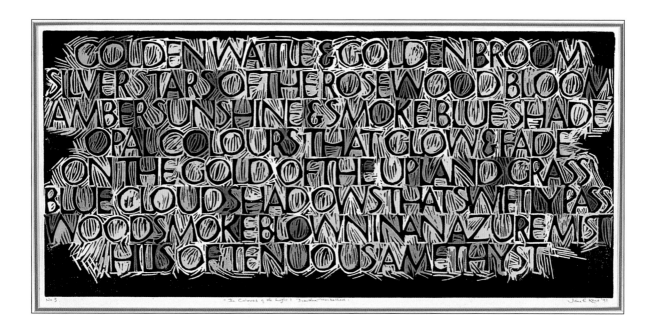

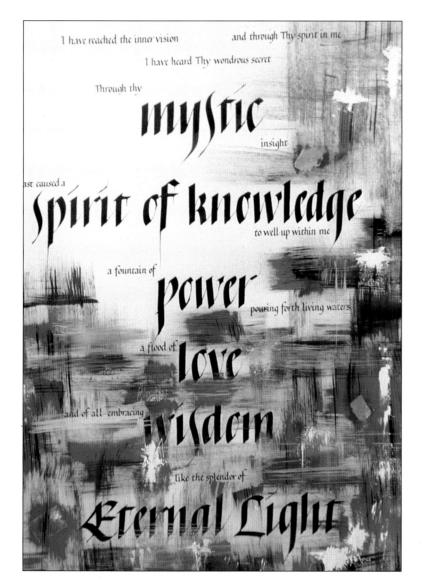

**▲ JANE KENT**

Exploring different methods, experimenting with materials, and new ideas is incredibly time consuming, but seldom time wasting; rarely is there totally negative feedback or absence of discovery, warranting no further investigations to be conducted. Calligraphers always seem to continue, ironically and particularly working with tools and techniques of disciplines of equal intensity to their own. If the work pushes past limits aside, then much can be learnt.

   This work began as a lino cut with letters carved in relief. It was then printed by hand using oil-based printing inks on rice paper. Watercolour washes were applied individually to each print. The work evolved during a search for form and colour to express the words of an Australian poem by Dorothea Mackellar. Influences and inspiration were found in works by Rudolph Koch and Paul Klee: specifically, Koch's Neuland hand, and Klee's 1918 watercolour *Already Submerged in the Greyness of Night*. 610 x 280mm (printed edge)/24 x 11in

**◄ ANNIE MORING**

Calligraphic inspiration was found in these words from the Book of Essenes: 'I have reached the inner vision'. Working on Arches paper, acrylic colour and pieces of gold leaf were used to create a strong background to the words rendered by metal nib with Chinese ink and gouache. 330 x 483mm/13 x 19in

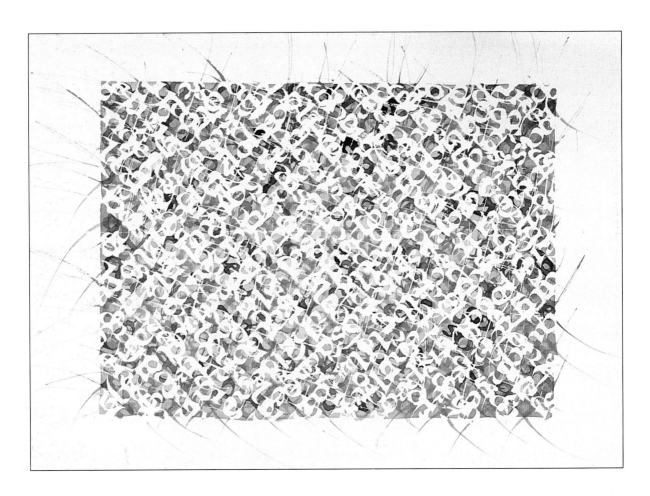

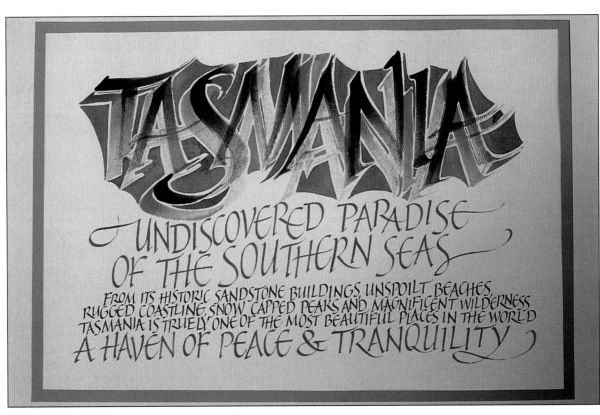

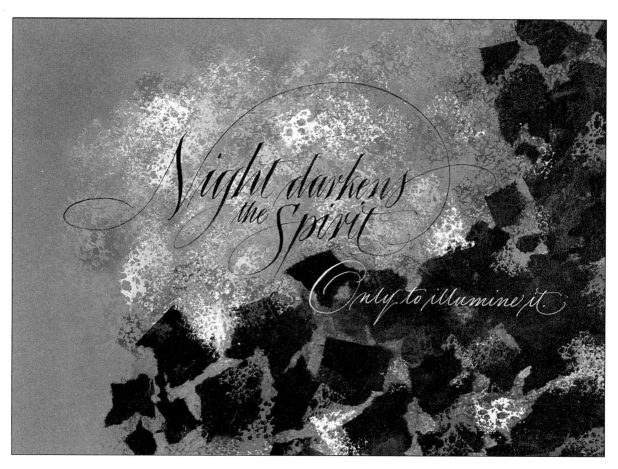

▲ CAROLINE PAGET LEAKE

Determining an appropriate layout for a quotation is usually a personal and artistic consideration, dependent on an interpretation of the words juxtaposed with a designer's eye for how to communicate that interpretation. This exhibition work was produced by pointed flexible nib held in an oblique holder, with Sumi ink. The Canson paper was prepared and decorated with gouache using sponges of various grades and sizes to give a sense of texture, particularly in the lighter colours. Torn black tissue paper was used as a collage material to give a greater sense of depth and density to the sponged texture. The choice of writing colour then became a matter of light tone on dark, and vice versa.

This approach, treating writing, colours and design as an integrated whole, is a challenge, but infinitely more satisfactory than attempting to address the background and writing independently of one another. In employing an overall design strategy, every mark made, every material and piece of equipment used, must be considered in relationship to one another and must embrace the whole concept of the design. A more fragmentary approach is often less satisfactory although, due to circumstances, this is occasionally unavoidable.
241 x 318mm/9.5 x 12.5in

▲ REILTÍN MURPHY

Patterns made of calligraphy strokes are often used for borders and line fillers. However, calligraphy itself is capable of producing patterns of interest and diversity, each with their own complexities. These patterns will usually be created by the addition of specific effects, such as changes in the weight of writing, decrease or increase in interlinear space, colour contrast and tonal changes, to develop rhythm and texture. This exhibition work entitled *Autobiography* creates its own pattern, shapes and texture through some of these methods. The work was composed using Brause nib, masking fluid and watercolour on watercolour paper. Fine hair lines, created by dragging wet paint with the corner of a nib or a very fine brush, project into the margin area. This is a style reminiscent of some decoration of old manuscripts, in particular, enlarged capital letters found in medieval antiphonaries.
330 x 230mm (image area)/13 x 9in

◄ JUNE FRANCIS

Calligraphy is an excellent medium through which to convey personal and shared sentiments. Making a statement about the smallest state of Australia begins with bold letters, written using a balsa-wood pen with coloured ink. The text, composed by the calligrapher, expresses the fact that the number of attractions for residents and visitors is far from small. The words are written using metal nibs with gouache.

**JUNE FRANCIS**

The *Serenity Prayer* is written and decorated in gouache on Arches watercolour paper. The gilding is transfer gold on acrylic gesso. The importance of selecting a style which is appropriate, complementary and sympathetic to the context of the words, and then finding a design which supports this choice is clearly illustrated in this work. Further decisions must be made concerning presentation. Ideally, these can be made as an integral part of the overall design plan. For this unelaborated work, with words written in Uncial, there are no visual distractions from the content of the prayer, but an added richness is achieved by using a marble paper mount of subdued, dark hues.

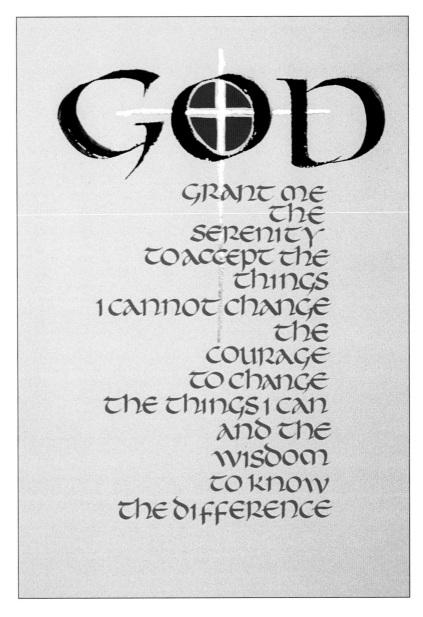

**MELANIE GOMM**

Even using a limited selection of calligraphy equipment, the wide choice of production methods can ensure great variety in the final work. A range of metal nibs guarantees a breadth of results unrivalled in many other visually creative disciplines. This aspect of calligraphy production allows great freedom to express ideas and explore an enormous variety of concepts. Working on a personal exploration, this work was set up as a challenge to write very small and precisely. The fine lines of the capital letters are only 3mm in height in this rendering of the Chinese Taoist philosopher Lao Tsu's *Kindness in Words*. The materials are gouache with steel nib on Fabriano paper.

68 x 47mm (unframed)/2.63 x 1.87in

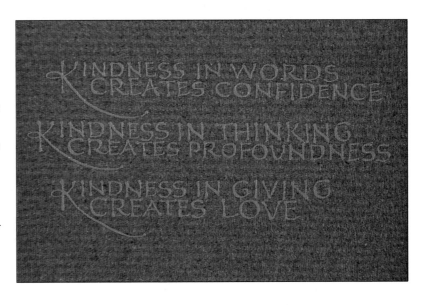

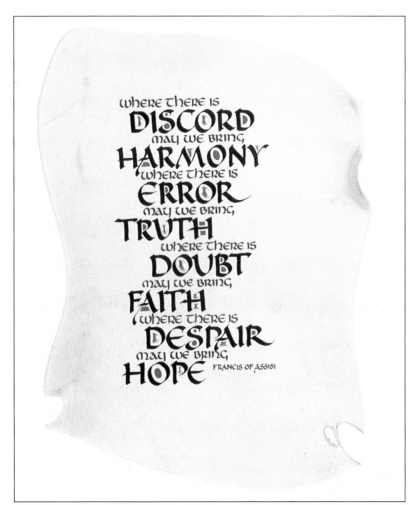

STUART BARRIE
This exhibition piece has fine letters drawn with a brush using ink and gouache on hand-made paper. The presentation of this quotation from the Gospel of St Luke defies the difficulty in organising work in this circular format. As a guide, use radial lines from the centre of the circle to aid rendering work in this way.
400 x 400mm/15.75 x 15.75in

GWYNETH DAVEY
A rendering of a prayer by Francis Assisi written with pen and Chinese stick ink on vellum. The modern, pen Roman letters provide generous counter spaces for the raised gilding on gesso, an uncomplicated and effective method of decorating letters.
350 x 280mm/13.75 x 11in

children are like kites, you spend a lifetime trying to get them off the ground. You run with them until you are breathless, they crash, you add a longer tail, they hit the ground, you pick them up, you patch comfort and adjust, then watch as they are lifted by the wind, and assure them that someday they'll fly. Finally they are airborne, but need more string, you keep letting it out, and with each twist of the twine, there is a sadness that goes with the joy, because the kite becomes more distant and somehow you know that it wont be long, before that beautiful creature will snap the lifeline that bound you together and soar as it was meant to be.....

## Free and alone

**LYNDA COWAN**
Black ink and gouache have been used to effect this work. The unusual and effective border is composed of extracts from the main text, plus additional personal detail, combined with streaks of pale blue and imitation gold.
500 x 650mm/19.75 x 25.63in

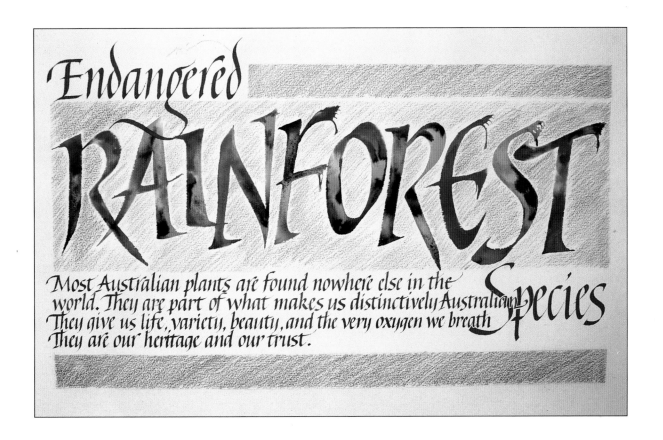

**Endangered RAINFOREST Species**

Most Australian plants are found nowhere else in the world. They are part of what makes us distinctively Australian. They give us life, variety, beauty, and the very oxygen we breath. They are our heritage and our trust.

▲ JUNE FRANCIS
*Rainforest* captures the enormous variety of colours found in the flora of Australia. The word was rendered with water, and drops of Dr Martin's pure watercolour were immediately applied to the wet letters. This method creates a mottled appearance - reminiscent of that which occurred accidentally in childhood paintings.

◀ JUNE FRANCIS
Sources of information can be found in unusual and interesting locations. This recipe for rose jam was found at Narryna, The Tasmanian Folk Museum in Hobart. The text is written in black waterproof ink and decorated with gouache and watercolour. The selection of materials and the nature of the design took into consideration the Georgian era of the early settlement of Tasmania by the British, from which the words originate.

DAS BUCHSTABENMACHEN
IN JEDER FORM IST MIR DAS
REINSTE UND DAS GROESSTE
VERGNUEGEN UND IN UNZAEH
LIGEN LAGEN UND VERFASSUN
GEN MEINES LEBENS WAR ES
MIR DAS WAS DEM SAENGER
EIN LIED DEM MALER EIN BILD
ODER WAS DEM BEGLUECKTEN
EIN JAUCHZER DEM BEDRAENG
TEN EIN SEUFZER IST ES WAR
UND IST MIR DER GLUECKLICH
STE UND VOLLKOMMENSTE
AUSDRUCK MEINES LEBENS
RUDOLF KOCH

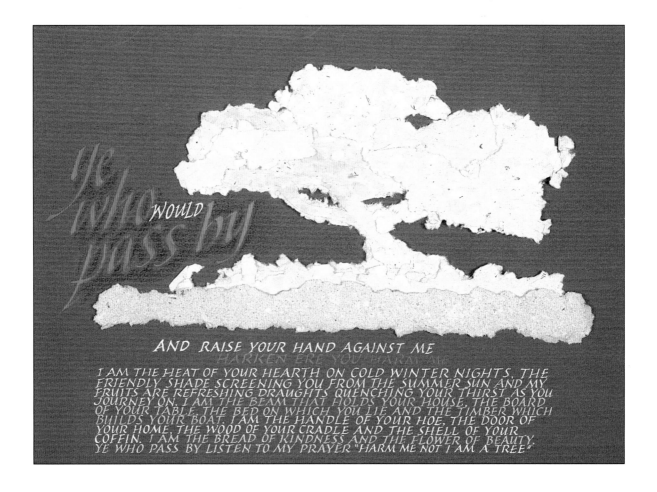

ye who WOULD pass by

AND RAISE YOUR HAND AGAINST ME
HARKEN ERE YOU HARM ME
I AM THE HEAT OF YOUR HEARTH ON COLD WINTER NIGHTS, THE
FRIENDLY SHADE SCREENING YOU FROM THE SUMMER SUN AND MY
FRUITS ARE REFRESHING DRAUGHTS QUENCHING YOUR THIRST AS YOU
JOURNEY ON. I AM THE BEAM THAT HOLDS YOUR HOUSE, THE BOARD
OF YOUR TABLE, THE BED ON WHICH YOU LIE AND THE TIMBER WHICH
BUILDS YOUR BOAT. I AM THE HANDLE OF YOUR HOE, THE DOOR OF
YOUR HOME THE WOOD OF YOUR CRADLE AND THE SHELL OF YOUR
COFFIN. I AM THE BREAD OF KINDNESS AND THE FLOWER OF BEAUTY.
YE WHO PASS BY LISTEN TO MY PRAYER "HARM ME NOT I AM A TREE"

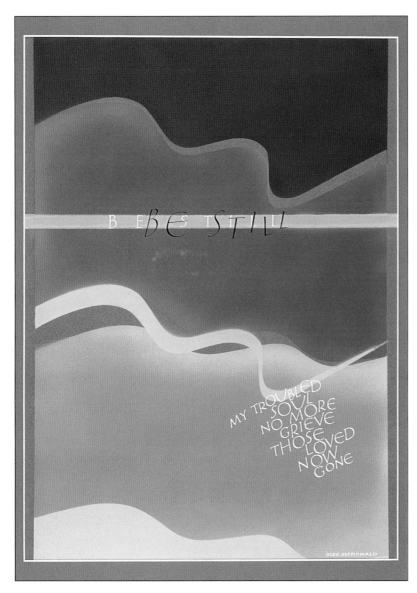

◀ MEGAN McDONALD
Preparing, treating or altering a substrate in any manner can seem to give the words a firmer grounding, add richness and vitality, or evoke certain moods. The methods which can be used include staining, collage, wash, masking, sponging, cut-out and embossing.

This experiment with airbrush and ink demonstrates another method. Areas were masked during airbrushing, so that there was control in the areas exposed to the ink. Steel nibs with gouache and ink were used for the lettering.
270 x 370mm
10.63 x 14.63in

▲ KARL WILHEM MEYER
Foundation shapes of Roman capital letters rendered with colour felt pen have been decorated with fine points of colour in this picture of words by Rudolf Koch.

◀ COLLEEN LITTLE
All the lettering in this work was produced by metal nib and gouache. The red italics which act as a title immediately capture the attention, clearly illustrating that a heading does not necessarily have to be positioned at the top of a page. Colour and tone, style, and a change in weight and size of lettering in relationship to the remaining text, can be used to support a heading placed elsewhere on a page. The remaining lines of this poem are freely rendered Roman letters with more interest created and legibility aided by the slight alteration in tonal quality. The image of the tree was constructed from torn hand-made paper.

Contemporary calligraphers are most fortunate in the ready availability of an enormous range of materials, equipment and substrates. There are attendant drawbacks to this accessibility and quantity; one is the consistency of quality, another is the difficulty of making the best selection for a specific purpose. Take note of those that give favourable results, and never stop experimenting and trying new materials which can be added to a 'good to work with' list.
380 x 260mm/15 x 10.25in

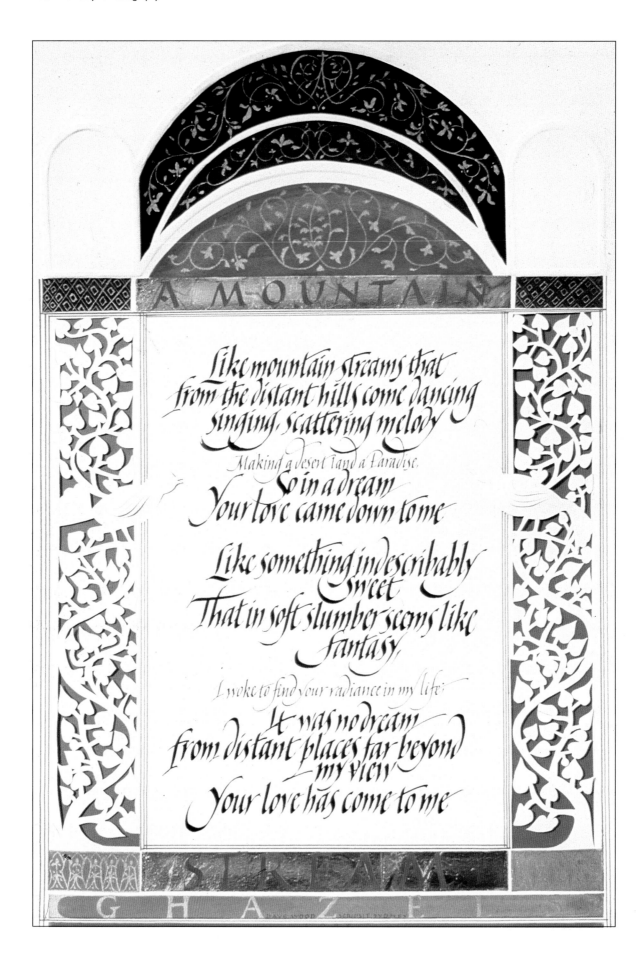

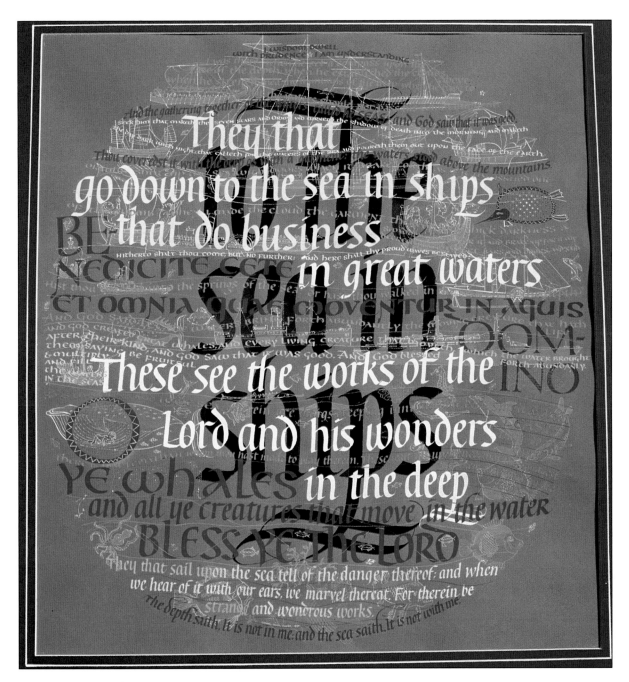

**▲ KENNEDY SMITH**

The determination of a design which communicates on many levels is not easy. A design can reflect the meaning of the words, and the author's subtext. A calligrapher's interpretation is another layer. The best way to communicate these thoughts and images without compromising either the author or the artistic eye of a calligrapher is not easy to find. Exploration and experimentation with visual ideas, aided by trying different materials and methods of production could occupy an entire lifetime.

This work is a result of numerous experiments, culminating in the large letters produced with waterproof black ink, intermediate scripts written with acrylic, and smaller writing in gouache on Canson paper. The line drawings which decorate the work were effected by quill pen and watercolour.

500 x 460mm/19.75 x 18.12in

**◀ DAVE WOOD**

A *Mountain Stream* is a Persian love lyric rendered by steel nib with gouache and Chinese stick ink, with variegated gold. Delicate hand-cut lace work and the colours gold and blue were only incorporated after extensive research of ancient Persian architecture. Particular interest was found in the minarets, and also the strong tradition of depicting Islamic calligraphy on ceramic tiles in pure blue hues.

580 x 420mm/22.87 x 16.5in

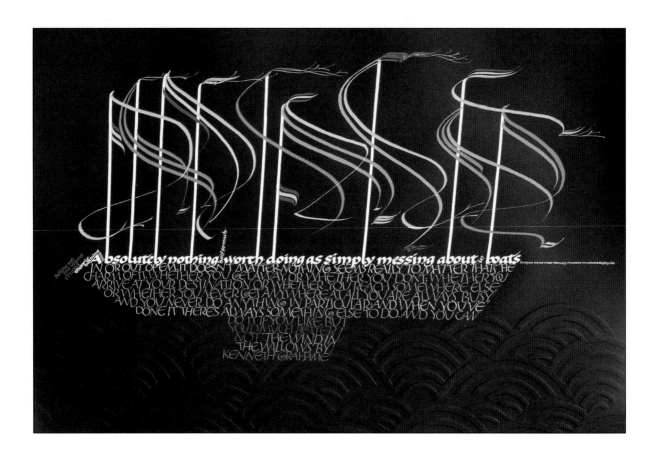

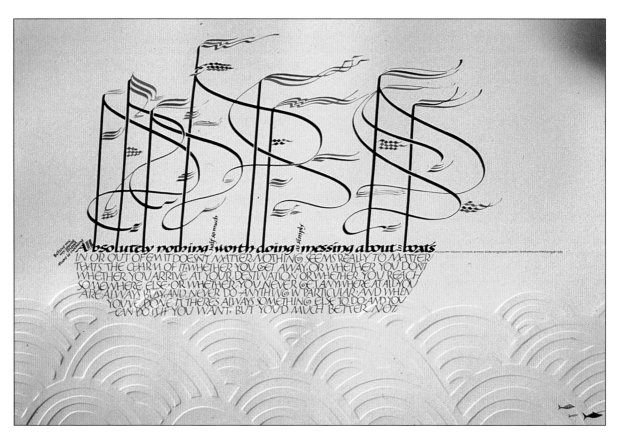

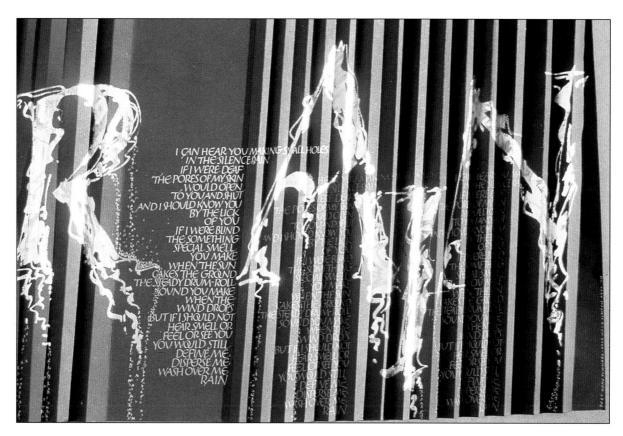

▲  DAVE WOOD
Considerations for a single calligraphic work are many and may include choice of subject matter, imagery, words, feelings and emotions, perceptions and understanding, besides specific design and practical considerations. This extraordinary work, and others in the same series which exploit the same subject, are made stronger and more convincing by the calligrapher's personal understanding, interpretation and experience of rain. The poem is by the Maori poet Hone Tuwhare. The words have been silk screened, using a 'blend' method, of more than one colour on the same screen (sometimes known as a rainbow roll). The bold use of variegated gold for the large letters creates an effect similar to the shimmering light on a dark, wet, road surface. The light source could be either headlights of a moving vehicle or stationary street lamps. Additional detail is the folding of the substrate to represent the rippling, unpainted corrugated iron used for many roofs in antipodean countries.
580 x 420mm/22.87 x 16.75in

▲  DAVE WOOD
The use of bold, opaque, gouache colours on black Canson paper proves striking and effective. The freely flowing calligraphic marks attached to the tall, slender masts evoke boats of earlier centuries, but the keel composed as a calligram is very contemporary. Its shape is the profile of the controversial, but award-winning Australian design which helped that country to win the America's Cup in 1983.
580 x 420mm/22.87 x 16.75in

◄  DAVE WOOD
This presentation illustrates how the choices of substrate colour and modifications can alter the ambience of a work. Although the fundamental imagery is the same and the pictures have their own identity, the colour changes create a very different mood and impact. Steel nib was used with gouache and just a hint of colour to indicate flags and ensigns flying from the masts, inspired by the idea and perceived imagery of the Spanish Armada and similar fleets.
580 x 420mm/22.87 x 16.75in

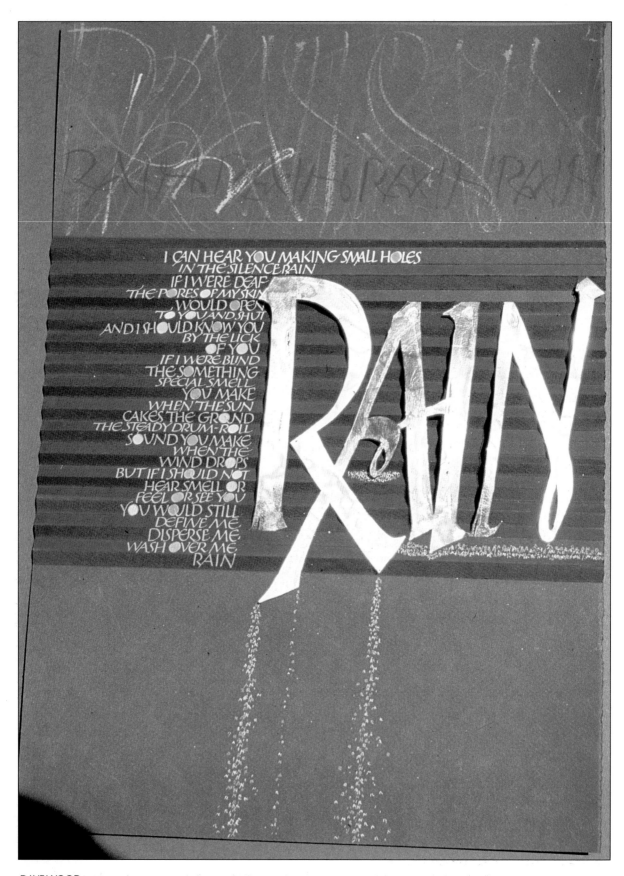

I CAN HEAR YOU MAKING SMALL HOLES
IN THE SILENCE RAIN
IF I WERE DEAF
THE PORES OF MY SKIN
WOULD OPEN
TO YOU AND SHUT
AND I SHOULD KNOW YOU
BY THE LICK
OF YOU
IF I WERE BLIND
THE SOMETHING
SPECIAL SMELL
YOU MAKE
WHEN THE SUN
CAKES THE GROUND
THE STEADY DRUM-ROLL
SOUND YOU MAKE
WHEN THE
WIND DROPS
BUT IF I SHOULD NOT
HEAR SMELL OR
FEEL OR SEE YOU
YOU WOULD STILL
DEFINE ME
DISPERSE ME
WASH OVER ME
RAIN

**DAVE WOOD**
An original version of the *Rain* poem produced by steel nib and gouache. The falling and fallen letters spell out 'rain' and the names of the poet, Hone Tuwhare, and the calligrapher.

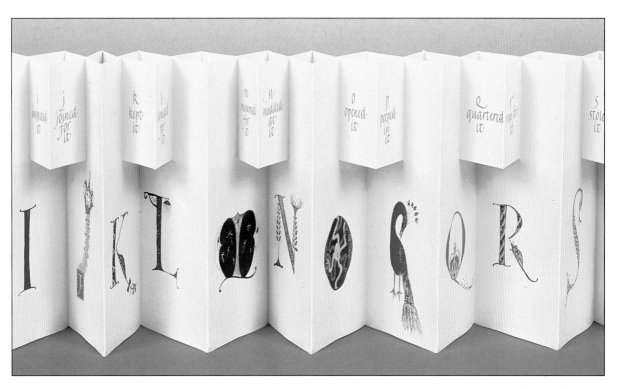

**DAPHNE DOBBYN & CATRIONA MONTGOMERY**
Detail from an alphabet manuscript book. This is the product of a collaboration between a bookbinder and a calligrapher - two most complementary disciplines. The lettering and decorative details were rendered with gouache on Canson paper. Japanese paper was hand-printed for the cover.
80 x 150mm/3.12 x 5.87in

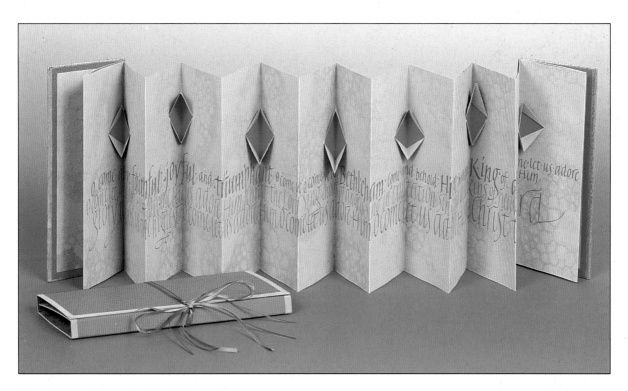

**DAPHNE DOBBYN & CATRIONA MONTGOMERY**
Another collaboration between bookbinder and calligrapher, using marbled Canson paper, with gouache and gold leaf. This extraordinary manuscript includes an interesting manipulation of the paper to create a quirk which evokes the idea of a choir singing in their choirstalls with mouths wide open.
100 x 200mm/3.87 x 7.87in

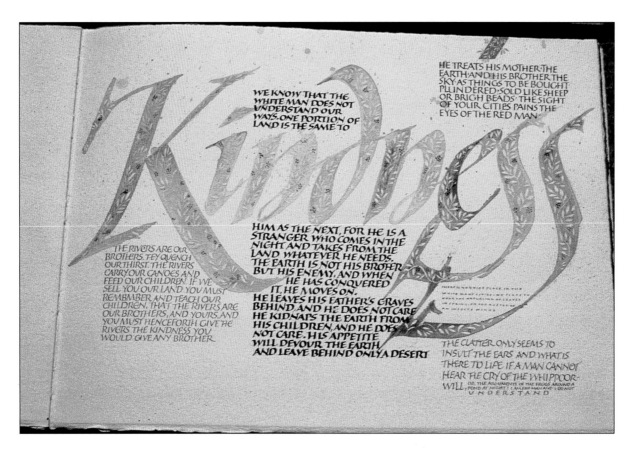

▲ DAVE WOOD

An A4 French binding provides this presentation of Chief Seattle's famous 1854 environmental statement. The words of *This Precious Earth* are rendered on Roma paper by steel nib, brush and sponge with gouache, and additional decoration and emphasis with variegated gold. The discovery of some irregularities on the painted surface of a letter in the word 'kindness' led to its decoration. Although this may have occurred by default and not initially by design, it proved to be a worthwhile discovery, and the word which dominates the page was delicately decorated using steel nib with gouache.

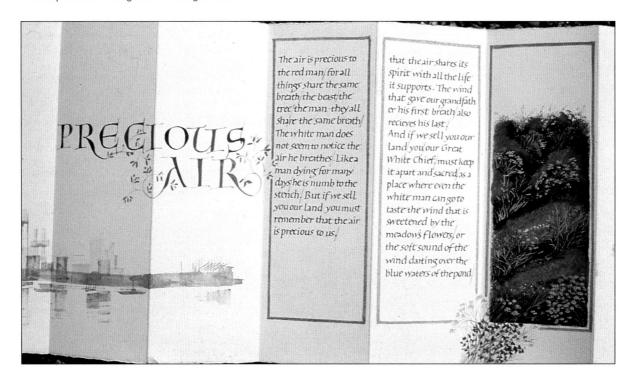

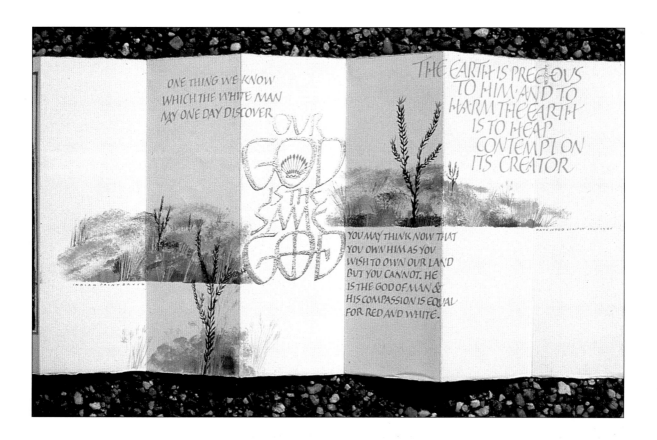

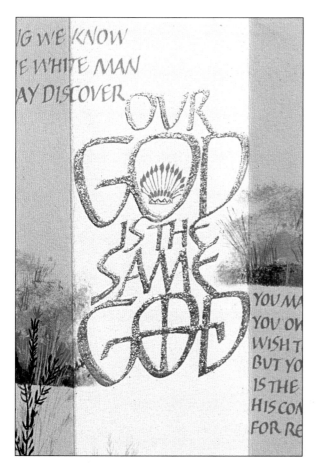

▼ ◀ ▲ DAVE WOOD

A different rendering of Chief Seattle's environmental statement presented in concertina format. The concept was to evoke an earlier period of manuscript book presentation, but in a modern context. The illustrations were treated as miniature paintings, with subjects of flora, fauna and landscape painted in a 'flat' medieval style. Production was by steel nib, brush, wooden (chop) stick and ruling pen with gouache, and the addition of blind embossing. A wooden stick was manipulated to produce the illustration beginning on the right, to suggest how smoggy and gross the air in cities has become. The next section has some pages with borders made by ruling pen with shell gold. These add strength to the illustrative panel rendered with gouache using sponge and brush. The enlarged gold letters are produced with variegated gold.
1850 x 500mm (fully extended)/72.74 x 19.75in

Detail of gold letters.

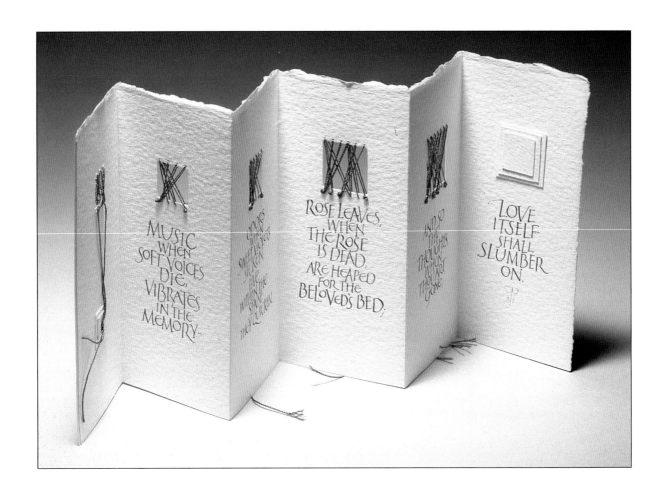

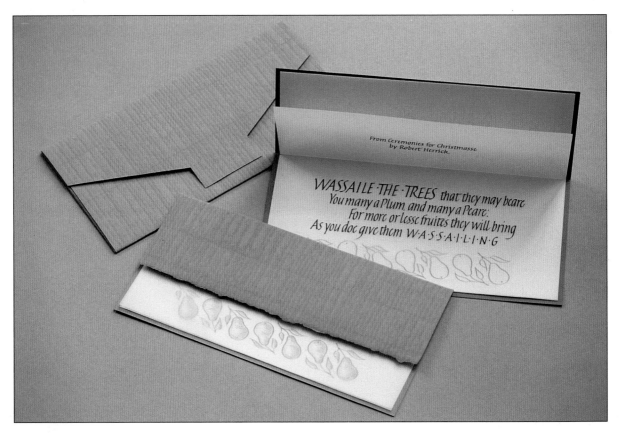

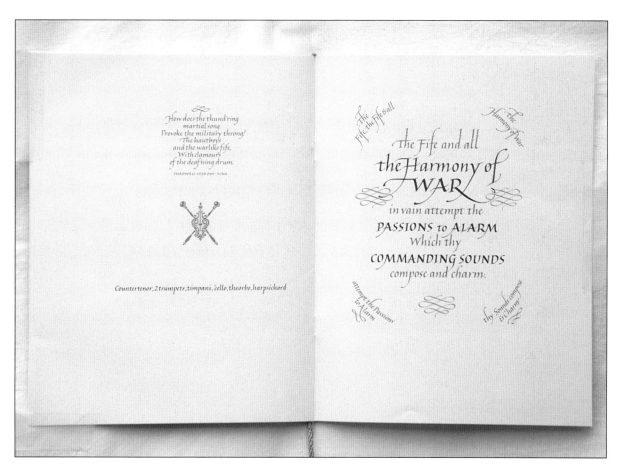

▲ TIMOTHY NOAD

In earlier centuries, the production of manuscripts relating to music usually meant graduales and antiphonaries, and these large volumes, in the absence of reproduction methods, formed a large part of scribes output. For the contemporary calligrapher, no longer bound by the restrictions of medieval use, manuscripts can be designed and produced in direct response to works of music.

This manuscript book is entitled *Hail Bright Cecilia, an Ode on St Cecilia's Day, 1692*, written by Nicholas Brady with music composed by Henry Purcell. The music has many parts, including chorus and solo, which contribute to a calligraphic interpretation by evoking colour, tone and form, supported by illustrations based on carefully researched carvings and instruments of the seventeenth century. A baroque nuance is sustained by the use of italic lettering with additional flourishing. The manuscript has pages of Zerkall paper, and calligraphy and illustrations produced with gouache and powdered gold. Unlike the antiphonaries, this manuscript has been printed and used as a programme for the 300th anniversary performance of the Ode - first played in London on St Cecilia's Day in 1692.

▲ GRETCHEN WEBER

In this rendering of *When Thou Art Gone*, squares have been cut out of the pages, and silk threads have been threaded and sewn across the resulting void made in the hand-made paper. The delicately scribed letters, based on a Roman hand, create a texture of their own as they travel down each page, each line hanging off an imagined vertical line. Varying the size of the letters creates more rhythm and texture.
70 x 140mm/2.75 x 5.5in

◄ ELIZABETH MacDOMINIC

Robert Herrick's poem about the traditional ceremony of wassailing was first published in 1648. An annual event, wassailing was held on Twelfth Night when the villagers in apple growing districts of England would gather together and drink the health of the fruit trees to ensure a good harvest and continued prosperity. This multi-layered card celebrates that occasion.

On the inner layer of translucent tracing paper (90gsm) are the title and accompanying text. The middle layer of cream paper has pen-drawn outlines of pears filled in with 3B pencil (in picture one is not). The outer casing (the cover) is pale-green, hand-made paper. The inner sheet was folded and tipped-in, on to the cream paper so the position of the pears is immediately below the verse. These two layers were then tipped on to the cover, so that when the cover is closed, the frieze of pears is still visible. The deckle edge of the hand-made paper is exploited so it lays against the strip of pears. The whole card can be encased in a folder made of the same paper as the cover.
195 x 199mm/7.63 x 7.87in

▲ EVA-LYNN RATOFF
A miniature manuscript, consisting of a concertina text block held in a wrap-round cover. This manuscript, brightly decorated and adorned with beads and ribbon, can be worn as a brooch using a clasp attached to the back board. The pages within contain a salient message, 'All things are possible', written with a black key-line and filled-in with metallic inks. The paper for the text was initially decorated by writing the words of the phrase freely in silver.
22 x 20mm/0.87 x 0.75in

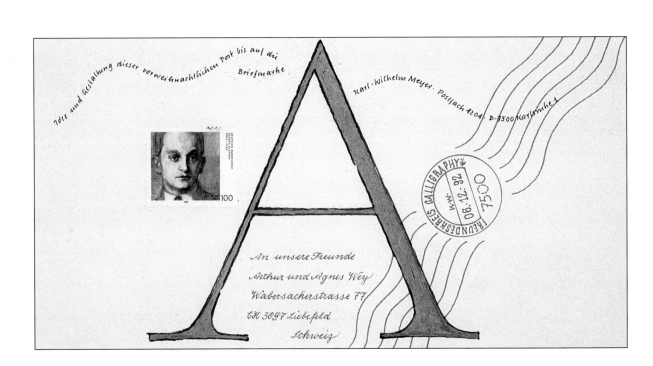

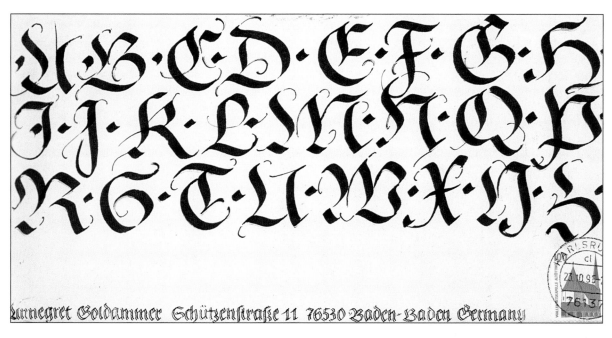

▲ KARL WILHELM MEYER

An enticing invitation is extended to the calligrapher via envelopes. The surfaces (front and back, and inside, if hand-made) provide an opportunity for exploration and visual adventure. This example is adorned with handwritten Fraktur capital letters created with steel pen. The recipient's details are rendered with an outline (split-nib) pen.

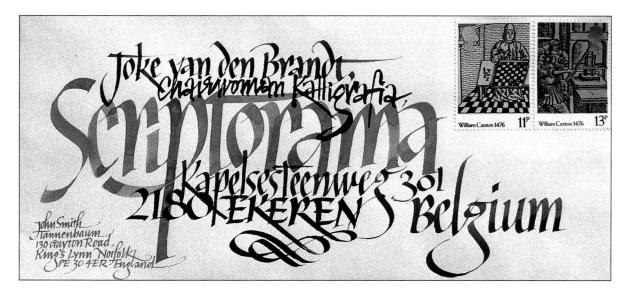

▲ JOHN SMITH

The variety of work coming into and emanating from a calligraphy studio is enormous. Idiosyncratic designs for any occasion worthy of celebration and sharing can be addressed calligraphically. Distinguishing styles and quirks of individual calligraphers do get recognized, acknowledged and unfortunately at times - expected. Envelopes are not exempt from the calligrapher's pen. This one was an entry in a Scriptorama competition. The words were written in gouache and brown watercolour.
230 x 100mm/9 x 4in

◀ KARL WILHELM MEYER

The elegant Roman 'A' and postmark facsimile are freely drawn using ink and gold paint marker. All other details on the envelope are handwritten using ink.

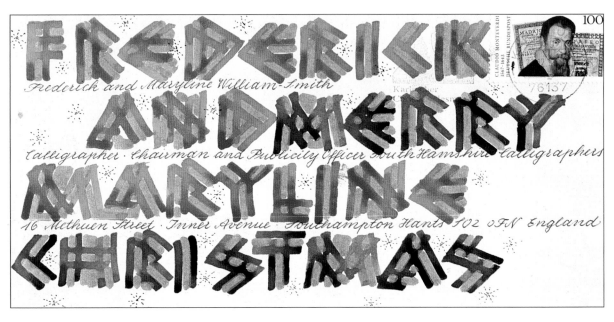

▲ KARL WILHELM MEYER

On this envelope the extravagantly rendered details are handwritten with a hand-cut, bamboo pen and ink. Gold paint marker has been used to fill in the counters and shapes created by the 'double' construction of the letters.

▲ KARL WILHELM MEYER

Writing the recipient's details until the whole surface of an envelope is covered creates an unusually interesting visual texture. On this envelope it also echoes the design of the stamp issued by Deutsche Bundespost. The sombre choice of colours for the envelope and the fountain pen and ink written details are offset delightfully by the flashes of colour used for this particular stamp.

▶ DAVE WOOD

This testament of appreciation was extended by the Flying Doctor Service in Australia to a group of lawyers whose principals gave their services freely over many years to that organisation. The only request to the calligrapher was to reflect and acknowledge the love of Australian flora and fauna shown by the lawyers. The work was composed by using steel nib and brushes, with gouache and additional elements of variegated gold leaf and blind embossing.
560 x 420mm 22 x 16.5in

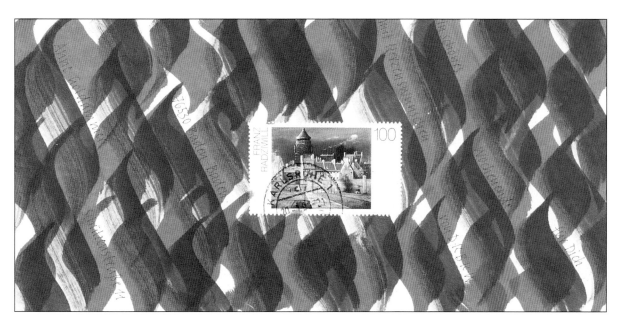

KARL WILHELM MEYER
Permanent marker pen has been used to produce these freely rendered calligraphic forms. These provide a ground on this envelope for the details written with felt pen.

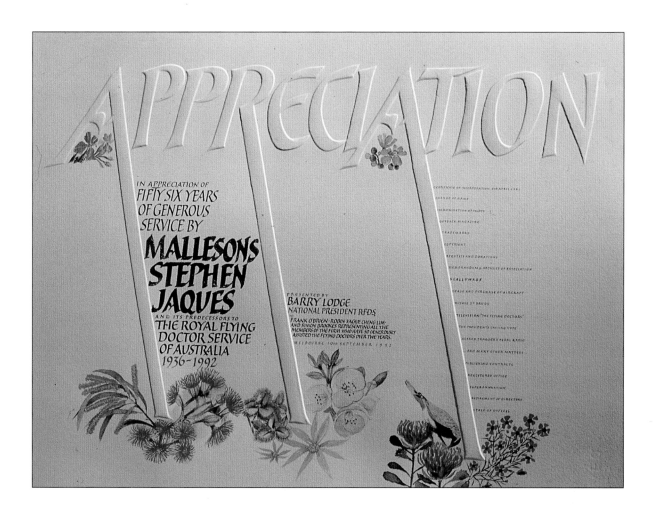

◀ DAVE WOOD
Beautiful celebration for a golden wedding, produced on vellum by quill and brush, with gouache and traditional gilding of loose leaf gold on gesso. There are examples of coterminous strokes as the gold extension to the 'L' in 'Golden' travels up the page, sharing its path with the letters 'E', 'T', 'R', 'A' and 'N'.
100 x 230mm/4 x 9in

◀ CELIA KILNER
This quotation is taken from Chapter 27 of Dame Julian of Norwich's *Revelations of Divine Love* a document considered to be one of the most outstanding recordings of medieval religious experience. This presentation is solely of blind embossing, a technique involving the carving in relief of the letters and then making an impression. The result is raised letters or ornament. The writer was a mystic and her visions are interwoven with personal reflections. When a calligrapher is selecting words to render, absolute consideration should be given to their literary sense.
279 x 203mm/11 x 8in

▶ FRANCES BREEN
A one-off Christmas card produced with
veneer and Brause nibs with white gouache,
watercolour and gold crayon on Fabriano
Roma paper.
130 x 120mm/5.12 x 4.75in

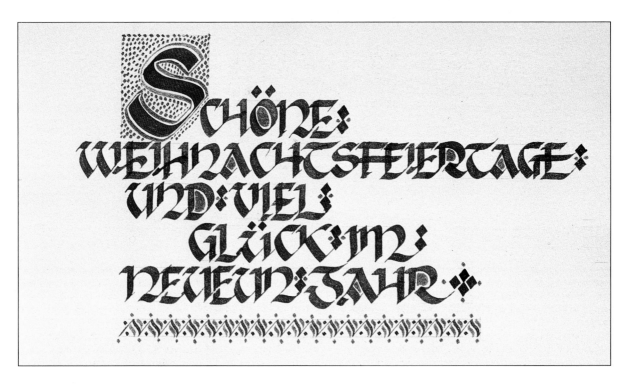

ONE ROOF
ONE SHOP
ONE STOP
AND ONLY ONE KIND OF SERVICE
PERFECT

*osmiroid fountain pen*

*come and see many more fascinating products, from a different angle at Wills Quills*

Enjoy the
friendly service
& browse through
the myriad of fabulous
calligraphic supplies,
(give yourself at least 2 hours!)
If you require anything remotely connected
with calligraphy, we are bound to stock.

WE ARE OPEN:
DAILY 9 - 6pm
CLOSED: SUN & MON.
LATE NIGHTS THURS.
41 2500

Wills Quills
IF WE DON'T HAVE - WE GET

166 Victoria Avenue
Chatswood
New South Wales 2067
Australia

MAILORDER

◀ DAVE WOOD
Designing with calligraphy affords excellent flexibility. This advertisement designed for insertion in a local newspaper used a variety of nib, and therefore letter size to create visual texture in the confined space. The use of a bold and unusual image, placed so a portion bleeds out of the frame of the work, adds to its ability to catch the reader's eye as the pages of the newspaper are turned. The design of the image itself merits comment for its original viewpoint, reminding us of (and inspiring us with) the validity and accessibility of using what is right under our noses.

◀ DIANA HARDY WILSON
The opportunity to work in a language other than the mother tongue can be exciting, but does demand sensitivity to the nuances and customs of the other culture. This card, one of a commissioned selection of seasonal greeting cards is a perfect example of the kind of interesting challenge which can arise.

For this series of cards, the layout was the greatest problem because of the juxtaposition of words of diverse lengths: for example, a nineteen letter word, preceded by a six letter word and succeeded by three and four letter words. For a native English speaker the problem was of generous magnitude, and the example reproduced here still does not truly solve the problem - certainly not in an adventurous manner. This reflects the inhibited constrictions which can be felt when working for another culture and not being absolutely *au fait* with it.

A further example of this arose in the design of some of the other cards in the series. These had an enlarged, minimally decorated capital letter from which a broad gold band dropped away to finish short of the tail edge in a 'fringe' of fine lines. Unknown to the calligrapher, this had religious significance. Though, in this case the additional resonances were not a problem, it provides a cautionary tale.

RODNEY SAULWICK

Calligraphy and paper are of course intrinsically linked and continue to enjoy a long and profitable relationship. Therefore it is fitting that, for a premier paper range, calligraphic forms should be used for a logo. A Copperplate script was combined with an inline italic to produce the artwork which was prepared by metal nib, technical pen, brush and ink on A3 Bond paper. The work was reproduced in many colourways for application to a wide range of paper products.

RODNEY SAULWICK

Calligraphy has a long tradition of association with certificates and citations awarded for an infinite range of achievements, from academic and sporting to those in the public arena. On many such awards, affordable and accessible printing has relegated the calligraphy to the insertion of the recipient's name and the date of receipt. However, some arrangers of these presentation certificates astutely commission calligraphers to make a greater visual contribution, more in keeping with the long-held tradition. This calligraphic head was for a series of A3 parliamentary certificates effected by Coit 3/8th pen, mono-nib and ink on Bond paper.

**RODNEY SAULWICK**
The potential for using calligraphy in the public domain is universally recognized, but sadly seldom realised. Although there are plenty of examples produced by machine involving a calligraphic feature, these do not quite have the finesse of the hand product - where the agility of the human touch and, ironically, its fallibility create original, non-clinical solutions. This logo was produced for a presentation. The A5 artwork was prepared with a Gillott 404, technical pen and ink. The intention and need was to capture and express the elegance and style to be found in Melbourne, Australia.

**RODNEY SAULWICK**
To celebrate the seventy-fifth anniversary of the Australian Music Examinations Board, this logo was designed to be used nationally on all stationery and selective publications. The final composition needed to relate to existing typographical arrangements set in Palatino. This artwork was prepared on A4 Bond paper using 0.4 technical pen, mono-line nib, and China black ink; it was printed in two colours with '75th' in corporate blue.

▶  GAIL RUST

Finding other disciplines and their materials
which sit comfortably and work well with
calligraphy is not difficult. There are many
which have at some time had a close
association or direct link, for example,
bookbinding. Discovering complementary
arts which are original in their inclusion
with calligraphy is less easy. *Living Leaf* is a
solarised photograph, that is, one which is
exposed to light during developing. The
print has been window mounted in three
strips using Canson paper. The fragmenting
of the picture causes two bands to run
through it; here, words have been placed
and gold leaf applied.

▶  GEMMA BLACK

Once the decision has been made to work with three dimensions, the challenge can be to discover new or novel shapes, other than the
obvious cube and sphere. This original hanging pyramid has been covered with Italic writing inscribed using metal nibs with designer's
gouache. The absence of interlinear space is deliberate, to create texture on the surface pattern; changing the colour and size of the
lettering adds further to this. Calligraphy can be used highly effectively to provide surface decoration on many materials and formats.
Whether the intention is to disguise or exaggerate the shape of an object (either two or three dimensionally), working with the shape or
format should lead to a more exciting finished product.

▲ GEMMA BLACK

Calligraphers often make their own seasonal greetings, birthday and celebratory cards, even decorating large sheets of paper to wrap gifts. A greater challenge can be found in the move from two to three dimensions. These boxes, decorated by the application of designer's gouache using metal nibs, show Italic letters making their way around the six surfaces. In a feat reminiscent of *trompe l'oeil*, the 'ribbon' is painted on the surface, with the letters set against the dark background of the 'paper'.

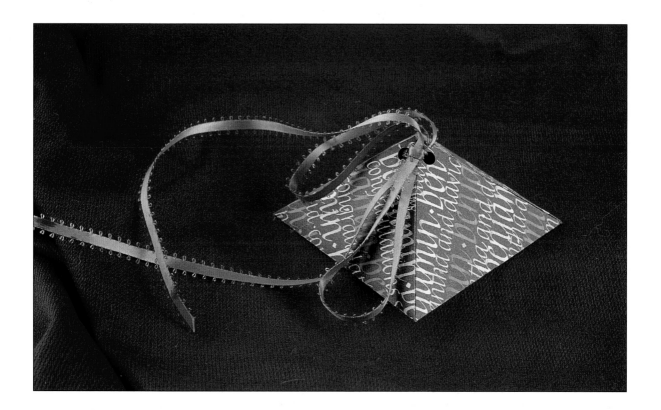

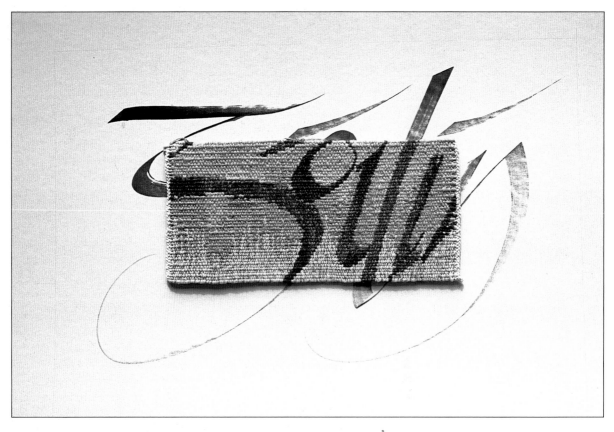

▲ FRANCES BREEN & JOANNE BREEN

Work produced in collaboration with an artist working in another discipline has potential for exciting results. The shared learning experience can be most rewarding with each artist - through the access to language, tools and equipment of another discipline, not always obviously complementary - taking something back to their own domain. This collaboration brings calligraphy and tapestry together in the same frame. A period of intense exploration and experimentation preceded the final production. Much time was spent determining how to effect the calligraphy, and the final decision was for the lettering to be reasonably abstract and expressive. The calligrapher's comment is that this enabled the tapestry to take the writing further than any intricate illumination might do. This panel *Góilín* is one of a series of six for *Feth na Fairrge* (Heartbeat of the Sea).

   After the production of many roughs made with great concentration, the rendering of the letters was relatively swift. By contrast, the tapestry was slowly worked, but with meditative quality equal to that required by the lettering roughs, rather than the final writing. This labour time is particularly interesting considering the reputation calligraphy has for labour intensiveness.

520 x 390mm/20.5 x 15.63in

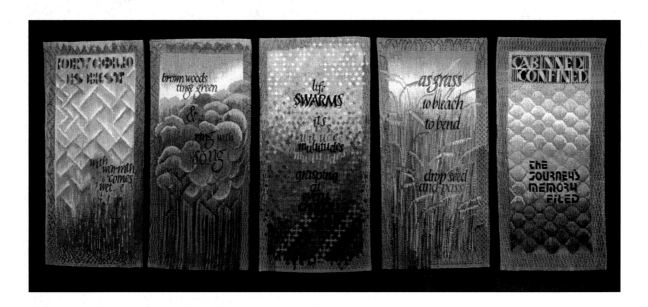

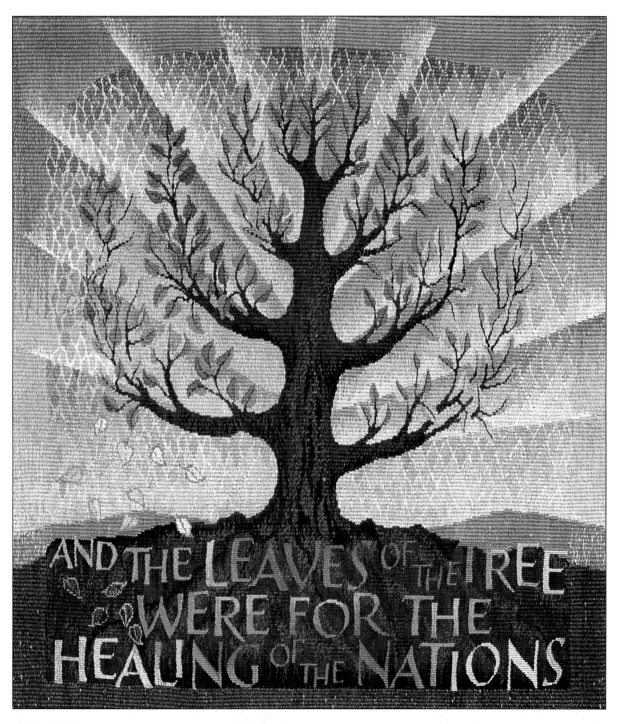

▲ PAT JOHNS

The *Tree of Life* is a Gobelin tapestry. The colours of the lettering shine brightly, reflecting the leaves still on the tree, and the density of the background behind the letters gives strong definition to the counter shape of the well-defined letter forms. This gives exceptional life to the work and creates its own pattern of positive and negative, echoing the leaves on the tree and their background; repeated pattern which seems to outline the mature, fully leaved tree.

◀ PAT JOHNS

This tapestry entitled *Year's Journey* is divided into five panels. The woven work is a Gobelin tapestry. (Gobelin tapestries were made from the fifteenth century at a factory just southeast of Paris, and the name is also used for tapestries woven in similar style.) Traditionally the yarns used were wool and silk, or cotton and silk.

2700 x 750mm/106.11 x 29.5in

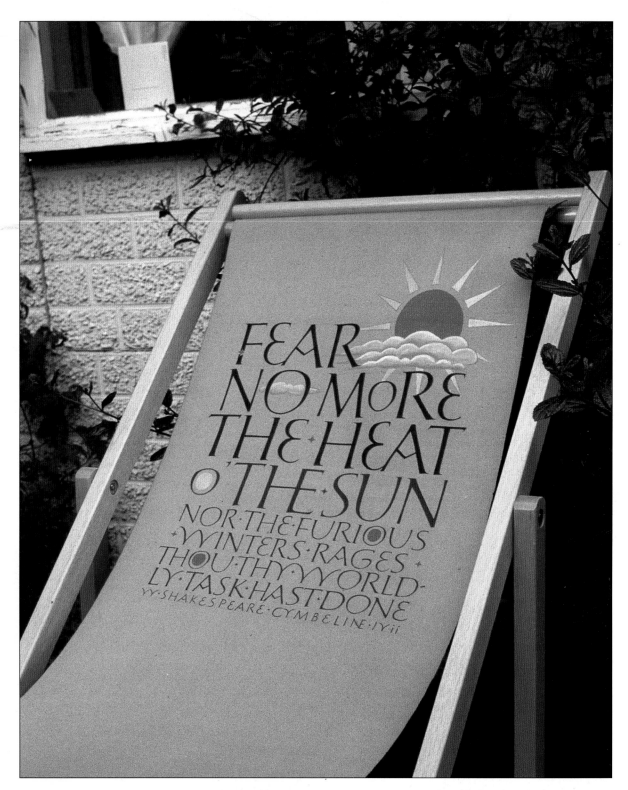

**ANNE IRWIN**
Working with calligraphy brings frequent new personal discoveries: new layouts, formats, colour combinations, styles, materials and techniques and, the objects, substrates, surfaces and purposes to which these might be applied. Painting letters on canvas with fabric paint is just such a discovery. It may be a more familiar sight on banners, but on a piece of furniture, such as a deck chair, it is most unusual and effective. The words from Shakespeare's *Cymbeline* are appropriate to the whole design concept, which includes some letters with coterminous strokes, letter 'A' with the half diamond cross bar, boldly filled in counter shapes and delicate, round 'e' forms.

SUE COX
Calligraphy is enriched by being embraced into other media. The creations of these calligraphic sculptures in vitrified porcelain is very labour intensive. Chinese brushes, roller, cut metal letter shapes, a broad palette of high-temperature colours and very plastic porcelain are among the requisites for making these large letters interpreted as three-dimensional forms. This follows in the tradition of Islamic architecture which splendidly exploited the combination of pottery and calligraphy.

The letters are stretched and modified and a model is made in card to determine the final design. The technique used included painting high-temperature ceramic colours on to the porcelain; cutting into the surface with the shape of a letter to give a small-scale letter; rolling the porcelain very thin (approximately 3mm) and then selecting the most interesting areas of this fine porcelain and cutting, shaping and joining it while it is still semi-hard. It is fired to 1300°C, at which temperature it forms a crystalline vitrified internal structure.
229 x 127mm/9 x 5in

SUE COX
A calligraphic sculpture in vitrified porcelain.
356 x 356mm/14 x 14in

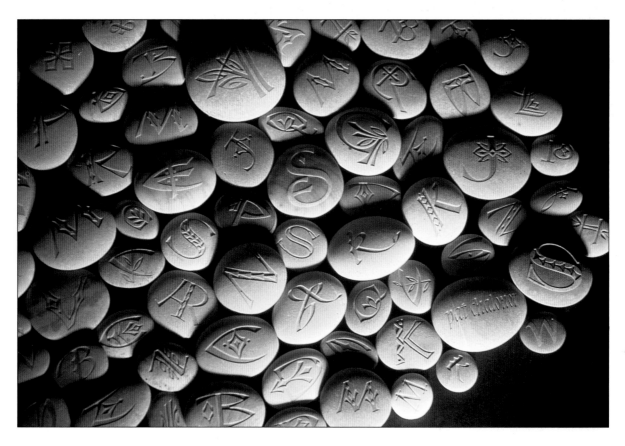

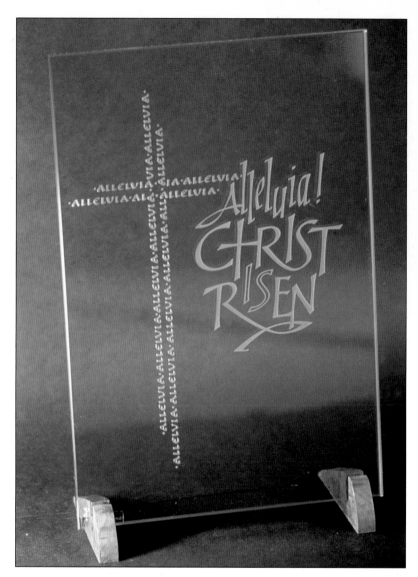

◀ PAT CHALONER
Plate glass, with its exceptional characteristics of high quality and thickness, was used for this elegant exhibition work. The letters were grit blasted. The design of the layout, particularly the visual working of the word 'alleluia' into a cross, proves a most effective and refined, though uncomplicated, solution. The use of coterminous strokes is clearly illustrated by 'HR' in 'Christ'. A most original solution is seen in the use of an outline only for 'IS', denoting its status both as a word itself and as a part of 'risen'.
190 x 280mm/7.5 x 11in

▲ CELIA KILNER
A quotation from Rupert Brooke's poem *Heaven* incised into Welsh slate. The natural hue of the slate evokes the shallows and depths of the 'Eternal Brook' in which the fish swims, entirely composed of the quotation in the form of a calligram. Extensions to well positioned individual letter strokes form the fins and tail. The overall visual effect of the work, with its total absence of any unnecessary embellishments, is simple, succinct and elegant.
380 x 280mm/15 x 11in

◀ PAT CHALONER
The inviting surface of similarly hued pebbles with a mean size of 50-60mm (2-2.5in), has been grit blasted with letters and decorative calligraphic forms. For this experimental work, the clean line and shapes of the pebbles are complementary to the calligraphic marks. This innovative idea reinforces the need to be ever alert and receptive to inspirational sources, which can be found in very accessible and obvious places, as well as the more obscure.

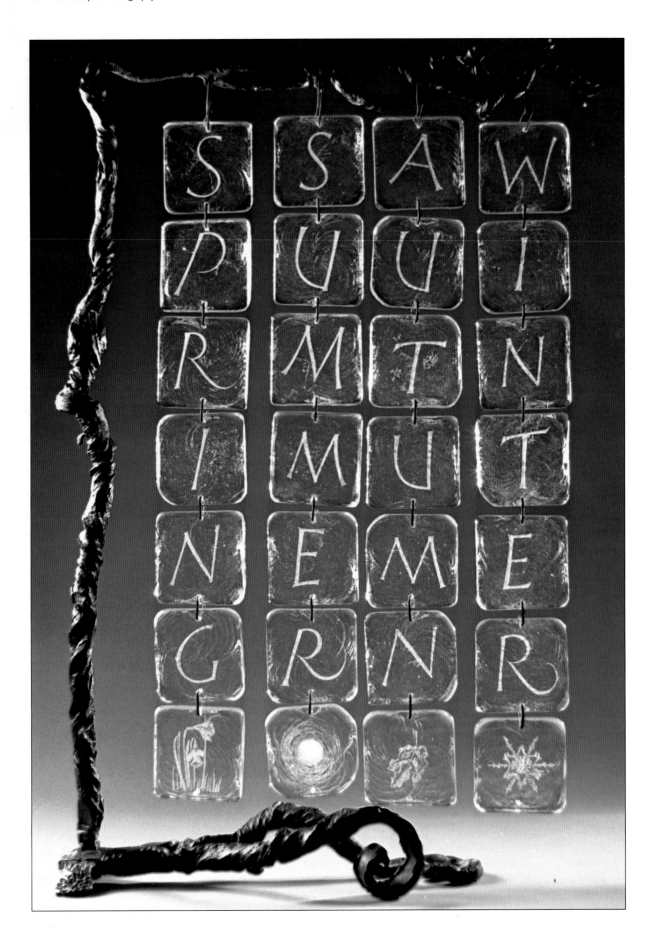

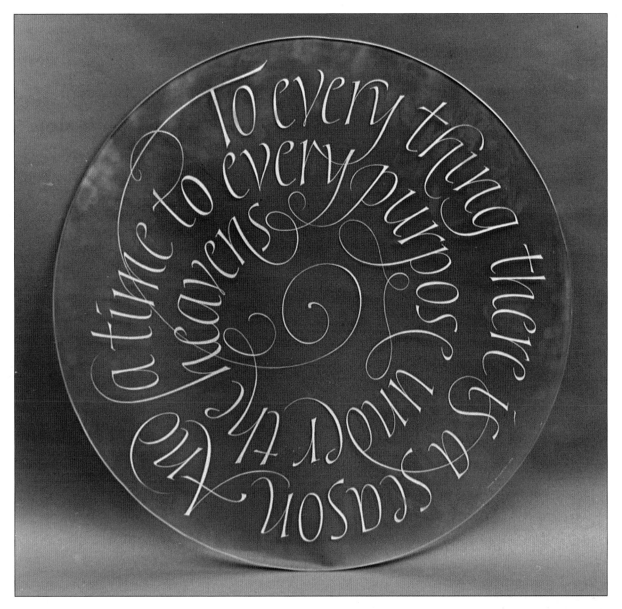

▲ DAVID PILKINGTON
Quotation from the Biblical book of *Ecclesiastes* in a barely perceptible spiral, adorning a glass table top. The letters were engraved in reverse on the underside of the circular form before toughening. The apparent deftness of the application defies the difficulties which can be encountered in this process. Note the way the fine line extensions to many letters evolve to become other forms, parts of letters or entire letters.
610mm/24in diameter

◀ DAVID PILKINGTON
The four seasons, four elements and similar recognisable groupings are another source of inspiration for innovative work with letters. These letters are engraved on hand-made crystal tiles, which are suspended from a specially commissioned, wrought-iron support designed by Ed Sveikutis. The work, entitled *The Four Seasons* is a window sculpture, designed to stand on a window ledge and catch the changing light as the sun makes its way across the sky.
813mm high x 508mm wide/32 x 20in

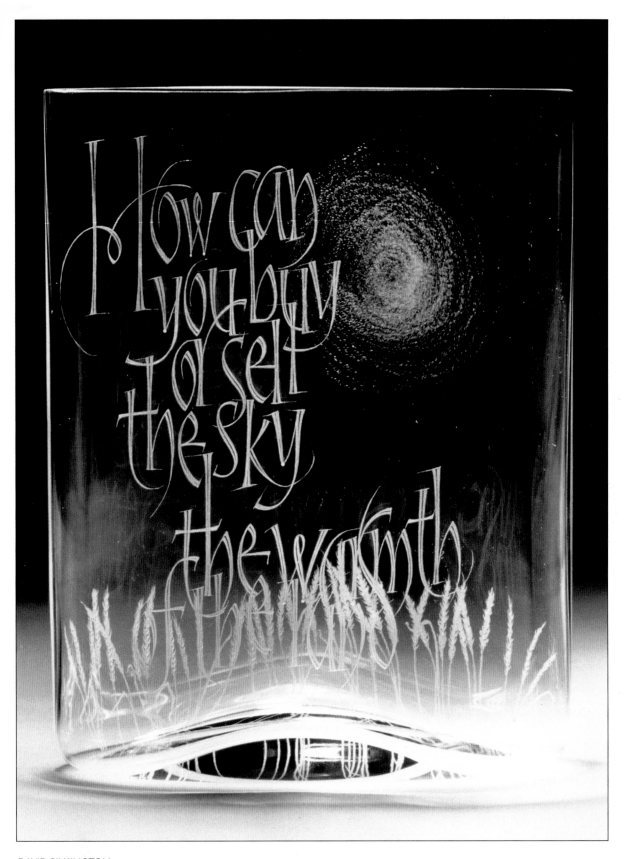

DAVID PILKINGTON
An elegant oval vase engraved with the opening words of an American Indian quotation *How can you buy or sell the sky...* Engraved on the reverse face of the vase are a symbolic sun and ears of wheat.
254mm/10in high

# Bibliography

ARIETI, Silvano
*Creativity: The Magic Synthesis*
Basic Books, Inc,
Harper Colophon Book
(New York, 1976)

ATKINS, Kathryn A.
*Masters of the Italic Letter*
Allen Lane, The Penguin Press
(Great Britain, 1988)

BAIRD, Russell N., McDonald,
Duncan, Pittman, Ronald K. &
Turnbull, Arthur T.
*The Graphics of Communication*
Holt, Rinehart and Winston
(USA, 1987)

BANN, David
*The Print Production Handbook*
Macdonald & Co (Publishers)
Ltd (London, 1986)

BAUDIN, Fernand
*How Typography Works (and
why it is important)*
Design Press (New York, 1988)

BIGGS, John R.
*Basic Typography*
Faber and Faber Limited
(London, 1968)

BUZAN, Tony
*Use Your Head*
BBC Books (London, 1987)

CANNON, R.V. & WALLIS F.G.
*Graphic Reproduction*
Vista Books (London, 1963)

CAUDWELL, H.
*The Creative Impulse in writing
and painting*
Macmillan & Co Ltd
(London, 1951)

CHAMBERS, Harry T.
*The Management of Small-Offset
Print Departments*
Business Books Limited
(London, 1969)

CROSS, Nigel (ed)
*Developments in Design
Methodology*
John Wiley & Sons
(Chichester, 1984)

CROY, Peter
*Graphic Design and
Reproduction Techniques*
Focal Press (London, 1968)

DE BONO, Edward
*The Use of Lateral Thinking*
Penguin Books Ltd
(England, 1977)

DIMNET, Ernest
*The Art of Thinking*
Jonathan Cape
(London, 1929)

DOERNER, Max
*The Materials of the Artist*
Granada Publishing
(London, 1984)

DONDIS, Donis A.
*A Primer of Visual Literacy*
The MIT Press (USA, 1993)

EDWARDS, Betty
*Drawing on the Right Side of
the Brain*
Fontana Paperbacks
(Great Britain, 1982)
*Drawing on the Artist Within*
Simon & Schuster
(New York, 1986)

ETIEMBLE
*The Written Word*
Prentice-Hall International
(London, 1962)

EVES, Ian
*Paper*
Blueprint Publishing Ltd
(London, 1988)

GARLAND, Ken
*Illustrated Graphics Glossary*
Barrie & Jenkins (London, 1980)

GRAY, Nicolete
*A History of Lettering*
Phaidon Press Ltd
(Oxford, 1986)

GRILLO, Paul Jacques
*Form, Function and Design*
Dover Publications Inc
(New York, 1975)

HATTON, Richard G.
*Design: An exposition of the
principles and practice of the
making of patterns*
Chapman and Hall Ltd
(London, 1925)

HILL, Donald E.
*The Practice of Copyfitting*
Graphic Arts and Journalism
Publishing Company
(Alabama, 1971)

HOLT, John
*How Children Learn*
Pelican Books (England, 1979)

HUNT, Morton
*The Universe Within:
A New Science Explores The
Human Mind*
Corgi Books (London, 1984)

HURLBURT, Allen
*The Grid*
Barrie & Jenkins Ltd
(Great Britain, 1979)

JACKSON, Frank
*Theory and Practice of Design*
Chapman and Hall Ltd
(London, 1894)

JEAN, Georges
*Writing: The Story of Alphabets
and Scripts*
Thames and Hudson
(London, 1992)

JOHNSON, Arthur W.
*The Thames and Hudson Manual
of Bookbinding*
Thames and Hudson
(London, 1984)

KEPES, Gyorgy
*Language of Vision*
Paul Theobald
(Chicago, 1951)

KLEE, Paul
*Pedagogical Sketchbook*
Faber and Faber (London, 1981)

KOBERG, Don & Bagnall, Jim
*The Universal Traveller*
William Kaufmann, Inc
(Los Altos, California, 1974)

KOLLER, E.L.
*Modern Styles: Decorative
Ornament*
International Textbook Company
(Scraton, Pa, 1930)

KRUSI, Hermann
*The Life and Work of Pestalozzi*
Wilson, Hinkle & Co
(Cincinnati, 1875)

LAWSON, Bryan
*How Designers Think*
The Architectural Press
(London, 1983)

LEWIS, John
*Typography/Basic Principles*
Studio Vista (London, 1968)

LUKER, Leslie G.
*Beginners Guide to Design
in Printing*
Adana (Printing Machines) Ltd
(England, 1973)

McLEAN, Ruari
*The Thames and Hudson Manual
of Typography*
Thames and Hudson
(London, 1980)

McLUHAN, Marshall
*The Gutenberg Galaxy: The
making of typographic man*
University of Toronto Press
(1962, reprinted in USA, 1964)

MAURER, Herrymon
*Tao the Way of the Ways*
Wildwood House (England, 1986)

MAY, Rollo
*The Courage to Create*
Bantam Books (New York, 1980)

MITCHELL, Frederick J.
*Practical Lettering and Layout*
Adam and Charles Black
(London, 1960)

NESBITT, Alexander
*The History and Techniques
of Lettering*
Dover Publications, Inc
(New York, 1957)

NEUGEBAUER, Friedrich
*The Mystic Art of
Written Forms*
Neugebauer Press USA Inc
(USA, 1980)

OGG, Oscar
*The 26 Letters*
George Harrap & Co. Ltd
(London, 1955)

PAGLIERO, Leonard (ed)
*The Retail Stationer's Handbook*
The Stationers' Association of
Great Britain and Ireland
(London, 1949)

PEARCE, Charles
*The Anatomy of Letters*
Taplinger Publishing Company
Inc (New York, 1987)

PYE, David
*The Nature of Design*
Studio Vista (London, 1969)

RESNICK, Elizabeth
*Graphic Design: A Problem
Solving Approach to Visual
Communication*
Prentice-Hall
(USA, 1984)

SILVER, Gerald A.
*Graphic Layout and Design*
Van Nostrand Reinhold
Company
(New York, 1981)

SMITH, Robert Charles
*Basic Graphic Design*
Prentice-Hall
(New Jersey, 1986)

STEIN, Morris I.
*Stimulating Creativity,*
*Volume 1: Individual Procedures*
Academic Press (New York, 1974)

STEPHENSON, C. &
Suddards, F.
*Ornamental Design For*
*Woven Fabrics*
Methuen & Co (London, 1897)

STRANGE, Edward F.
*Alphabets: A Manual of Lettering*
*for the Use of Students with*
*Historical and Practical*
*Descriptions*
George Bell and Sons
(London, 1898)

SWANN, Cal
*Techniques of Typography*
Lund Humphries (London, 1980)

THOMAS, Alan G.
*Great Books and Book*
*Collections*
Spring Books
(London, 1988)

TRUDGILL, Anne
**Lettering Workbooks:**
*Basic Skills*
Studio Vista (Great Britain, 1989)
*Traditional Penmanship*
Studio Vista (Great Britain, 1989)

TYMMS, W.R.
*The Art of Illuminating*
Studio Editions (London, 1987)

WARD, James
*Elementary Principles of*
*Ornament*
Chapman and Hall Limited
(London, 1890)

WESTWOOD, J.G.
*The Art of Illuminated*
*Manuscripts*
Bracken Books (London, 1988)

WHALLEY, Joyce Irene
*The Pen's Excellence: Calligraphy*
*of Western Europe and America*
Midas Books
(England, 1980)

WHITE, Jan V.
*Mastering Graphics: Design and*
*Production Made Easy*
R.R. Bowker Co
(New York, 1983)

WILSON, Diana Hardy
*The Encyclopedia of Calligraphy*
*Techniques*
Headline Book Publishing plc
(London, 1990)

# Index